VIA Folios 171

Finding Dandini

All rights reserved. Parts of this book may be reprinted only by written permission from the author, and may not be reproduced for publication in book, magazine, or electronic media of any kind, except in quotations for purposes of literary reviews by critics.

© 2024, Thomas Ruggio

Library of Congress Control Number: 2024931288

Published by
BORDIGHERA PRESS
John D. Calandra Italian American Institute
25 W. 43rd Street, 17th Floor
New York, NY 10036

VIA Folios 171
ISBN 978-1-59954-219-5

FINDING DANDINI

THE REDISCOVERY OF A PAINTING AND A 17TH-CENTURY ARTIST

Thomas Ruggio

BORDIGHERA PRESS

Contents

PART I • TWENTY-FIRST CENTURY

1. Church Visits	11
2. A Discovery	14
3. Pause	33
4. On the Painter's Trail	35

PART II • SEVENTEENTH CENTURY

5. The Devil He Knew	49
6. Here and Now	72
7. Son of Thunder	80
8. Redux	114
9. Apotheosis of Carita	150

Selected Bibliography	163
Acknowledgments	171
About the Author	173

*to my late mother, Phyllis, who taught me how to dream;
to my father, Thomas, who encouraged my aspirations;
and to my daughter, Livia, who inspires me to achieve.*

PART I

TWENTY-FIRST CENTURY

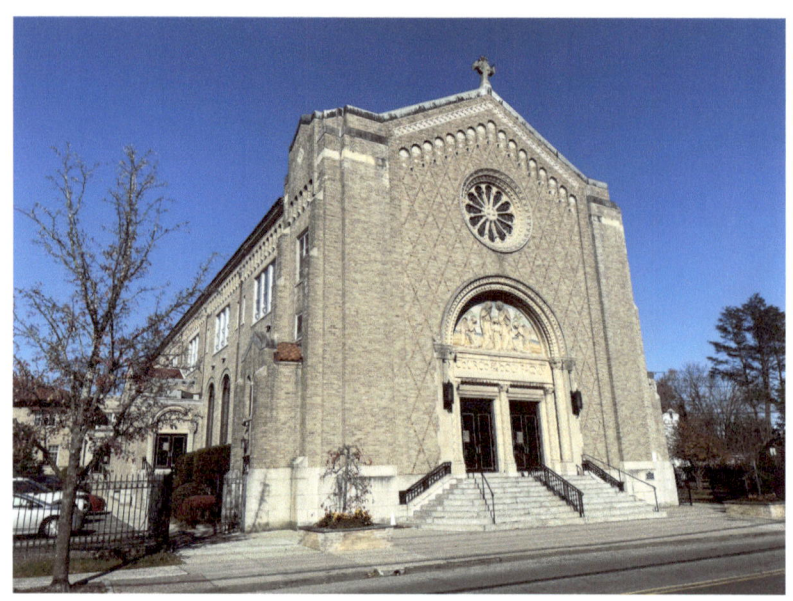

Church of the Holy Family, New Rochelle, New York.

CHAPTER 1

Church Visits

"Thank you, professor," is what I heard from the last of my students as they left my winter session class at Iona University (then College). After thanking them in return, I turned off the lights in the art studio. I lowered the strap of my leather satchel from over my head and onto my shoulder. As it pressed across my chest, I sighed. My bag wasn't heavy, but there was imbalance in my life; something was missing. Although I rarely noticed it when I was teaching or working on projects that required my complete attention, it was evident in the idle moments. From the outside, it may have appeared fine—I had shared custody of my nearly eight-year-old daughter and I was in the profession of my choosing, teaching fine art and art history on the university level. There were blessings in my life, for which I was grateful, but there was also a lack of fulfillment, exacerbated by the financial challenges I experienced some months. A new professional direction was under consideration, but on this overcast Thursday, January 16, 2020, my immediate destination was only two blocks away. I was going to the Church of the Holy Family, and it was not for a church service.

I began visiting churches when I lived in Lucca, Italy. My mother passed away in the spring of 2010 due to complications caused by what was initially deemed a "successful surgery." The entire ordeal, from the initial diagnosis to her unexpected death, was, as so many others also unfortunately know, difficult. We lose our parents; it is the cycle of life. However, she entrusted her care to me, along with my

older brother Philip. When the situation deteriorated, I privately and unnecessarily bore that burden. And this occurred during the early stages of achieving my greatest aspiration up to that point: founding an art program in Italy.

The studio doors of my art program opened in Borgo a Mozzano, Lucca, in June of 2012, shortly after the birth of my baby girl, Livia. Studio Borgo was the most demanding and fulfilling endeavor of my life up to that point. By living, teaching, learning and parenting in a wonderful new world, I became more aware of my capabilities and my limitations with each day. This period, during which I was under the most intense pressure I had ever felt and riding emotional peaks and valleys, was evidently more taxing than I knew at the time. When I arrived in Lucca, known as "The City of One Hundred Churches," I sought out many of those special local resources. The artistry that adorned the church interiors of Lucca, from floor to ceiling, was a treasured yet secondary benefit for me. Although I was raised Roman Catholic, I had not kept up with formal practice, but had kept my faith. Despite the intellectual challenges that I had perceived for years with this or any other organized religion, I had developed an unshakable belief in this abstract concept since the year of my mother's death.

It was during the "off-hours," my term for when mass is not in session, that I visited those dimly lit, most peaceful places. Each visit began with a genuflection facing the altar on the other end of the nave. I always sat in the back, partially because it appeared to be the most secure and quiet location, and also because I believed I knew my place: I thought those who never missed Sunday mass and presumably knew every prayer and hymn by heart were more deserving of the middle and upper rows. Typically, I sat quietly, absorbing the sights, smells, and space in a sort of spiritually meditative state; all activity outside of those doors and much of the noise within my head ceased. A presence became more existent to me and it wasn't my mother's or God's necessarily; it was actually my own. Occasionally, I silently recited prayers and shared some updates with my mother and while I cannot say with certainty if any of my messages were received, the counter-energy that I perceived was profound. Saint Augustine wrote, "The reward of this faith was to see it." My reward was feeling it.

I brought this tradition back to New York with me from Italy, and in 2016, I took notice of a beautiful church in New Rochelle, two blocks from Iona's main campus. Although I had driven past the Church of the Holy Family each day and always admired the exterior, I never seemed to have the time to visit. One day in December of 2019, right before the fall semester ended, I finally went inside. The darkness of the vestibule instantly swallowed the daylight as the door closed, reminiscent of the way the heavy Italian church doors spring shut just as your second footstep touches down on the marble floor. The church interior was also dark. It struck me how some of the churches in Italy must have served as inspiration for the builder or patron of this space when the design plans were drawn up. Columns topped with Corinthian capitals constructed in the early twentieth century appear ancient in style while supporting a more Romanesque-inspired interior space. This kind of architectural period mixing occurred often in Italy because leftover Roman columns from ancient temples or forums, still strong as the day they were constructed, were accessible. These ready-made supports were also monuments to past greatness, so when pragmatically fitted into Romanesque-era churches or basilicas, there was an implied greatness for the "new" projects. The subjugation of those monumental columns was also thought to demonstrate the supremacy of Christian dominion. The ages of art and architectural history that took place in every Italian city were expected, but in Westchester County, the juxtaposition of these different architectural styles was a curiously asserted effort. Just a little strange, I thought, but the Church of the Holy Family felt strangely familiar and welcoming from my first visit. It wasn't until my fourth visit that something extraordinary occurred.

CHAPTER 2

A Discovery

It was about 1:30 in the afternoon of Thursday, January 16, when I entered the church, and upon sitting down in the rear pew, I noticed that the atmosphere was different this time—there was more light. The chandeliers were shining more brightly, and I noticed a framed painting above a doorway on the right aisle wall for the first time. Even from this distance, from my last row vantage point, I immediately knew I was looking at a seventeenth-century Italian painting.

"What . . . ?" is what I uttered out loud. What an extraordinary sight! I'd grown accustomed to seeing work like this in Italian churches: "But here?" Astonishing. As I got closer, the quality of the work was unmistakable. "Incredible . . .," I whispered, gazing up at the framed canvas. The Virgin Mary, the Christ Child, Joseph, and the infant Saint John the Baptist were all painted beautifully. The work not only displayed the typical characteristics of the Italian Baroque period, but I knew I was looking at a masterpiece by a top-level artist. Given the location, the quality of the work, and the fact that I'd been in the church three times before, it was still difficult to process. With my iPhone already in hand, I began taking photos. Those same shining lights that revealed this beautiful work of art to me also created a strong glare on the painted surface. I tried to be as creative as I could by taking the images from a variety of angles; even if the photos didn't turn out very well, I reasoned they were better than nothing.

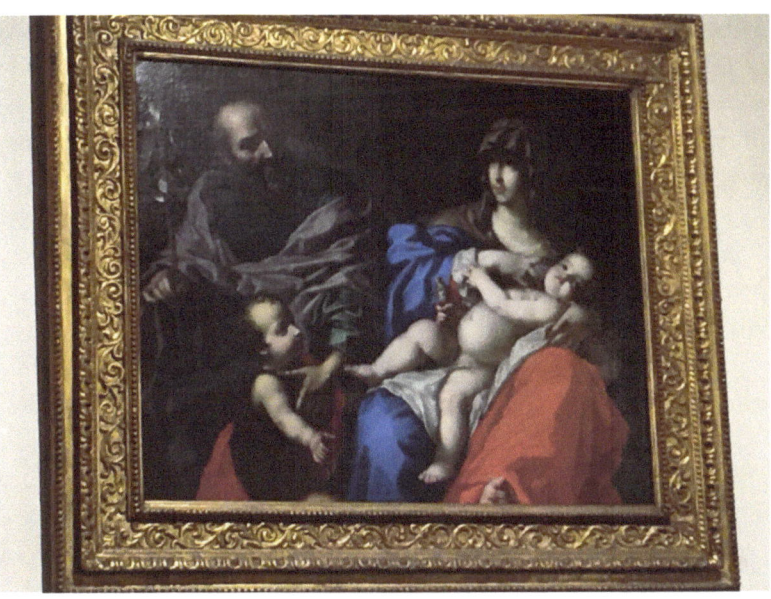

Thomas Ruggio's first photo of the New Rochelle mystery painting in the Church of the Holy Family, New Rochelle, New York, 2020.

As soon as I arrived home, I enlarged photos of the painting on my laptop and began scouring the internet for images. I intended to eventually search my shelves for every book I owned on Italian Baroque painting, which was a substantial number. Unbeknownst to me at the time, I possessed a book that contained a key clue to identifying the unknown painter, but I hadn't yet gotten to my library. My eyes darted back and forth between the images of the New Rochelle mystery painting and the works from artists that appeared in my internet search. I concentrated on seventeenth-century Italian paintings that contained multiple figures. In addition to specific artists, I considered the potential region of Italy or "school" for this artist. I presumed, based on the quality of the painting, that the artist had left behind a reasonable body of work for me to find.

Shortly after, I sent an email to Dr. Massimo Bonino, a renowned restorer and conservator of Italian old master paintings, to inquire about his thoughts. I met Dr. Bonino while living in Borgo a Mozzano, a

town in the Italian province of Lucca, and we have collaborated on projects and developed a friendship over the years. Beyond the physical skills of his craft, Dr. Bonino possesses the vision and knowledge of an Italian painting scholar, and I thought there was even a chance that he may have worked on a painting by the unknown artist. In general, a great restorer is not only capable of reconstructing sections or layers of masterworks to precision, but also of identifying and correcting any later interventions that may be obscuring some of the original work. His in-depth understanding of Renaissance and Baroque painting techniques, as well as his ability to recognize and replicate original paint applications that are consistent with the unique tendencies of individual painters, were the reasons why I wanted Dr. Bonino to view this painting as soon as possible. In the subject line of my email to him, I wrote *Una Scoperta*, which translates to "A Discovery." I knew I had come upon something special and always believed that two or more heads are better than one.

The following morning, Dr. Bonino replied and appeared as enchanted with the painting as I was. He described it as "a beautiful thing from the first half of the seventeenth century" and suspected the influence of the *pittori Emiliani* (painters from Reggio Emilia).[1] Dr. Bonino also recognized that the painting had been mostly well-restored, but he detected a surface inconsistency on the left side of the canvas near the infant Saint John's head. On my end, I was still looking for idiosyncrasies and consistencies. Italian Baroque painters, like other artists, but perhaps more so than their predecessors due to the relative creative freedom and independence they enjoyed, frequently returned to certain distinctive characteristics. These traits may be subtle, such as the inclusion of fingernails on the hands they painted, or more general such as the colors they worked with. For example, beyond the groundbreaking realism and pioneering use of *chiaroscuro* (light-dark), the seventeenth-century painter Caravaggio used a color palette that was quite limited. In his later years, the great sixteenth-century Venetian painter Titian, who was always at least one step ahead of the most talented of his contemporaries, stated

1 Dr. Massimo Bonino's exact words from his initial email reply to me regarding the painting.

that good painters only need three colors: black, white, and red (my students have heard this quote). A little more than twenty years after Titian's death, Caravaggio created one of the greatest painting styles of all time, the Italian Baroque, and he mostly used those same three colors. Caravaggio's style and limited color palette spread through southern Italy and into other parts of Europe such as Spain and the Netherlands. The color palette for this painting was more expansive.

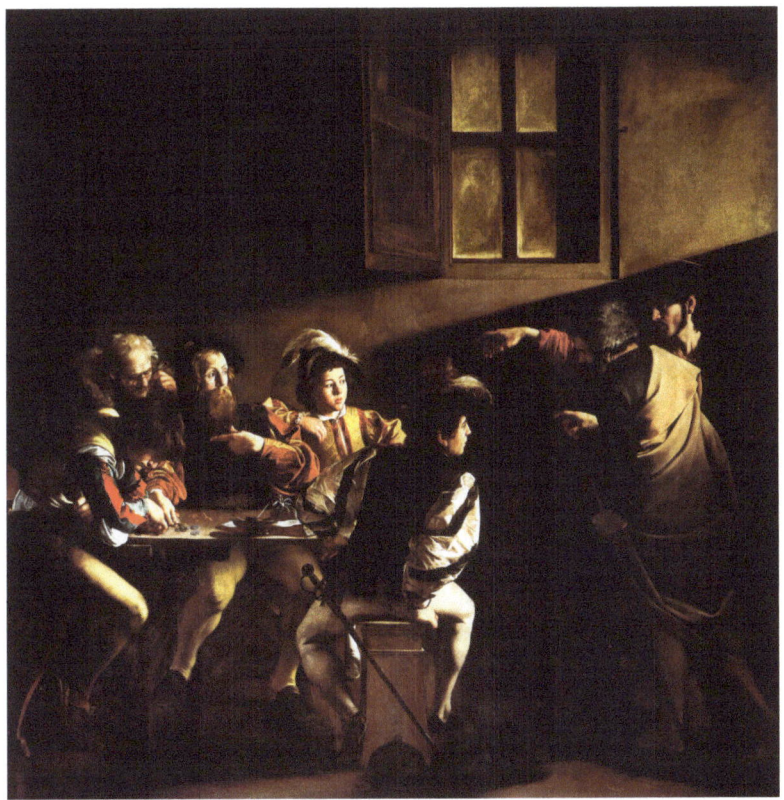

Caravaggio "Calling of Saint Mathew," oil on canvas, 1599-1600, Capella Contarelli, Chiesa di San Luigi dei Francesi, Rome, Italy.

As a professor of fine art and art history, I've been in a unique position to place myself, on the "other side of the brush," so to speak.

I would like to believe that this is a potential benefit with regards to teaching, but in the end, it probably just about cancels out the disadvantages of wearing two hats rather than one. My personal experience as a painter has made me profoundly aware of the human component behind paintings, in addition to the tendencies and historical precedents. While most artists typically rely on their strengths and return to what was successful in the past, which essentially define a given style, some creative choices could have been a result of additional factors that pertained to the artist's life outside of the studio, such as a great change in one's living environment or a once-in-a-lifetime opportunity. Physical or mental health could also factor in with regards to process. There would be some considerations to those factors within the extended research for this project. As for who this mystery artist was, the painting in the Church of the Holy Family presumably contained all the necessary clues I needed, but I'd have to first figure them out before I could follow them.

The composition was intended to be viewed from a lower perspective and this is called *di sotto in su* translating to "from below to above." One can determine this from the overall perspective and the view of the bottom of the Virgin Mary's foot. So, I began looking for a painter who must have been comfortable using that perspective. The superbly painted hands were also clearly emphasized, something I had taken note of from early on.[2] The faces of babies or children were invented as was typical, but I noticed that the face of the Virgin Mary looked more stylized than Joseph's and I saw this as another possible clue for an artist who didn't always work from life. At an early moment during my search, I thought of Mattia Preti. The Calabrian Preti employed a chiaroscuro-rich style, and although the relatively expanded palette of the New Rochelle painting didn't feel like a Southern Italian effort, I couldn't yet rule Preti out as a potential author of the work due to his use of *di sotto in su* perspective, compositional similarities, and the impeccably painted hands he created. The use of color and the face

2 Although I considered the beautifully painted hands in the painting to be a potentially identifying element in my search for the attribution for the then-unknown painter, conservator Blair Bailey pointed out Dandini's painting of fingernails.

of the Virgin Mary, however, looked like work from a more northern part of Italy, and I thought those elements somewhat resembled the paintings of Carlo Bononi, an Emilian painter of that era, which corresponded with Massimo Bonino's initial assessment regarding a possible region for the artist. Although I wasn't yet closing in on a potential attribution, the seemingly endless field of Italian Baroque painters was narrowing.

Mattia Preti "A Mother Offering Her Sons to Christ," oil on canvas, ca. 1635-1636, Pinacoteca di Brera, Milan, Italy.

Upon calling the Church of the Holy Family rectory, I was informed that the Monsignor was inquiring about the painting, and that he would shortly share whatever information he could find out. The lack of readily available information deepened the mystery for me and certainly piqued my already high level of curiosity. A meeting between myself and Monsignor Dennis Keane of the Church of the Holy Child was eventually arranged.

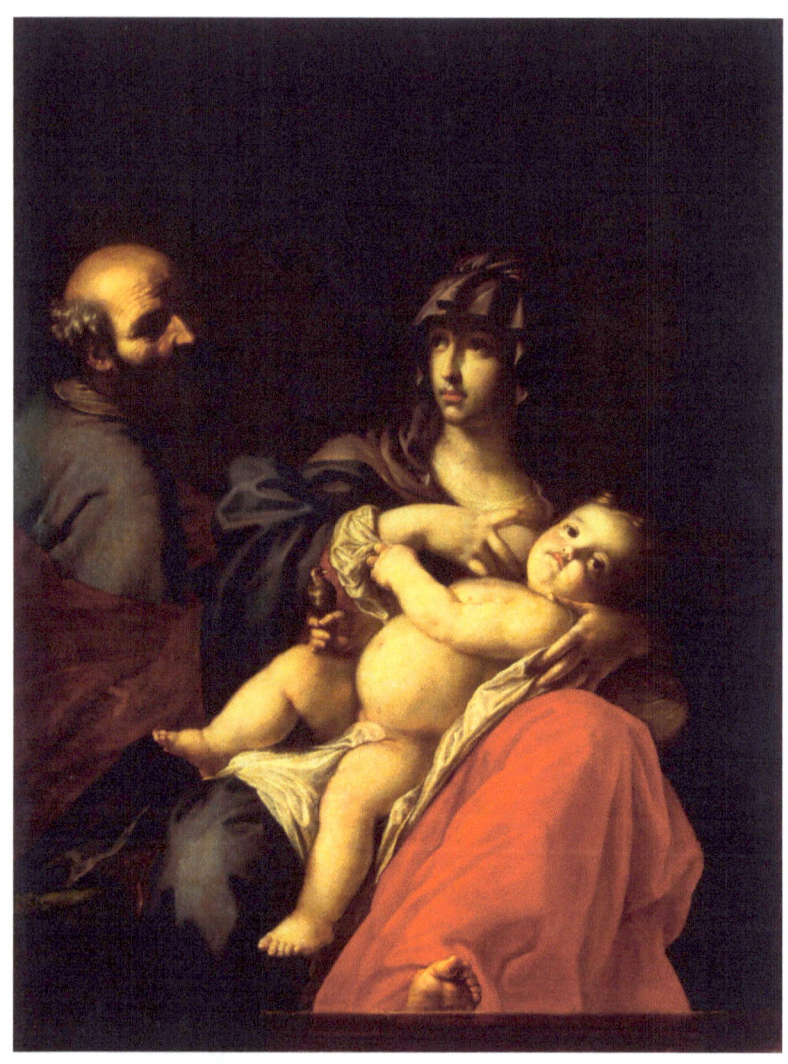

Cesare Dandini, "Holy Family," oil on canvas, ca. 1632-1634 (?), State Hermitage Museum, Saint Petersburg, Russia.

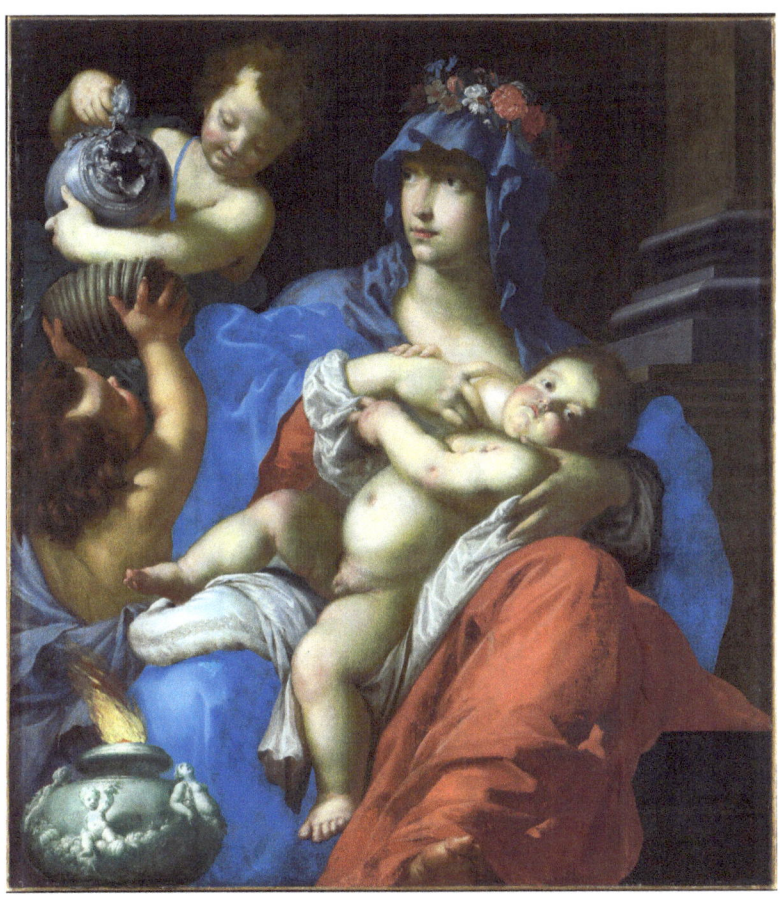

Cesare Dandini, "Charity", oil on canvas, ca. 1632 (?) and after1658 (?), Metropolitan Museum of Art, New York, United States.

On January 21, I received an email that would elevate the investigation. Although Dr. Bonino acknowledged that my earlier thoughts about Mattia Preti were reasonable, the attached image included in his reply essentially eliminated any doubt of authorship for the New Rochelle painting. The image was of Cesare Dandini's "Holy Family" from the State Hermitage Museum in St. Petersburg, Russia, along with the message "I believe we have found your artist." My eyes widened as I looked at an image that contained the Virgin Mary and

Christ Child figures in the same exact poses as the mystery painting. The figure of Joseph was also present in the Hermitage Museum painting, albeit in a much simpler pose and with less compositional emphasis on the left side of a vertical canvas. In addition, there was no infant Saint John in the Hermitage version. With the exception of a few variations in tonal value, almost every detail on the Virgin Mary and Christ Child matched precisely. I promptly typed in the artist's name on my laptop keyboard, and an image of yet another painting that corresponded with the New Rochelle painting appeared on my search page. Cesare Dandini's "Charity" painting in the collection of the Metropolitan Museum of Art in New York City also contained the same Virgin Mary and Christ Child figures, albeit with different identities; the figures in the Met's painting represented the allegory of the Christian virtue of charity. Because of the exceptional quality of the New Rochelle painting, I knew that it could not have been a workshop copy, so I thought about the other sixteenth and seventeenth-century painters who repurposed figures and even entire compositions. Based on the evidence that came to light in the previous five minutes, I was almost sure that Dandini had also engaged in this practice. However, further evidence was required to validate this theory and I also believed a scholarly consensus was necessary for an accepted Dandini attribution. I turned to my personal collection of books, and John T. Spike's 1980 publication, "Italian Baroque Painting from New York Private Collections," provided me with more evidence.[3] Another "Charity" painting contained the same maternal figure's head as the other three. Part of the artist's process was being revealed—I wasn't yet a Dandini scholar—but my education was underway.

 Dr. Paola Betti from Lucca, Italy is an expert on Italian Baroque painting and she was the first to identify Cesare Dandini as the artist of the New Rochelle painting. Dr. Betti passed along the HermitageMuseum image to Massimo Bonino who in turn, sent it to me. I conferred with Dr. Betti at the recommendation of Massimo Bonino regarding a painting that was included in

3 Spike, John T., Italian Baroque Paintings from New York Private Collections, The Art Museum, Princeton University in association with Princeton University Press, New Jersey, 1980, p. 50.

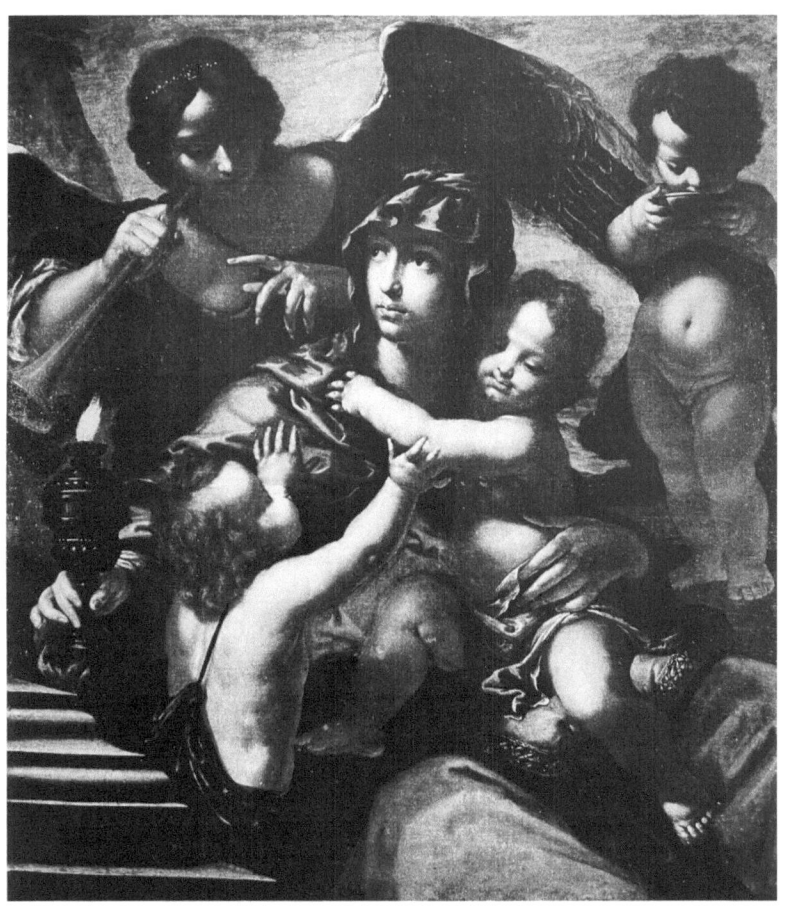

Cesare Dandini, "Charity," oil on canvas, ca. 1632 and after 1658 (?), former Ganz family collection.

a Peter Paul Rubens exhibition that I co-curated years earlier. In that case, she shared her expertise, helping to specify a vague and somewhat useless previous attribution of "17th-century Italian School" for a work that clearly displayed the recognizable characteristics of a particular region. I knew for certain that the painting was the work of a Venetian painter and even suggested Giulio Carpioni as the possible artist. And while another scholar thought Giulio Carpioni was a reasonable choice, Dr. Betti suggested the best fit; the Venetian painter Andrea Celesti. Dr. Bonino had mentioned on more than one

occasion, that the eye of Paola Betti was as good as any and I found this to be true just from our limited experience together a few years earlier. I felt fortunate to have access to Dr. Betti's invaluable insights as well as Dr. Massimo Bonino's unmatched experience during this point in my research of the New Rochelle painting. Although Dr. Betti had explained that Cesare Dandini was a painter that she was very familiar with and was very confident in her attribution, and the identity of the painter seemed obvious—the existence of the four connected paintings along with the caliber of the work in the New Rochelle painting had nearly removed all doubt about the identity of the artist—there was more to uncover. I accessed some of the Metropolitan Museum of Art's notes on their "Charity" painting available online and in one paragraph, there was a mention of a missing painting by Dandini that contained the Virgin Mary, Joseph, the Christ Child and the young Saint John.[4] A missing . . . Dandini.

In our meeting, Monsignor Keane explained that when he became pastor in the year 2014, everything, including the art collection that was in the church and the rectory was already there for many years. At that point, he still wasn't sure how the church had come into possession of the painting and told me that he'd inquire with some parishioners who had a long family history at the church. As I shared the information that I had about the painting and Cesare Dandini, Monsignor Keane seemed happy, but perhaps a little anxious, and it was quite understandable. After all, he was still processing the unexpected news that a lost Florentine Baroque masterpiece had been hanging unassumingly in his church for a very long time.

My next direction was clear, considering that a painting by Cesare Dandini in the collection of the Metropolitan Museum of Art was connected to "Holy Family with the Infant Saint John" in New Rochelle. My email inquiry, containing some attached images, prompted an enthused reply from the Associate Curator of European Paintings at the Metropolitan Museum of Art, David Pullins. We scheduled a day to meet at the Museum. Dr. Pullins expressed that I would have access

4 Zeri, Federico, with the assistance of Elizabeth E. Gardner, Italian Paintings: A Catalogue of the Collection of The Metropolitan Museum of Art. Vol. 1, Florentine School, The Metropolitan Museum of Art, New York, 1971, Pg. 212

to the Cesare Dandini archives, and that we would also examine the "Charity" painting, which was not on display at the time, in light of this find. Prior to my appointment at the Metropolitan Museum of Art, I felt it necessary to view the painting again and acquire additional information.

The monsignor authorized the removal of the painting so that I could investigate it more closely, and Iona University agreed to provide personnel to assist. To better familiarize myself with Dandini's work, I studied the highest-quality images of his paintings that I could locate beforehand. In addition to the excitement derived from the opportunity to examine the painting closely, I hoped to find additional evidence to support a Cesare Dandini attribution, or alternatively, any indications that may suggest another direction. The probability of discovering something as stirring as Dandini's signature, which the seller of the painting would have likely discovered early on, was extremely low. Even if the canvas had been signed on the reverse side and was somehow missed, it would have been concealed during the apparent relining procedure during the restoration of the painting. I did not anticipate seeing *Cesare Dandini's fecit* on the back or elsewhere on the canvas, but of course the overall close-up inspection was essential.

On the afternoon of Monday, February 3, 2020, I returned the Church of the Holy Family accompanied by one of my Iona students who offered to chronicle the event by taking images with his phone. Although I was seeking additional information, I was arriving with new knowledge. An old black and white photo of the painting had been published in a book entitled *"Cesare Dandini: Addenda al Catalogo dei Dipinti"* (2007 Edition) by the renowned Italian scholar of Florentine Baroque art Sandro Bellesi with a possible attribution (followed by a question mark) to a student of Dandini's, Giovanni Domenico Ferrucci.[5] Dr. Bellesi had taken on the great task of chronicling Dandini's entire body of work over the course of two books, and did so brilliantly. However, the Italian scholar hadn't had the benefit of seeing the actual painting firsthand; his only reference was an old photograph of a painting that wasn't in optimal condition. I had also received

5 Bellesi, Sandro, "Cesare Dandini: Addenda al Catalogo dei Dipinti," Edizione Polistampa, 2007, p. 36.

news that provided a partial provenance of the painting: Monsignor Keane was informed that the painting was purchased by Monsignor Charles Fitzgerald at an art gallery in Rome, Italy in 1961 to celebrate the 50th anniversary of the Parrish. The parishioners who informed the monsignor were relatives of Monsignor Fitzgerald. At that point, I came to the realization that a painting, which had previously been considered missing, had been hiding in plain sight for nearly sixty years.

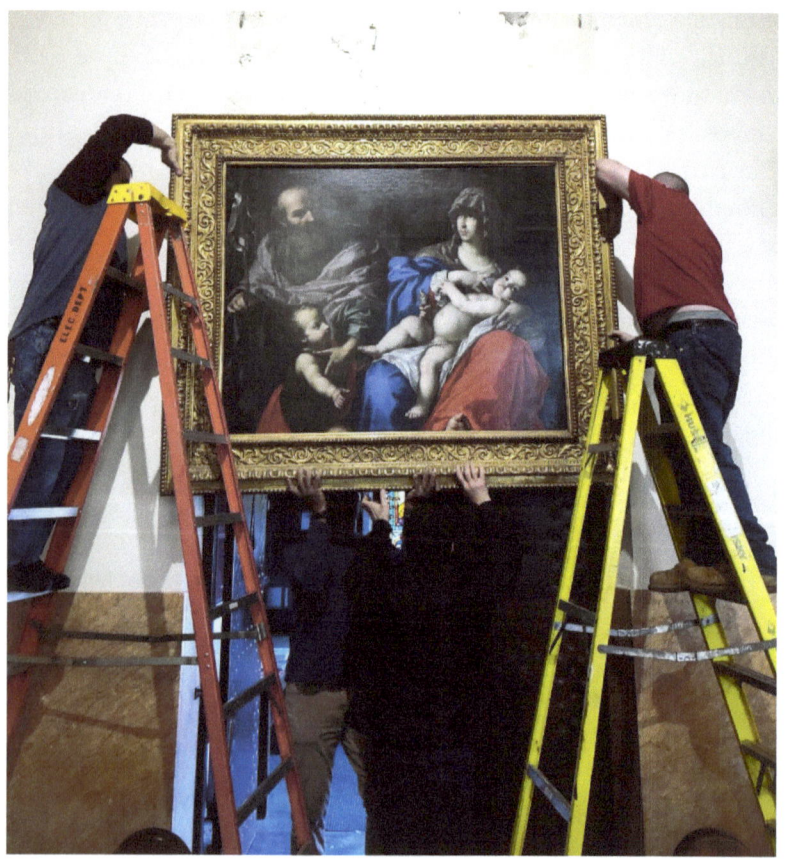

Lowering of the painting in the church; Church of the Holy Family, New Rochelle, New York, 2020. Photo credit: Rocco Borghetti.

The church porter, together with two facility management staff members from Iona, were already waiting. Looking up at the painting with the thought that that it needed to be taken down without incident was, for a moment, concerning. The excitement of seeing it up close and the responsibility to do so quickly overcame that feeling. The two Iona workers stood high up on ladders and at once, tried to assess the weight of the painting before attempting to lift the wire off the bolts that kept it suspended and secured to the wall. I tried to gauge the weight of the large framed canvas by watching how they handled it. When the painting came loose and was lowered, I reached up to gain a grip on the frame. From the center position, it was my responsibility to stabilize the picture and eventually assist in bringing it down, and I honestly couldn't wait to get my hand on it. As soon as I grasped the heavily carved frame, I was immediately aware of its weight, which was substantial. After a series of rapid checks and reassurances that included "Got it!", "Ok!", "Got it?", and "I'm good!" the painting slowly descended to the ground and held upright.

On one knee, I knelt down to see the painter's sensitive gradations of tone and color. The subtle craquelure, the typical web of fine cracks on the surface of an aged painting, was an immediate reminder of the centuries that separated the work from the current era. Especially detectable from a viewing distance of inches, I observed the paint's subtle texture variations, such as the slightly thicker build-up of paint for the hair created by the brilliant, once-fluid movements of the artist's small round brush, now forever frozen in place. At that moment, I realized I was occupying the same space as Dandini when he leaned in to add the final details that brought these figures to life. The coexistence of the connected paintings prompted me to initially focus on the Virgin Mary's face, which was evidently significant to Dandini during this period since he reused it repeatedly. It was then that I searched for images on my phone to compare some inconsistencies I had previously noticed between the connected paintings; they initially seemed odd. I would soon realize, however, that it was those details that helped establish a timeline for the order in which the paintings were made, or at least started. The Virgin Mary figure of the "Holy Family" paintings retains the same pose held by the "Charity" maternal figure, holding

her left breast as if in a nursing gesture. Often, maternal figures were depicted as nursing a child or putto in charity-themed paintings. Although the pose persists, it appears less logical and a questionable choice due to the fact that the Virgin Mary's breast is covered in the "Holy Family" paintings. Similarly, the nude body of the nursing putto from the Met's "Charity" painting was covered when the figure was reused in the "Holy Family" works as the Christ Child. Ultimately, it is the shared pose of the "Charity" maternal figure and the Virgin Mary that all but assures that the Metropolitan Museum of Art's "Charity" was at the very least, started before the "Holy Family" paintings. During the Council of Trent meetings, held in 1545- 1563, nudity for religious figures in artwork was strongly discouraged as a response to the Protestant Reformation, so Dandini's decision to fully clothe and cover the Virgin Mary and Christ Child figures was understandable.

Just like many great Florentine painters that came before him, it was clear that Dandini had attempted to balance the humanizing family relationships in his "Holy Family" paintings with a foretelling of Jesus' fate through symbolic imagery. The Christ Child was holding in his hand a goldfinch, a bird known to eat the seeds of the thistle plant, the same plant that was thought to be used to make the crown of thorns. Here, the presence of the goldfinch seems to represent both Jesus's future suffering as well as a form of protection for the divine infant.[6] I thought how perhaps the most faithful seventeenth-century Florentine observers may have experienced a feeling of guilt from the fated Christ Child's glare, and that even modern-day viewers could read the mood Dandini expressed in this "Holy Family" painting. Later on, I'd wonder if that expression had also been inspired by a dejected collective Florentine spirit; Dandini worked through a dark period in his city's history.

The most significant difference between the two "Holy Family" paintings was the inclusion of the infant Saint John the Baptist in the New Rochelle work, which expanded the familial unit and Dandini's composition with the addition of a patron saint of Florence, considered one of the champions and protectors of the city. His infant exuberance in

6 Ruggio, Thomas, *Cesare Dandini's Holy Family with the Infant St. John: A Rediscovered Florentine Baroque Masterpiece*, Iona College, New York, p. 10

the painting, along with Joseph's brilliantly considered counter-actions, brought a dynamic that was lacking in Dandini's other "connected paintings" and of this, I'd later write, "With Joseph's compelling pose, our attention is diverted from the Madonna and Child just enough to bring a captivating symmetry to the painting's composition. Displaying nearly elegant agility, Joseph firmly restrains the infant St. John with one hand as he gently secures the future Baptist's cross-staff in the fingers of his other hand. Typically relegated as a tertiary figure, Cesare Dandini's dutiful Joseph is represented as a man enlisted by God to fulfill a crucial role. Not only was he painted as the earthly protector of the newborn savior, but he was also shown to be worthy, if only for a moment, of safeguarding the message of St. John, *Parate Viam Domini* (Prepare the way of the Lord), inscribed on the banderole."[7]

Architectural elements such as pilasters, pedestal bases or columns, often appeared in Dandini's paintings. By incorporating classical architecture, the painter had continued an association that began with Renaissance tradition. The partial column and base implied a larger classical setting that is otherwise out of our view and although the column is one of elements in common with the Metropolitan Museum of Art's "Charity" painting, the presence of the shadow-obscured partial column within the context of the "Holy Family" paintings additionally must be considered a subtle reference to the passion of Christ, specifically the flagellation or scourging at the pillar.

Throughout much of his work, Cesare Dandini utilized the *chiaroscuro* (light-dark) technique that had dominated painting in Italy for decades during the seventeenth century, and beyond, while drawing inspiration from the work of the sixteenth century; the painting before me appeared to be that same kind of synthesis. I marveled at how the painted flesh appeared from the clothing with such conviction that seventeenth-century Florentine viewers of this painting may have imagined the bodies beneath all of that fabric. My eyes followed the folds of clothing that smoothly emerged from shadows to purvey the animating forms and poses mostly associated with the period. The spread fingers of the Virgin Mary

7 Ibid, p. 12.

and the position of the Christ child, however, appeared to relate to Mannerism as much as the Baroque style. As I had observed in my photos, but far more evident in-person, the full-color palette clearly distinguished this painting from Roman and more Southern Italian efforts of the 1600's. The Florentine Dandini masterfully distributed his green and red in a way that brought a chromatic balance while still allowing for a soft punctuation of the Virgin Mary's blue in the center of the composition. "Look at that . . ." It may have sounded as if I was pointing out a problem, but I was actually expressing admiration for Joseph's expressive, naturalistic face, which, unlike the other figures, was clearly painted from life.

As expected, there was no visible signature, nor was there any original canvas to see on the reverse side of the painting. During the restoration process, the canvas was indeed relined and based upon the old black and white photo in Sandro Bellesi's book, the relining of this canvas was imperative. Most centuries-old paintings on canvas loosen and sag. Because the original oil paint was applied to a tight, consistent surface stretched during the Baroque era, the shifting, expanding and contracting of wood stretchers and canvas ultimately leads to paint loss. To prevent this, a new canvas was adhered to the original, followed by a refastening to either new wood stretchers or the originals. When the New Rochelle painting was restored, the typical relining process entailed the perilous use of a hot iron press to smooth an adhered new canvas to the old canvas. When done incorrectly, this method often resulted in permanent damage to the painted surface. Advances in conservation include a relining procedure that employs a vacuum pressure application that makes no contact with the canvas. Fortunately, the "Holy Family with the Infant Saint John" was in very good condition and exhibited a relatively taut painted surface as a result of the restoration and relining that had taken place.

The time had come for the canvas to be raised up and hung in place once more. Somehow, the same location on the wall that served as the painting's conspicuous but apparently effective refuge for nearly six decades appeared far less secure now. "Knowledge is the true organ of sight, not the eyes," is a quote from the Panchatantra, translated from the original ancient Sanskrit. It occurred to me that, I was the

only person in the world who could look up at this painting hanging in a church in New Rochelle, New York, and see it with knowledge at that moment. I did not believe, however, that I was the only person who had some concern about it; I was certain that Monsignor Keane shared my sentiments.

On February 28th, I arrived at the Metropolitan Museum of Art. David Pullins greeted me and then led the way to the painting storage room, where a relatively smaller percentage of works from one of the world's greatest museum collections were housed. As soon as the rack of paintings that contained Cesare Dandini's "Charity" was rolled out, I noticed that the Met's painting, which I had viewed for weeks in digital images, was considerably brighter than I had anticipated, especially in comparison to the much darker "Holy Family with the Infant St. John" that I had just seen in New Rochelle. Images of the Hermitage's "Holy Family," indicated that their painting was also darker than the "Charity" and utilized *chiaroscuro* very similarly to the New Rochelle painting. I began thinking that perhaps this was due to the difference in subject, intended setting for the commission or simply a creative decision by the painter. Later, I'd see the brighter palette as a possible clue. Less than one minute into our comparison of the photographs from my phone to the Dandini painting in front of us, Dr. Pullins perceptively drew attention to the superior treatment of hands in the New Rochelle painting. There was no denying the contrast—the painted hands in the New Rochelle painting had been an early standout for me—and this was yet another potential clue for later.

After completing our comparison of the paintings, in which we discussed the quality of both works, the difference in subjects, and the general seventeenth-century workshop painting practice, I examined the museum's records on Cesare Dandini in a study area. As apprised, the information on Dandini was limited, but I was grateful for the opportunity to read through whatever the museum had on the painter. Among the old handwritten notes, typed letters, and black and white photocopies were some scholarly thoughts on Dandini's "Charity," mentions of related works including the "missing" painting, and information pertaining to the painting's provenance.

All of which contributed to my growing understanding of Dandini's connected paintings.

The close-up inspection of both paintings, the meeting with David Pullins and access to the museum's Dandini archives were all vital early steps in this work. As I drove out of the Metropolitan Museum's indoor parking lot and into the light of day, I was eager to move forward, but sadly, the entire world was about to come to a standstill.

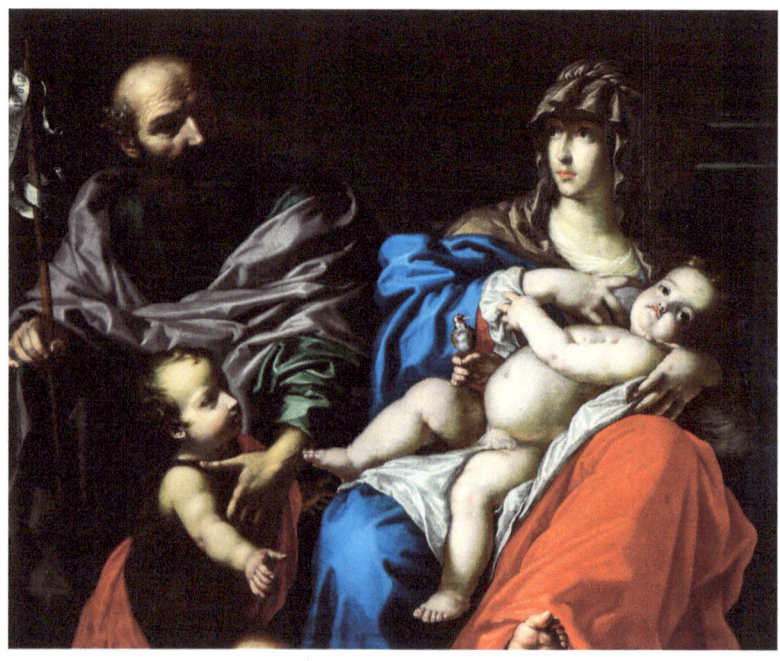

Cesare Dandini, "Holy Family with the Infant Saint John", oil on canvas, ca. 1632-1634 (?) Church of the Holy Family, New Rochelle, NY, United States. Photo credit: David Guarino.

CHAPTER 3

Pause

In March of 2020, the Iona campus received a disquieting email message from the Office of the Provost, instructing students, faculty, and staff to leave campus that afternoon due to the spread of COVID-19.

Although I had already been receiving information from friends in Italy, this marked the official beginning of my own pandemic odyssey. For many, it had already been or would become tragic, and the situation would also prove to be economically destructive, politically divisive and incredibly confusing. Throughout the nearly two years of what was referred to as a "new normal", I was thankful for my daughter's and my own good health, as well as that of my extended family and friends. I was also grateful for my continued employment and Iona's continued support for this project.

One of my earliest references for the "Holy Family with the Infant St. John" painting in New Rochelle was the Cesare Dandini "Charity" painting in the Metropolitan Museum of Art's collection, dated ca. 1630. It was during the COVID-lockdown that I began to discover what the early 1630s were like in Florence, Italy. The plague arrived in 1630, and with one short period of remission in 1632, it lasted well into 1633. Because everyone, regardless of political beliefs, faith or lack thereof in public officials, or views on the scientific guidance, had to adjust their lives for an indefinite period due to the COVID-19 protocols, I began to consider how the plague must have affected the Florentine citizens, and more specifically, Cesare Dandini and the rest

of the artists of the city. As the current health of the world population was being measured, Dandini's health came to mind. He suffered from asthma, which my daughter and I also have. Although barely mentioned, it was the cause of his death. I considered how it may have also been life-affecting for the painter. Apart from navigating daily life as a father and then as an educator and existing in a way that none of us fully understood, my sole scholarly focus was the prospective exhibition of Dandini's previously lost painting; I had already initiated some tentative but optimistic planning. I looked forward to expanding my research, though, including the implications of the plague and the painter's asthma, after the exhibition.

A highlight amidst the surreality of the early pandemic period with regards to this work occurred in July of 2020. With the permission of Monsignor Keane and funding from the office of the Dean of Arts and Science at Iona, I arranged a photography session for Dandini's once-lost painting. Along with a then-eight-year-old assistant, who would accompany me on all subsequent travels related to this project, I arrived at the Church of the Holy Family where a photographer was already setting up his equipment. The outcome of the afternoon-long session was the first professional color images of the "Holy Family with the Infant Saint John." This felt like an achievement, marking a notable progression in the ongoing work I had been undertaking. Upon viewing the high-resolution images, it became evident to me that Cesare Dandini's painting would be properly reintroduced to art history as soon as conditions actually normalized.

CHAPTER 4

On the Painter's Trail
Travels, Examinations and Analysis

MADRID, SPAIN, JULY 2022

No one could have predicted the level of interest in the rediscovery of the painting when the exhibition "Cesare Dandini's Holy Family with the Infant St. John: A Rediscovered Florentine Baroque Masterpiece" opened in the Iona University Ryan Library on September 16, 2021. From that point, Dandini's painting was on the global stage, something the artist could not have foreseen when he completed this work nearly four centuries ago.

As a result of the international media coverage of the painting's rediscovery, messages containing images of artwork from around the world began to arrive in my work email inbox. In January 2022, I received an email from Madrid, Spain, which stood out from the rest. At first glance, the attached image of a painting was extremely familiar. A private owner possessed a copy of the "Holy Family with the Infant St. John" and after some email correspondence, it was determined that this was a copy that was previously known to be in Valladolid, Spain, but the owner explained that the family had moved to Madrid. The first time I encountered the Valladolid-now-Madrid painting was in Sandro Bellesi's catalogue raisonné for Cesare Dandini, in which the art historian included a black-and-white photograph of it.

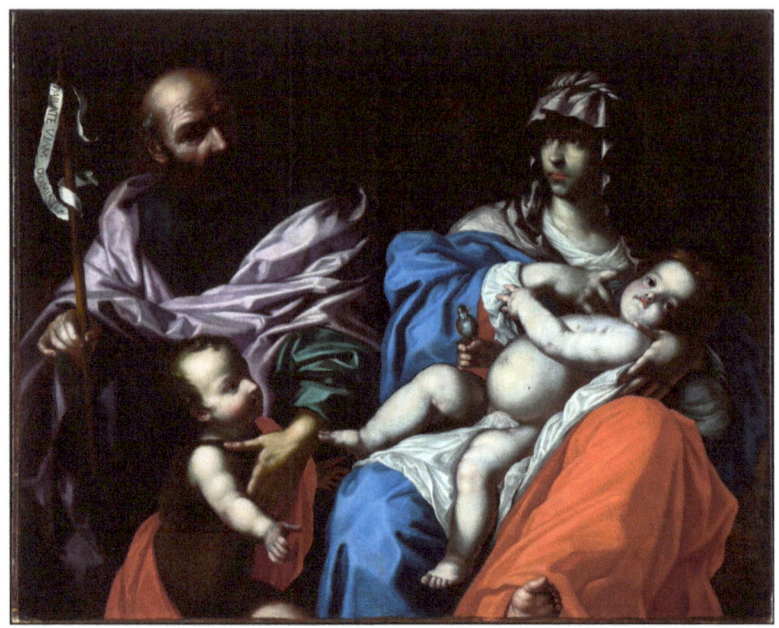

Workshop of Cesare Dandini (or Cesare Dandini and Workshop?) "Holy Family with the Infant Saint John", oil on canvas, ca. 1632-1634 (?), Collection of Joaquin Luaces.

While there was a marked contrast in quality between the painting in the photo and the New Rochelle painting, the owner also shared that his painting was attributed to Cesare Dandini in the 1970s. The photographs from Madrid were of poor quality, and the painting was obviously in need of restoration, so thoughts about Dandini's tendency to make master copies or duplicates of paintings, as well as other Italian painters who had done the same, came to mind. Beyond the idea of master copies, duplicates or second versions of paintings, it is believed that Leonardo da Vinci allowed and oversaw an additional "La Giaconda (Mona Lisa)" painting executed in his studio by another painter, possibly an apprentice, as he worked on the "original" and that painting happened to be in Madrid, Spain, at the *Museo Nacional del Prado*. Copying by learning from the master was common practice for students in traditional painting workshops, and works completed by apprentices were available for sale at a lower price. I suspected that

the Madrid painting was an example of the latter studio practice, but considering the old attribution to Dandini and the painter's penchant for reusing figures and making his own duplicates, I kept an open mind. I expressed gratitude to the sender for initiating contact and inquired about the possibility of personally observing the painting in Madrid; the eager response was "Si!"

During the arrangements that I made for a visit to Madrid during the month of July, I requested a professional cleaning and if possible, restoration before my arrival to which the owner happily complied. My reasons were that surface dirt and overpainting could easily obscure the quality of a painting and even hinder a proper attribution. The high-profile case of the "Salvator Mundi" painting was a point of reference for me. Eventually hailed by some as a "new" Leonardo da Vinci and even (regrettably) as the "Male Mona Lisa," the painting was long thought to be a copy by either Bernardino Luini or a follower of Leonardo prior to the cleaning and somewhat controversial restoration by Dianne Modestini circa 2005-2006.[1] Some still consider Luini's authorship.

Side by side images; Infant Saint John figures painted by Cesare Dandini (left) and his workshop (right), 1632-1634 (?).

1 Farago, Jason, New York Times article, "That $450 Million Leonardo? It's No Mona Lisa," November 15, 2017.

On a warm summer morning in the city of Madrid, and accompanied by a ten-year-old assistant, I met with the owner of the painting, Señor Joaquín Luaces. My first impression of the painting was that the now-cleaned and restored work was much more impressive than the images I had spent considerable time studying on my laptop. My next thought, not surprisingly, was that the majority of the painted areas were not of the same caliber as the New Rochelle painting. As I looked over the details of the Madrid painting, I was shown the black-and-white 1970s Italian publication entry that actually contained a published attribution of Cesare Dandini for the painting. I then shared my thoughts and discussed the differences in the two paintings with Sr. Luaces. I explained that his work, in my opinion and in the opinion of experts such as David Pullins and Paola Betti, both of whom had seen the pre-restoration images, was a painting from the Dandini workshop rather than a painting by Cesare Dandini himself. I also explained that there was, however, the possibility of the master's hand in a few areas. In terms of painting quality, the face of the Virgin Mary stood out, and some of the folds in the clothing and drapery seemed somewhat consistent with the New Rochelle painting. However, there was no doubt in my mind that the two infant baptizers were painted by two different artists, along with additional obvious distinctions. Based on his clear knowledge of art, I was confident that Sr. Luaces also recognized the contrast between the two paintings. I reminded him that I would be bringing images of both paintings to a meeting with the Curator of European Paintings at the Prado Museum because I was still developing a scholarly consensus. At the conclusion of the visit, I explained that what I believed to be a Dandini workshop copy was an important work of art in its own right, as it confirmed the significance of the rediscovered New Rochelle masterpiece and would surely contribute to an overall comprehension of Dandini's process.

At the Casón Building, part of the *Museo Nacional del Prado* complex, I met with Andrés Úbeda, the museum's curator of European paintings and one of the foremost experts on Italian and French painting. The primary objective of our meeting was to examine high-resolution side-by-side images of the Madrid and New Rochelle paintings and include his invaluable perspective in this study. Early in

our viewing session, I brought attention to the area that I believed best exemplified the disparity in quality, namely, the depiction of the face of the infant Saint John; the brushwork for the infant Baptizer's face in the New Rochelle painting was more free and confident, and that the more simplified features of the same figure in the Madrid painting appeared to represent a less gifted painter trying to replicate or keep pace with the beautiful work of the original. Dr. Úbeda agreed, and as we made our way to a higher area of the canvas, he drew attention to the apparent differences between the two painted faces of the Joseph figure; clearly, the artist who created the Madrid painting, although able, lacked the master's sophistication. I explained my belief that some of the most brilliantly painted areas in the New Rochelle painting were in the shadows; concurring, Dr. Úbeda stated that the same areas in the Madrid painting were more generalized and considerably darker. Dr. Úbeda also recognized the relatively high quality of the face of the Virgin Mary in the Madrid painting in contrast to other sections of the work. However, he noted that the execution of the Virgin's painted headdress did not exhibit the same level of quality as observed in the New Rochelle painting. We were in agreement that if there was a possibility of Dandini's hand in this work, it was the painting of the face of the Virgin Mary specifically. Dr. Úbeda had also observed that the drapery and clothing in the Madrid painting were comparable to those in the New Rochelle painting, and then suggested that perhaps Dandini may have left the drapery and fabric layering to a studio collaborator or an apprentice in both paintings. As I would later learn, Dandini avoided blending fluid oil paint as much as possible, so the hypothesis was certainly within the realm of possibility. Our meeting resulted in sound conclusions, but intriguing questions were raised regarding Dandini's methodology. When Dr. Úbeda asked if the New Rochelle painting had undergone an x-ray or imaging process, and it had not up until that point, I recognized that this type of examination represented the next scholarly level for such an important project. Upon my return to New York, I immediately sought and received approval from Monsignor Keane and the Parrish Council for the imaging of the "Holy Family with the Infant Saint John" painting.

NEW ROCHELLE, NEW YORK, JANUARY 2023

After learning that I had received funding support from Iona University and approval from Monsignor Keane and the Parrish Council, I made arrangements for an on-site imaging analysis of the "Holy Family with the Infant St. John" painting at the Church of the Holy Family in New Rochelle, New York. A team of conservators from ArtCare Conservation, led by Blair Bailey, met me at the church on a morning in January 2023, to conduct a variety of lighting and imaging techniques with the objective of gaining an understanding of Cesare Dandini's painting process.

The painting was removed from the church wall for a third time related to my research, but this time, an examination was about to take place that would hopefully divulge secrets beneath the surface layers of Cesare Dandini's paint. While the first half of the session was still in progress, a surprisingly distinctive technique employed by the seventeenth-century Florentine painter became apparent: imaging had revealed that Dandini's application of paint on the canvas did not involve a typical method of coverage, such as glazing and leaving areas in reserve (temporarily unpainted sections). Instead, he exhibited a preference for painting in overlapping layers, working from "back to front," so to speak.[2] Dandini began by painting the information furthest in the distance of the pictorial space, eventually painting objects or forms that appeared to be closest to the viewer in the composition. To do so, he allowed the dense, pigment rich, oil paint in a certain portion of one figure to completely dry before proceeding to paint the subsequent layers or any adjacent sections, whereas other painters would have ordinarily built up a section by applying less opaque layers and glazing. By employing this practice, which may have been reserved for larger works, Dandini surely required a longer duration of time to complete his paintings.

2 "Back-to-front" is the term Blair Bailey used to describe the order in which Dandini painted his subjects.

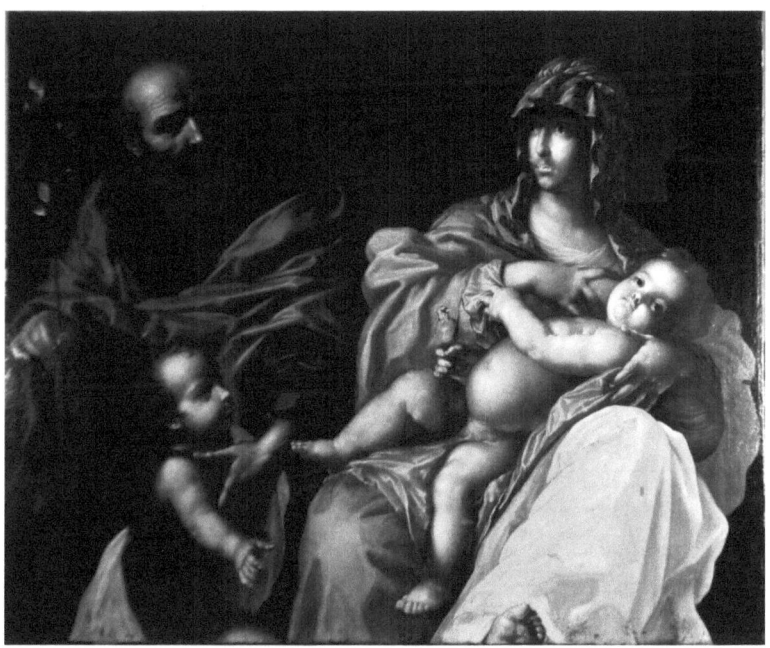

Infrared Reflectography image of Cesare Dandini's "Holy Family with the Infant Saint John" from the ArtCare Conservation imaging analysis that was conducted in 2023.

The examination also revealed that Dandini initiated his painting process by applying a red ground first layer, a technique that was gaining popularity among other painters of the era. This rich and opaque foundation layer served as a means for requiring the usage of less black or dark earth paint for the darkest tonal values, a signature element of Italian Baroque painting. In addition to saving on the creation and application of darker colored paint, as well as lessoning its drying time, the practice also allowed for Dandini to spend less time actually painting those areas. Separate research divulged that Dandini may have possessed an extra discernible motivation for adopting this approach, potentially linked to his health. In addition to painted areas of darkness, Dandini utilized the technique in such a way as to contribute to completed areas of painted figures, exhibiting a unique and exceptional quality in some of his shadows.

Through the efforts of this examination and additional research, another significant discovery was made regarding one of Dandini's techniques for reusing painted figures in different works: the employment of a tracing procedure that involved a kind of paint transfer of imagery.

After the final analysis of images was conducted at the ArtCare lab and the report was completed, the reward was unprecedented insight into Cesare Dandini's unexpectedly unique painting method which supported a key theory presented within the narrative of Part II.

FLORENCE, ITALY, FEBRUARY 2023

On February 16, 2023, I arrived in Florence, Italy, with the purpose of viewing some of Dandini's most important paintings firsthand, visiting key sites, and meeting with esteemed scholars of Florentine Baroque painting. And in between appointments, there was the opportunity to walk in the painter's footsteps which was essential for this project.

The first scheduled visit took place at the Basilica Della Santissima Annunziata (SS. Annunziata) to view Cesare Dandini's "Assumption of the Virgin Mary with Saint James and Saint Roch (with a View of Florence in the Distance)" (ca.1631- 1632) with Dr. Massimo Bonino, who at my request, arranged for the first professional color images of the painting. Hosting the visit was Father Emanuele Cattarossi, the convent archivist, with whom Dr. Bonino and I had arranged the examination and photo session months earlier.

Dandini's "Assumption" constituted a significant career milestone for the painter, and it was completed during some of the most difficult circumstances: the Florentine plague. In fact, I had already discovered evidence that the epidemic as well as other noteworthy conditions likely inspired the painter to create a strikingly unique rendition of this theme that, according to conventional thought, could have posed a risk to the painter, of which he was undoubtedly aware. The few available photos of the painting were not of the highest quality, so in addition to the planned examination of the painting's surface, direct observation was imperative to properly interpret the imagery. The clarity of the details, viewed up close, only reinforced my findings.

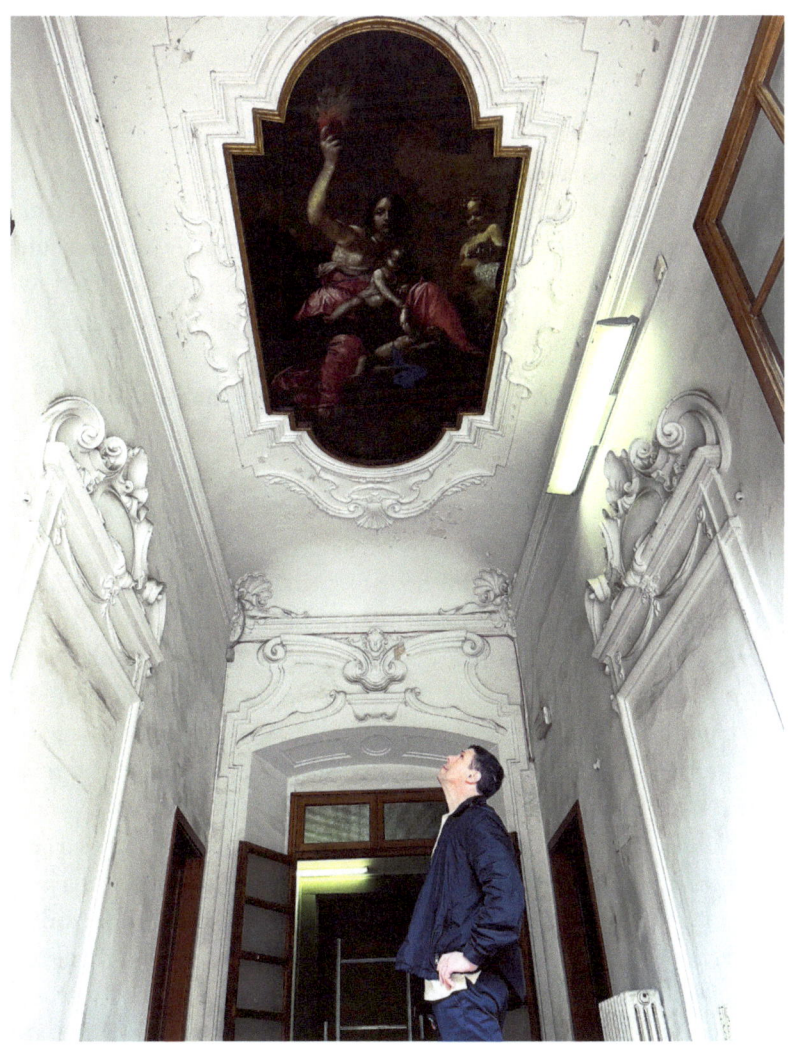

Thomas Ruggio viewing Cesare Dandini's "Allegory of Christian Charity" inside Casino Mediceo in Florence, Italy, 2023. Photo credit: Livia Ruggio.

Dr. Bonino began looking closely at the physical surface of the work, using a hand-held ultraviolet light, also known as a Wood's light, and a magnifying glass. Notably, a well-done restoration appeared to be part of the relatively more recent history of this painted work that

included minimal touch-ups. The absence of a drying medium was also detected which was unexpected given the era for an Italian painting. Dr. Bonino also pointed out how the large canvas was likely cut down after it was completed to fit into the vaulted space for the Palli Family Chapel. After discussing Dandini's painting technique and the painted subjects, it was time for the first professional color photographs of this Baroque era plague masterpiece. The presence of a chandelier that could not be removed presented a minor obstacle as it slightly obstructed the top edge of the composition. The deep architectural framing of the piece produced shadows around the perimeter of the canvas, which made it more difficult to achieve proper lighting. However, despite the encountered challenges, the all-important photographs were taken. Of equal importance was the examination of the painting's surface with Dr. Bonino in the hopes of furthering the comprehension of Dandini's painting methods.

To complete our visit at the SS. Annunziata, we were led by Father Cattarossi to the sacristy to see Dandini's "Lamentation of the Angels over the Dead Christ in the Presence of Saints Alesso Falconieri and Filippo Benizzi." The large painting, completed in 1625, was Dandini's first public commission, and stylistically, it was not consistent with his later work or the painting that we had just observed; at the time of the completion of the "Lamentation," it appeared that the painter was still searching.[3] A superficial examination of the painting's surface also revealed that it had been subjected to extensive overpainting and in painting, which could have been caused by a number of factors.

Another vital visit in the city was scheduled at the Casino Medicieo di San Marco (Casino Medici). The primary purpose of visiting Casino Medici, also known as Palazzo Buontaleni, was to view Cesare Dandini's "Allegory of Christian Charity" (1634) painting, but it was also very important to gain a more comprehensive understanding of what the atmosphere was like inside the former Medici residence and how the numerous painted scenes contributed to it. The visit began

3 Baldinucci, Filippo, Notizie de' professori del disegno da Cimabue in qua opera di Filippo Baldinucci fiorentino accademico della Crusca con note ed aggiunte, dalla Società tipografica de' classici italiani contrada del Cappuccio, Milano, 1812, (Internet Archive), p. 136

with a personally guided viewing of the frescoed ceilings throughout the interior which, as expected, established the general theme of the glorification of the Medici Family. Upon reaching the "Allegory of Christian Charity," my attention was immediately drawn to Dandini's prominent and triumphant central figure. Although the building had recently transitioned to accommodate a university program and the stunning work almost appeared to be temporarily forgotten in the currently empty space, this location was significant when Dandini's painting was completed and installed. The positioning of the work, with the bottom of the canvas towards the doorway, suggests that what appears to be a rear exit door today was likely considered an important point of entry when Cardinal de' Medici selected the ceiling space nearly 400 years ago. Later research revealed just how important the location may have been to Cesare Dandini. Although the painter's career extended well beyond the "Allegory of Christian Charity" and more scholarship was required on my part, this painting marked the conclusion to a harrowing chapter in the history of Florence and served as the bookend for the historical narrative I was writing.

PART II

SEVENTEENTH CENTURY

CHAPTER 5

The Devil He Knew

As it always had, the copper sphere of the lantern atop the Cathedral of Santa Maria del Fiori captured the rays of the sun. The cross surmounting the sphere was symbolic of a world under Christian rule, but the lantern's "base"—Filippo Brunelleschi's awe-inspiring dome—exemplified human ingenuity and was conceived from classical ideas. Nearly 114 meters below, where the Florentines carried out their daily activities, a pall was lingering in contempt of the broad daylight of summer. Giovanni Baldinucci wrote in his journal on August 12, 1630, "It is greatly feared that contagious sickness in the area may enter the city."[1] Many citizens were already aware that the *Magistrato alla Sanità* (Health Magistracy) in Florence had been communicating with health boards from Northern Italian States for months about the rapidly spreading illness they were experiencing and as far back as November of the previous year.[2] The Tuscan State was also receiving updates on an epidemic in Milan.[3] The fears felt by the Florentine people were justified, for within ten days of Giovanni Baldinucci's first journal entry, he recorded that "115 people were dying each day in

1 Henderson, John, *Florence Under Siege: Surviving Plague in an Early Modern City*, Yale University Press, 2019, p. 85, n. 4, (Baldinucci, Giovanni, *Quaderno*, p. 66), *JSTOR*, https://doi.org/10.2307/j.ctvk8w059.9.
2 Ibid, p.25, n. 11, Archivio di Stato Firenze, Sanita, Negozi 144, 7.xi. 1629; 145, f. 14r, L.1.1630 (cited as Sanità, Negozi).
3 Ibid

the *lazaretto* (makeshift isolation hospital)" that had been established in the city.[4] Although *la peste* (the plague) had been officially declared in Bologna in May, there was initial resistance in Florence to labeling the outbreak as such; Francesco Rondinelli, the ducal librarian and official chronicler of these events, wrote that early opinions were "divided" and that those who referred to the plague "were called the frightened ones."[5] It wasn't very long however, before everyone understood that the plague had in fact returned with a vengeance to their bustling city. The Archbishop explained in a sermon that on August 15, the day of the Festival of the Assumption of the Virgin Mary, a procession would commence at the *Duomo* (Cathedral) and proceed to the Basilica della Santissima Annunziata (SS. Annunziata).[6] The procession was to be led by the Archbishop, all members of the clergy, "all leading members of Church and state," the Grand Duke and his family.[7] Unfortunately, after growing ill, the Archbishop did not live long enough to lead this effort; he died on August 13th, two days before the scheduled procession.[8] *La peste* was not cited as the reason for the Archbishop's rather sudden passing, but if it wasn't apparent before, the people of Florence must have understood how swiftly death could come in these times.

It had been a century since the plague darkened the entry of the Florentine city walls, but this old nemesis was unfortunately a part of European history. As evidenced by reports from Italian city-state records and from other parts of Europe, the strategy for combating plague had remained largely unchanged for centuries, consisting primarily of quarantines, treatment of symptoms, and appeals to God.[9] Throughout history, the arrival of the plague was often linked to

4 Henderson, John, p. 85, n. 5, (Baldinucci, Giovanni, *Quaderno*, pp. 66, 67)
5 Plague declared in Bologna, Henderson, John Florence Under Siege, p. 26, n. 16, Pietro Malpezzi, (ed.), I bandi di Bernardino Spada durante la peste del 1630 in Bologna (Faenza, 2008), p. 228.
6 Targioni, Luca, *Relazione della Peste*, p. 300, quoted in Henderson, John Florence under Siege, pp. 149- 151, n. 6.
7 Ibid
8 Ibid, p. 151, n. 9 (Baldinucci, Giovanni, *Quaderno*, p. 66)
9 Henderson, John Florence under Siege, pp. 3, 4, n. 11, (Slack, The Impact of Plague, pp. 207-219)

participating in military engagements abroad and was even symbolically equated with an invading foreign force, and the perception endured to this day: To prevent the transmission of infectious diseases, armed Tuscan soldiers were stationed at designated checkpoints along regional borders to enforce a *cordon sanitaire*.[10] The twenty-year-old Grand Duke Ferdinando II de' Medici, the *Magistrato alla Sanità* (Health Magistracy), and church officials were already implementing their plans within Florence and the surrounding countryside, known as the *contado*. However, the densely populated seventeenth-century city probably facilitated the contagion more quickly than expected, prompting the creation of *campisanti* (plague burial pits) outside of the city walls to keep the infected cadavers as far from the populace as possible.[11] According to author Eric Cochrane, "Terror, in many ways, was (even) worse than the sudden high fever, the huge stinking boils, the delirium, and the splitting headaches that were the prelude to violent death."[12] Even those suspected of having plague were separated from their families and brought to a *lazaretto*. The confirmed would either recover or deteriorate, sometimes quite rapidly, in the absence of their loved ones.[13] Perhaps only the most well-positioned members of Florentine society may have been able to circumvent the strict protocol for a plague-death burial, and some of them had already fled the city for country villas.[14]

The ever-worsening situation was altering every aspect of Florentine society, including the painting profession, and would continue to do

10 Ibid, for a reference to plagues being linked to warfare, see p. 1 but the use of artillery at a religious procession presents the symbolic equation to war and for this see Calvi, Giulia, p. 249. For a reference to the Tuscan soldiers manning the borders, see Henderson, John, p, 27, n. 21, (Sanità, Copialettere 55, ff. 1 r, 3r-v, 16v, and are discussed by Cipolla, Cristofano, pp. 38-40) and n. 22, Rondinelli, Relazione, pp. 21-2).

11 Ibid, p. 40, just one of many references to the plague burial pits or *campisanti* throughout Henderson's book.

12 Cochrane, Eric, Florence in the Forgotten Centuries, 1527- 1800: A History of Florence and the Florentines in the Age of the Grand Dukes, University of Chicago Press, Chicago, 1973, p. 198.

13 Henderson, John, Florence under Siege, p. 190

14 Cochrane, Eric, Florence in the Forgotten Centuries, p. 197

so for the next three years. To begin with, painters from outside of Florence were either barred from entering or were unwilling to do so at various times between 1630 and 1633, disrupting the tradition of "foreign" talent, a term used for any artists who were not from Florence, fulfilling some of the storied location's commissions. The artists who were already living and working in the city needed to think about their own survival. The Florentine painter Cosimo Duti was perhaps the earliest artist plague victim in Florence in 1630.[15] Although there are conflicting dates, it is certain that the plague claimed the life of Bartolomeo Salvestrini in either the first months of the spread or during the unexpected resurgence of 1632-1633.[16] After studying under renowned painters Giovanni Bilivert and Matteo Rosselli, Salvestrini's work was beginning to garner recognition when his brief life and career ended.[17] Fearing *la peste*, Giovanni da San Giovanni, whom Neapolitan artist Salvator Rosa once described as "the best (*seicento*) painter the city had known," left Florence and did not return until after the epidemic ended.[18] Recognized as one of Florence's most gifted draughtsmen and known for his intrepid personality, Cecco Bravo (Francesco Montelatichi) spent the majority of the epidemic

15 Montaiglon, Anatole de, Mariette , Pierre Jean, Chennevières, Philippe de, Abecedario de P.J. Mariette: et autres notes inédites de cet amateur sur les Arts et les Artistes, Volume II, JB Dumoulin, Quai des Agustins #13, Paris; 1853-1854; pages 61-62

16 Boni, Filippo de, *Biografia degli artisti ovvero dizionario della vita e delle opere dei pittori, degli scultori, degli intagliatori, dei tipografi e dei musici di ogni nazione che fiorirono da'tempi più remoti sino á nostri giorni*, Seconda Edizione, Venice; Googlebooks: Presso Andrea Santini e Figlio, 1852, p. 908

17 Ibid

18 Regarding San Giovanni staying away from Florence to avoid the plague see: Banti, Anna, Giovanni da San Giovanni: Pittore della Contraddizione, Sansoni, Florence, 1977, pp. 24-26. The quote from Salvator Rosa is from Steen, Morton, Butchering the Bull of St. Luke: Unpublished Writings by and about the Painter-Poet Giovanni da San Giovanni, ANALECTA ROMANA INSTITUTI DANICI XL-XLI, 2016 Accademia di Danimarca ISSN 2035-2506 p. 63, n. 2 (In a letter to Giovanni Battista Ricciardi of June 30, 1649, Ascanio della Penna told that Salvator Rosa, their mutual friend, held that Florence had not known a better painter than Mannozzi. It seems unlikely that Rosa was referring to the less distinguished Florentine painter Vincenzo Mannozzi (1600-1658). Volpi & Paliaga 2012, 77.)

years away from his hometown, opting to work in Pistoia, Emilia, and Venice.[19] During the terrifying second wave, Francesco Furini, noted for his wonderfully painted *sfumato* technique and sensual unclad figures, joined the priesthood.[20] Despite his commitment to painting after entering the holy orders, things changed for Furini. It also appears that the emergence of a more conservative mindset, perhaps plague-inspired, led to criticism of his previously celebrated painted nudes.[21] Additionally, clerical duties demanded much of his attention for the remainder of his career. Through the turmoil, opportunities also emerged. A sixteen-year-old Carlo Dolci opened up his own artist workshop to become the youngest *maestro di bottega* in the history of Florence in 1632.[22] The more accomplished painters who remained in the city could conceivably benefit from a reduced field of competitors if there was any work to be had and as long as they could stay alive; among them was Cesare Dandini.

The Florentine painter had long exhibited an aversion to conformity and was probably regarded as something of a mystery.[23] Dandini likely appeared younger than his nearly thirty-four years of age and was taller than average; he cut a solemn but dashing figure.[24] Painters

19 Biseglia, Anna, Armida, Uffizi Gallery, Armida by Cecco Bravo | Artworks | Uffizi Galleries. (n.d.). https://www.uffizi.it/en/artworks/armida-cecco-bravo and Chappell, Miles. "Cecco Bravo. Florence." *The Burlington Magazine*, vol. 141, no. 1159, 1999, pp. 646–47. *JSTOR*, http://www.jstor.org/stable/888547. Both references present the evidence of how desirable Bravo was but also his personality as being "original" (by Biseglia in her Uffizi Gallery description of "Armida") or "quarrelsome (Chappell p. 646 The Burlington Magazine)

20 Campbell, Malcolm. "Francesco Furini Drawings at the Uffizi." *The Burlington Magazine*, vol. 114, no. 833, 1972, pp. 571–570. *JSTOR*, http://www.jstor.org/stable/877084. P 572

21 Baldinucci, Filippo, Francesco Furini, Notizie… p. 94

22 Straussman-Pflanzer, Eve, The Medici's Painter: Carlo Dolci and Seventeenth-Century Florence, Davis Museum and Cultural Center at Wellesley College, p. 13, 2017.

23 This is made apparent with events and descriptions of Dandini's behavior as per Filippo Baldinucci in "Notizie dei Professori del Disegno da Cimabue, in qua. Vol. II"

24 This notion is consistent with descriptions of Dandini's features according to Filippo Baldinucci in Notizie dei Professori del Disegno da Cimabue in qua. Vol. II

from the previous generation in the city may have still associated him with the artistic genius he showed as a child.[25] Although he mostly appeared reserved, he had a past and, in all likelihood, a reputation that preceded him. Dandini had been compelled to flee Florence years before for a different reason, so despite the risk, he probably had little desire to leave again in 1630.[26] For many artists, the decision to leave their home, a dedicated studio space, and a location that included an established list of clientele and reliable connections was a difficult one. Over one hundred years prior, two of the greatest painters in the city, Andrea del Sarto and Jacopo Pontormo, decided to leave Florence due to the outbreak of the plague. Although both made the best of their respective temporary locations—Sarto painted his masterful "Pieta" in the monastery of San Pietro in Luco del Mugello and Pontormo decorated the cloister of Certosa del Galluzzo with a cycle of frescoes—the plague eventually caught up with Andrea del Sarto, ending his life in 1530.[27] Settling elsewhere was no guarantee of safety and in addition to the previously mentioned factors, it appears that Florence provided Cesare Dandini with two distinct forms of security, which must have impacted his decision to stay.

It appears that throughout his adult years, Dandini was afflicted with asthma, a condition that ultimately claimed his life in 1657 or 1658.[28] It is impossible to determine whether this was a case of

25 In "Notizie" Baldinucci writes of how the copies made by a twelve-year-old Dandini were indistinguishable from the originals made by his first master, Francesco Curradi. The work from the adult Dandini's smaller output of paintings early on in his career may not have been impressive enough to supplant this recognition, at least for painters from Curradi's generation.

26 Dandini's reason for fleeing Florence in 1624-1625 is stated in Baldinucci, Filippo, Notizie, p. 134 and explained in forthcoming text of this chapter.

27 Shearman, John, Andrea Del Sarto's Two Paintings of the Assumption, The Burlington Magazine, vol. 101, no. 673, 1959, pp. 124–122. JSTOR, http://www.jstor.org/stable/872645 and Vasari, Giorgio, Vite, translated by Julia Conway Bondanella and Peter Bondanella, Oxford University Press, Oxford, New York, 1991, p. 404

28 Baldinucci states that Dandini suffered from asthma for "molti anni," Baldinucci, Filippo, Notizie de' professori del disegno da Cimabue in qua opera di Filippo Baldinucci fiorentino accademico della Crusca con note ed aggiunte, dalla Società tipografica de' classici italiani contrada del Cappuccio, Milano,

what is referred to today as occupational asthma or a preexisting condition, but according to his seventeenth-century biographer Filippo Baldinucci, the painter endured asthma for "many years."[29] Baldinucci mentioned a specific episode that took place in Pisa during the 1620s: Dandini had to leave Pisa, forgoing payment for work that he had already completed, due to the "thick air" of the hot Pisan summer that people from elsewhere "were not so well adapted to."[30] The more extreme changes in climate, such as the colder temperatures as well as the hot and humid months, can be especially difficult for asthmatics, and given how modern-day asthma treatments can fail, necessitating hospitalization, Dandini's condition probably fluctuated between controlled and life threatening. Regardless of the weather, allergens and certain activities can aggravate the condition at any time. From start to finish, the seventeenth-century painting process was fraught with potential triggers such as the initial canvas priming with glue-sizing, thinning oil paints with turpentine, using mediums and applying varnishes to complete a commission. The production and application of varnish would have rendered the air inside the stone walls of an ancient Tuscan studio space noxious, particularly for an asthmatic. In many cases, the master of a workshop wouldn't necessarily tend to such menial studio tasks, but circumstances were about to change, allowing for less access to workshop assistants. Long before the plague descended upon the city, the prospect of illness and death had already become an unwelcome companion of Dandini, so the looming dark specter that sent many fleeing may have been accepted by the painter as one more health challenge to overcome. And there may have been more that kept him in place.

1812, (Internet Archive), p. 143.
29 Ibid
30 Ibid, pp. 135, 136.

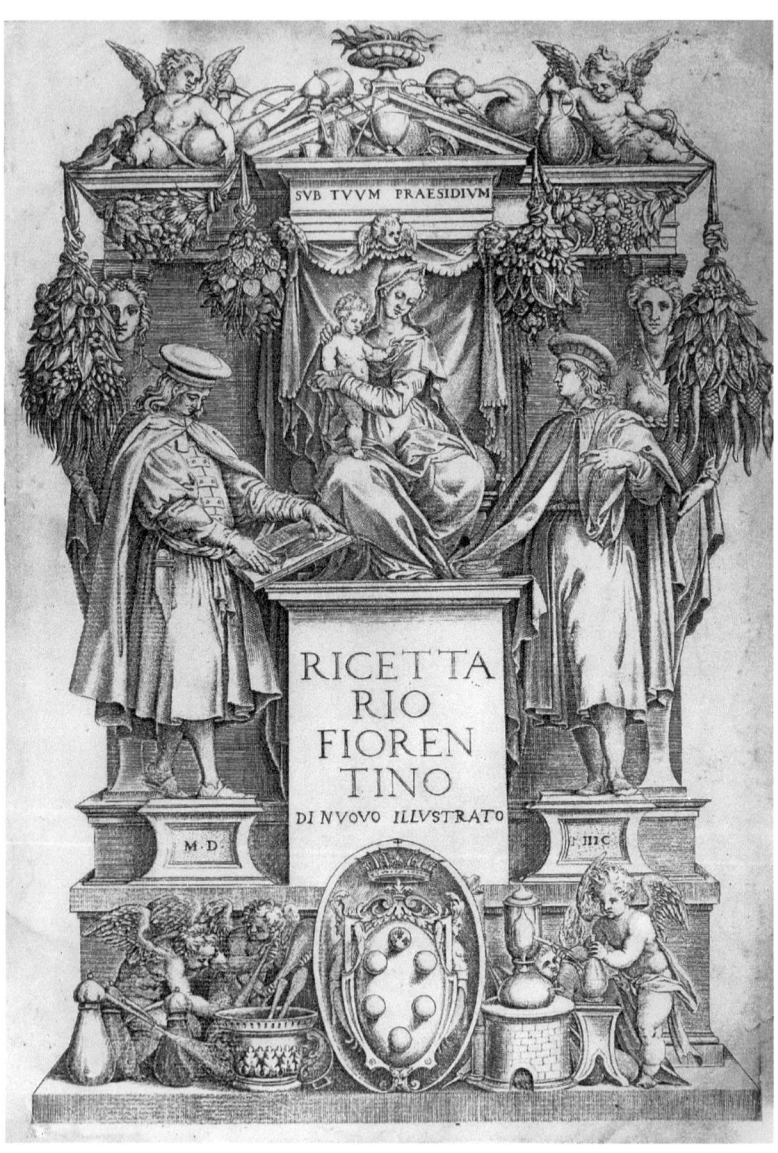

Pietro Cecconcelli (publisher), "Ricettario Fiorentino (frontispiece engraved illustration)," engraving, 1623. The "Florentine recipe book" of remedies and cures existed for centuries and this was the version available to the apothecaries and doctors of Florence and throughout Italy in 1630. This frontispiece features the Medici Family coat of arms

Since the late sixteenth century, Paracelsian medicine, the use of chemical compounds for medical remedies, had been supplementing, if not outright challenging, the traditional Galenic medicine in Europe.[31] The great interest and patronage of Grand Duchess Christina of Lorraine and her husband Don Antonio de' Medici, who died in 1621, had turned early *seicento* Florence into an Italian epicenter of *Nuova Medicina,* the encompassing concept that included Paracelsian medicine and other experimental techniques.[32] Christina's eclectic court was brilliantly curated to include some of the little known or previously unheard of Tuscan physicians as well as scientists, doctors and botanists from various parts of Europe.[33] The attempt to advance these studies seamlessly blended with the Medici family culture which had always embraced the latest scientific theories and in more recent years, alchemy. In addition to the research fostered by the Medici, Florence at the time had a greater number of apothecaries than the majority of other Italian cities south of Venice.[34] An asthmatic painter would have found this to be particularly important since apothecaries sold both art materials and medication. Dandini must have thought practically about his own unique situation: in a new location, would he still have the same access to supplies, remedies and whichever treatment he needed? And where else could Dandini find the same protection that he benefited from in the city of the Medici? In this circumstance, in the midst of the uncertainty and impending danger, Florence was certainly the devil he knew.

31 Barker, Sheila, "Christine of Lorraine and Medicine at the Medici Court" offprint from Medici Women: The Making of a Dynasty in Grand Ducal Tuscany, Edited by Giovanna Benadusi and Judith C. Brown. Essays and Studies, 36. Toronto: Centre for Reformation and Renaissance Studies, 2015, p. 157, n. 2

32 Ibid, p. 158, n. 3 (Galluzzi, "Motivi paracelsiani," 35)

33 Ibid, p. 158, n. 3 (Galluzzi, "Motivi paracelsiani," 35) and p. n. 8, (Targioni Tozzetti, Notizie, 3: 39), n. 10, On Musnier, Targioni Tozzetti, Notizie, 102–103. On de Naville and his treatise, see Targioni Tozzetti, Notizie, 3: 103, 256–274. In 1621, Christine recommended de Naville for a position at the Murate. See ASF, MdP 1458, fol. 190 r.

34 Strocchia, Sharon T., The nun apothecaries of Renaissance Florence: marketing medicines in the convent *Renaissance Studies*, Journal Article Vol. 25, No. 5 (NOVEMBER 2011), p. 629 https://www.jstor.org/stable/24420278

When Cesare Dandini was twenty-two years old, his father Piero Dandini died unexpectedly.[35] An artist himself, Piero was the primary motivating force behind his talented son's training even before a twelve-year-old Cesare Dandini amazed veteran painters with work that was indistinguishable from that of his first formal teacher, Francesco Curradi.[36] Although it is difficult to measure the impact of this loss, the young man was evidently left feeling *risentito* (resentful).[37] Dandini, the eldest of six children, may have been expected to assume a parental role, but he chose a different path, preferring to live on his own only one year after his father's passing.[38] Even as a student, the mercurial young man demonstrated more of the defiant, independent nature that would partially define his career and life. Before the senior Dandini died, he brought his teenaged son to the studio of Cristofano Allori, who was recognized as one of the best painters in Florence at the time.[39] Allori hailed from a nearly unrivaled educational pedigree that included his father, Alessandro Allori, and his father's teacher, Agnolo Bronzino, who was taught by Jacopo da Pontormo. It was known that Pontormo studied in the workshops of Leonardo da Vinci and Andrea del Sarto, among other great Florentine painters.

It appears that the environment in the Cristofano Allori workshop quickly felt unsuitable for the seemingly unamenable young Dandini.[40] Baldinucci explains that Dandini didn't approve of the studio culture which included jokes and perhaps gossip-mongering among the young apprentices who were left mostly unchecked largely due to an often absent Cristofano Allori.[41] It wasn't long before the young Dandini's

35 Baldinucci, Filippo, Notizie, p. 131
36 Baldinucci wrote that the twelve-year-old Dandini's copy of Francesco Curradi's (his first master) work was indistinguishable from the original. Ibid pp. 129, 130
37 Ibid, p. 131
38 Ibid, pp. 131-132
39 Ibid, p. 130
40 Ibid, p. 131
41 Ibid

patience evidently wore thin, prompting him to audaciously walk out, never to return.[42] Allori and Matteo Rosselli, known for his own successful workshop, were colleagues from their days studying together under Gregorio Pagani and a large fraternity of painters who had studied or were associated with both artists existed in the first half of *seicento* Florence.[43] Among the leading painters of this group were Giovanni da San Giovanni, Francesco Furini, Lorenzo Lippi, and Jacopo Vignali, who instructed a very young and promising Carlo Dolci. The news of Dandini's abrupt voluntary departure from one of the most respected workshops in the city couldn't have endeared the young painter to a wider segment of the local art community, a network that included artists and potential clients. A later incident of great consequence would only add to Dandini's dubious reputation.

When the *Accademia delle Arti del Disegno* (Academy of the Art of Drawing) was founded by Grand Duke Cosimo I and Giorgio Vasari, an artist who is also regarded as the first art historian, in 1563, admission was considered a most honorable benchmark for the professional artists of Florence. Although the Academy's prestige may have lessened by the *seicento*, academy membership was still a distinction and a potential entry into projects and commissions in the city. In the years immediately following Cesare Dandini's admission to the Academy, his sporadic output consisted primarily of smaller paintings and he had not yet received a public commission.[44] This less than prolific creative period for Dandini was interrupted when he suddenly found himself face-to-face with his own demise. Filippo Baldinucci provided a general account of a life-changing event that occurred during a late night out for the

42 Ibid

43 Thiem, Christel. "Fabrizio Boschi and Matteo Rosselli: Drawings Relating to the Theme of the 'Martydom of St. Sebastian.'" *Master Drawings*, vol. 7, no. 2, 1969, pp. 148–211. *JSTOR*, http://www.jstor.org/stable/1553016 and Chappell, Miles L. "Cristofano Allori's Paintings Depicting St Francis." *The Burlington Magazine*, vol. 113, no. 821, 1971, pp. 444–55. *JSTOR*, http://www.jstor.org/stable/876712

44 Baldinucci, Filippo, Notizie, p. 132

artist.[45] According to Baldinucci, Dandini encountered a belligerent man who had been drinking.[46] The two men engaged in an altercation that resulted in Dandini stabbing the man to death.[47] Although it was Dandini's antagonist who died, the fateful exchange ended life as the painter knew it, at least for the time being. Dandini fled Florence to avoid prosecution, keeping himself hidden for what ultimately turned out to be a short period.[48] After receiving assurances that the incident was perceived somewhat in his favor, Dandini's status as a fugitive was upgraded, allowing him to serve time under a form of house arrest with few restrictions.[49] However, the artist was required to live under the "protection of people of high standing " during this time.[50] These influential individuals could have played a part in Dandini avoiding a stay or served time in the Bargello prison or perhaps even an execution.

Once Dandini was allowed to live freely within the city walls again, Don Lorenzo de' Medici became and remained his protector for years, according to Filippo Baldinucci.[51] During this time and within this contextual framework, the terms "patronage" and "protection" were often employed interchangeably. Various forms of patronage existed, encompassing an array of relationships between a client and an artist. Often, an agreement resulted in a transaction that was subject to and governed by a *contratto* (contract) for a singular work of art. In some instances, when the commission work was of a larger scale or involved a series of works, the interactions could appear almost collaborative, where the patron's vision or ideas guided the artist from the project's inception. By the *seicento*, nevertheless, numerous patrons were more than content to defer to the artist regarding the particulars. Creative freedom and artistic license had become commonplace, albeit within the constraints imposed by the Roman Catholic Church. Given Dandini's scenario, Baldinucci's use of the term "protector" can be seen as an allusion to

45 Baldinucci, Filippo, p. 134
46 Ibid
47 Ibid
48 Ibid
49 Ibid
50 Ibid, pp. 134-135
51 Ibid

a distinct association between Don Lorenzo and the painter. *Patrono* (patron) was derived from the Latin word for father, *pater*, and in one form of patronage, *servitu particolare*, the artist was in fact treated like an additional member of the family.[52] This patron-client arrangement provided artists with the most security and was rooted in the ancient Roman concept of *patrocinium*, in which the patron was the protector, sponsor, and benefactor of the client.[53] In addition to a monthly allowance, there was the possibility for a *servitu particolare* artist to live in the patron's palace, gain access to numerous opportunities through routine introductions and associations with the patron's influential circle.[54] If a trip was deemed beneficial, all travel expenses were paid for as well.[55] And in principle, the artist maintained the freedom to secure commissions from additional clients, provided that there were no conflicts of interest. Don Lorenzo, who was nearly four years younger than Dandini, was certainly not in a position to fulfill the role of father figure, but the painter had acquired a powerful employer, guardian and advocate in him. Although there is no reason to believe that living quarters were part of their arrangement, the type of all-encompassing support the Medici prince could provide in Florence and essentially throughout the region may have been vital to Dandini regarding any past or future disputes, including legal issues. Surely, in addition to patronage, there was a time when the painter was especially in need of Medici protection, given the circumstances that prompted the establishment of their arrangement.

Similar to Dandini, the Medici prince had taken a less predicable route for his own life's journey. The twenty-six-year-old Don Lorenzo, light-hearted in nature, was a bachelor who lived with more autonomy

52 Haskell, Francis, "Patrons and Painters, Art and Society in Baroque Italy" Yale University Press, New Haven and London, p. 6, 1980
53 Haskell, Francis, "Patrons and Painters, Art and Society in Baroque Italy" Yale University Press, New Haven and London, p. 6, 1980 and Quinn, Kenneth, "*Poet and Audience in the Augustan Age*" In Haase, Wolfgang (ed.). *Aufstieg und Niedergang der römischen Welt.* Vol. 30/1, 1982, p. 117.
54 Haskell, Francis, "Patrons and Painters, Art and Society in Baroque Italy" Yale University Press, New Haven and London, 1980, p. 6, n. 1 ("many references" Pascoli I, p. 93 and Pascoli II, pp. 119, 332, 417, 435, etc.)
55 Ibid, p. 6, n. 3 (Pascoli II, p. 211, 302)

than the majority of his relatives.[56] Despite being the son of Grand Duke Ferdinando I, it appeared that he never had formal political ambitions. Rather, this prominent member of the ruling family championed the arts and happily applied his energies as an organizer of receptions in the city.[57] And also like Dandini, Don Lorenzo was a hunter.[58] It is reasonable to assume that the painter and the prince enjoyed each other's company, perhaps resulting in a friendship, given their similar interests, rebellious natures, and their relative closeness in age. Undoubtedly, Don Lorenzo de' Medici seemed to be the ideal *patrono* for the troubled Florentine painter.

Prior to those life-changing events and during the years immediately following his admission into the Academy, Dandini apparently hadn't always been focused on creating artwork. Baldinucci expressed that he enjoyed spending time with friends and preferred hunting to painting,[59] so a curious picture emerges—one of a gifted, well-trained young artist who initially didn't fully embrace his craft. This doesn't comport with the seriousness and commitment he showed as a student, learning under Francesco Curradi and Domenico Passignano—the same seriousness that purportedly prompted him to leave the Cristofano Allori workshop. The account is also inconsistent with Baldinucci's later description of Dandini as a stalwart of the painting tradition who zealously upheld the highest standards in his own studio.[60] It is reasonable to expect the artist's

56 Spinelli, Riccardo, Gregori, Mina (cura), *Fasto di Corte: La decorazione murale nelle residenze dei Medici e dei Lorena. II. L'età di Ferdinando II de' Medici*, (1628-1670), Edifir, Firenze, p. 33, 2006

57 Ibid p. 30 and from the notes (translated to English) on the same page: Don Lorenzo was delegated by the family, especially to the reception of princes, cardinals, ambassadors and important persons passing through Florence; ASE, manuscript n. 133, vol. VII, part I.

58 Medici Archive Project Document: Cardinal Carlo de' Medici Describes the Various Diversions, Mediceo del Principato, Vol. 6108, Folio 173, June 23, 1617 and Medici Archive Project Document: Dimurgo Lambardi Recounts Activities of the Tuscan Court, Mediceo del Principato, Vol. 6106, Folio 642, December 15, 1622

Although two are listed here to present a range of five years, there are many references regarding Don Lorenzo's passion for hunting found in written correspondences on https://mia.medici.org

59 Ibid, Baldinucci, Filippo, Notizie, p. 132

60 Ibid, p. 145

or anyone else's evolution over time, but only Dandini knew for certain why he did not paint more frequently after completing his training. At least part of the explanation may have lied in the physiological effect of his time spent painting inside the studio. Outdoors, he could have surely breathed easier while enjoying the physical activity, sunshine, and fresh air of the hunt. Despite the stark differences between painting and hunting, Dandini must have appreciated a shared characteristic between the two: the pursuit. One activity entailed the quest of pursuing prey, while the other called for the careful development of fully realized objects or figures from general painted shapes —the pursuit of successfully completed subjects. Experience, focus, diligence, and patience were required for both captures. Unfortunately, it was improbable that the former, his profession, elicited the same sense of physical well-being and vitality as the latter, conceivably even producing an opposing effect. Considering this aspect, might the air quality within the Cristofano Allori studio, where numerous students engaged in simultaneous painting activities throughout the day, be regarded as an additional element influencing Dandini's decision to depart from the esteemed workshop years earlier? Regardless, after his secured return to Florence, Dandini's value to the city, as well as the justification for his protection, were now entirely attributable to his abilities as an artist. Perhaps for no other reason than his obligation to produce work, the then-thirty-year-old Dandini was ready to finally fully commit to a painting career, regardless of how it impacted his health. And according to traditional norms, his standing as an artist should have been well established years earlier.

 Dandini's renewed creative focus would also, in theory, bring the added benefit of keeping him out of further trouble. In his notebooks, Leonardo da Vinci wrote about the importance of *ritiro* (retreat*)*, suggesting that the artist "should only seek out the company of friends who shared his intellectual interests or otherwise resign himself to spending time alone."[61] Dandini had not willingly subscribed to Leonardo's philosophy before he became an evader of justice, but the experience compulsorily introduced him to the concept of retreat and the self-reflection that it must have precipitated. The purported murder

61 122 MacCurdy, Edward, ed., The Notebooks of Leonardo da Vinci, Connecticut: Konecky & Konecky, 2003

committed by the revolutionary painter Caravaggio (Michelangelo Merisi), which resulted in his own fugitive status almost two decades prior, has since been romanticized and was presumably the stuff of legend by the time Dandini's life took a comparable turn. However, Dandini knew there was nothing romantic about his own situation—in the moment and during the initial days, he was likely overcome with fear and uncertainty. As a result of that experience, and in addition to perseverance, adaptation could also have been counted among Dandini's list of acquired skills, and both were particularly essential for his second chance in Florence and, again, for when life abruptly changed for everyone, in 1630.

The Black Death of the fourteenth-century had taken an unfathomable toll on all of Europe and in central Italy anywhere from 50% -75% of the population was lost.[62] During the sixteenth-century Florentine plague, the year of 1527 proved to be the deadliest, but a terrifying presence that persisted for four years somewhat offset the steady decline in deaths that followed.[63] There was no telling how devastating the latest incarnation of *la peste* would be, but in the autumn of 1630, deaths in Florence were nearly doubling with each month, with totals reaching more than 2,000 in November.[64] Restrictions were already in place, such as keeping women and children thirteen years old and younger indoors, curfews, and the prohibition of group gathering, with the exception of visits to the *Mercato Vecchio*, where Florentines had been purchasing necessities since the tenth century.[65] The market was the beating heart of the city.

On December 5th, a desperate, but what was hoped to be a

62 Cohn, Samuel. "After the Black Death: Labour Legislation and Attitudes Towards Labour in Late-Medieval Western Europe." *The Economic History Review*, vol. 60, no. 3, 2007, p 458 *JSTOR*, http://www.jstor.org/stable/4502106

63 Kirshner, Julius, Epidemics in Renaissance Florence, American Journal of Public Health, 1985, p. 530

64 The increasing numbers for plague burials by November of 1630, see Henderson, John, p. 41, fig. 21 (graphic chart) "Plague Burials in Florence, 1630-1."

65 Henderson, John, p. 131 and Eric Cochrane?

powerful, two-pronged assault on the plague was carried out.[66] Artillery was fired upward as the sounds of armed conflict accompanied church bells while the body of a saint was carefully carried from the Monastery of San Marco to the Church of Santa Maria Novella.[67] This procession was a summoning of San Antonio, a former archbishop who was known to be a public protector of Florence, for assistance.[68] Although it appeared extreme, the militaristic tactic was another example of the metaphorical association between contending with plague and warfare. Undeniably, this kind of demonstration of strength was also intended to bolster morale in some way. At the very same time, a just as significant but much more tranquil proceeding was taking place at the Convent of La Crocetta and then at the Palazzo Pitti: the canonization ceremony for Sister Domenica da Paradiso.[69] The venerated Sister Domenica was a champion of the last plague of Florence and her canonization was expedited in an attempt to draw on the strength of the newly sainted *sorella*.[70] The Grand Duke and the other male members of the Medici accompanied the procession of San Antonio, while his grandmother, the Grand Duchess, and the other Medici women took part in the canonization proceedings.[71] The sixty-five-year-old Christina of Lorraine appeared to be as fervently faithful as she was dedicated to medicine and all forms of healing, so her matriarchal presence at this ceremony was in keeping with the Medici equilibrium between piety and humanism.[72]

66 Giulia Calvi, Histories of a Plague Year, pp-249-250

67 Ibid

68 Ibid

69 Henderson, John, p. 163

70 Ibid

71 Calvi, Giulia, Histories of a Plague Year: The Social and the Imaginary in Baroque Florence, University of California Press: Berkley, Los Angeles, Oxford, 1989, p. 250

72 Barker, Sheila, Christine of Lorraine and Medicine at the Medici Court, pp. 157- 182, offprint from Medici Women: The Making of a Dynasty in Grand Ducal Tuscany. Edited by Giovanna Benadusi and Judith C. Brown. Essays and Studies, 36. Toronto: Centre for Reformation and Renaissance Studies, 2015. The duality of the Duchess' dedication to religion and medicine, cures and healing is well-presented throughout Sheila Barker's essay.

Some anecdotal results of this faith-based double offensive against the contagion may have seemed positive but it wasn't nearly enough. The ever-increasing death rate eventually led to an extreme measure in January 1631: Florence was placed in a forty-day quarantine by order of the *Magistrato alla Sanità* and in concurrence with Grand Duke Ferdinando II.[73] For the authorities, this appeared to be the best, if not the only, solution, but for many citizens, including artists, it was a foreshadowing of future difficulties.

Nearly all onsite projects such as fresco painting, sculpture installations, and architectural work came to a halt, although three builders were allowed to continue construction at the SS. Annunziata.[74] Preexisting in-progress studio work notwithstanding, an artist's ability to remain active during the quarantine depended upon certain factors. Apothecaries remained open so there was access to art materials, but beyond health, process, specialized genre, self-motivation and ultimately, an artist's standing would have likely determined the continuation of one's practice during such a confounding period. Theoretically, lower-tier painters could have been most active, continuing to work on a range of themes for the market or for *rigattieri* (secondhand dealers) in anticipation of the city's eventual reopening.[75] Small devotional works were typically quite formulaic and could likely be readily created under the circumstances. The same can be said for still-life paintings, depicting what could be less challenging subjects that might easily be found among the most common objects. Invented genre pieces, *vedute* (views) and idyllic landscapes, which appealed mostly to non-Italian clientele, could also be executed relatively quickly, especially if the dimensions of the painted surface were smaller, perhaps less than *un braccio* (one arm) in length.[76] Some of these finished works might have contained just enough embellishments to entice those with less refined tastes while distracting from indications of limited proficiency.

73 Henderson, John, p. 134, n. 54 (Cipolla, *Cristofano*, p. 98)

74 Ibid, p. 137, n. 77 (Sanita, DP 7, ff. 168v, 176v)

75 Fumagalli, Elena, Painting for Profit: The Economic Lives of Seventeenth-Century Italian Painters, Florence, New Haven, Yale University Press, 2010 p. 175

76 Haskell, Francis, The Market for Italian Art in the 17th Century, *Past & Present*, No. 15, Apr., 1959, pp. 48-59 (12 pages) p. 56

Somewhat ironically, unless a *dipintore*—a renowned painter of artistic works, as opposed to an artisan who also painted—had already begun a project, there may have been no work for them at all in the absence of patronage.[77] One exception was a commission for the highly regarded painter Jacopo Vignali that directly related to Sister Domenica's canonization as well as the plague.[78] Since the impact of Caravaggio, who had worked nearly exclusively from life, resulting in a previously unseen degree of realism, most *dipintori* also became known for their naturalistic results from working *dal vivo* or *dal naturale* (from life), requiring the use of models for their primary figures. Models or sitters, however, were nearly impossible to find during a state-ordered quarantine. In this instance, though, Vignali wasn't working from life; he was applying the pre-Caravaggesque concept of *invenzione* (invention) to create his figures.[79] Given the church's prohibition of using the recognizable features of actual individuals as saints, this was also a safer approach; it was also the approach most admired by traditionalists.[80]

One specialized genre, at least in the immediacy of the quarantine, was virtually unadaptable: portraitists essentially worked only for hire and from life. The Flemish born Justus Sustermans, known in Florence by his Italianized name *Giusto*, was acknowledged as the most talented portrait painter in the city, but the quarantine began the least productive period of his career. Even though Sustermans was the portrait painter of the Medici Family and had been painting

77 Fumagalli, Elena, Painting for Profit: The Economic Lives of Seventeenth-Century Italian Painters, p. 173

I believe the difference between *dipintore* and *pittore* are best stated in that passage by Dott.ssa. Fumagalli.

78 Henderson, John, Florence Under Siege: Surving Plague in an Early Modern City, p. 163

79 Robertson, Clare. "Annibale Carracci and Invenzione: Medium and Function in the Early Drawings." *Master Drawings*, vol. 35, no. 1, 1997, pp. 3–42. *JSTOR*, http://www.jstor.org/stable/1554287. Accessed 22 June 2023. Vignali's illustrative-looking figures lack the naturalism that would have been evident had he worked from models for this painting.

80 Farago, Claire, Renaissance Quarterly. Vol. 67, No. 2 (Summer 2014), pp. 558-559 Published by: Cambridge University Press on behalf of the Renaissance Society of America

Ferdinando II since he was a child, priorities in the city had abruptly changed and would remain so for the foreseeable future.[81] During the next few years, due to the varying severity of the plague in other areas, there was little or no opportunity to even leave Florence to work elsewhere, as the cosmopolitan painter had often done in the past. The salary that Sustermans was receiving from the Medici, which was in addition to any commission pay he could receive, would soon be reduced by the Grand Duke; there was simply no call for the Flemish portrait painter's talents during the mounting crises.[82]

A painted likeness was surely the furthest thing from Ferdinando II's mind; he was immersed in a campaign that no seventeenth-century leader could have prepared for or fully understood. According to the church, God's anger was at the root of the disaster, and while health officials may have also accepted this, they believed they knew how the cursed contagion operated.[83] It was thought that *la peste* spread primarily through *miasma* (corrupt vapors or aromas), so any business or work that involved or produced foul odors was adapted or limited, if not prohibited.[84] It was also believed that the plague could be carried in fabrics, so the textile industry, which had been a hallmark of Florentine commerce for centuries, came to a standstill.[85]

Although decisive, the actions taken by the authorities probably did little to alleviate the confusion and anxiety most Florentines were feeling at this time. Even the ominous costume worn by plague physicians, designed to resist both modes of transmission, was a far from comforting sight: the frightening long-beaked mask contained aromatics at the

81 Portrait of Ferdinando II de' Medici (1610-1670) as a boy: *Copy after Justus Sustermans | Ferdinando II de' Medici (1610–1670) as a Boy | The Metropolitan Museum of Art*. (n.d.). The Metropolitan Museum of Art. https://www.metmuseum.org/art/collection/search/437766

82 Fumagalli, Elena Florence, in Fumagalli, Elena Florence, in Painting for Profit. The Economic Lives of Seventeenth-Century Italian Painters, n. 58 (na)

83 Cipolla, Carlo M., Faith, Reason and the Plague in Seventeenth-Century Tuscany, W.W. Norton & Company, New York, London, 1979, p. 8.

84 Henderson, John, Florence under Siege pp. 36, 51- 83

85 Cochrane, Eric, Florence in the Forgotten Centuries 1527- 1800, University of Chicago Press, Chicago, London, 1973, p. 198 and Henderson, John, pp. 53, 54 and 98.

Paul Fürst "Plague Doctor of Rome," engraving, 1656. The engraving is consistent with descriptions of seventeenth-century plague doctors throughout Italy and other parts of Europe.

tip such as dried flowers, herbs, spices or a vinegar sponge to counter the *miasma*.[86] The foreboding full-length leather coat and hat were waxed smooth to prevent any contamination from adhering to fabric fibers.[87] The doctor's wooden *bastone* likely further contributed to the ambivalence his arrival evoked. Used for pointing, prodding, and lifting without making physical contact, this instrument could have resembled either a pastoral crosier or a weapon, depending on how it was carried.

Whether or not the Grand Duke fully believed that God had brought this wrath, he, along with the *Sanità* and church officials, were trying to oppose what many believed to be divine measures by any earthly and spiritual means available. These countermeasures needed to provide hope and inspire confidence nearly as much as they provided safety. Belying his youth, Ferdinando II assumed the role of patriarchal leader and made daily rounds of the city on foot to make sure everyone had what they needed throughout the quarantine.[88] As compassionate as leadership appeared, utter compliance was crucial, so the penalties for breaking quarantine or not honoring protocols could be harsh. The threat of public flogging, being sent off to work in the Grand Duke's galley and even execution were enough in most cases to maintain general conformation.[89] Nevertheless, individuals who were even suspected of concealing the ill or defying regulations also faced punishments, ranging from public humiliation such as being led through the city on a donkey to a form of torture as a means of extracting a confession.[90] Imperatively, the schedule for holy mass services was maintained but took place in the street as

86 Townsend, G.L., "The Plague Doctor: AN Engraving by Gerhart Altzenbach (17th Century). New Haven, Yale Medical Library, Clements C. Fry Collection." *Journal of the History of Medicine and Allied Sciences*, vol. 20, no. 3, 1965, pp. 276–276. *JSTOR*, http://www.jstor.org/stable/24621993.

87 Ibid

88 Henderson, Florence Under Siege: Surving Plague in an Early Modern City, John, p. 134

89 Calvi, Giulia, Histories of a Plague Year: The Social and the Imaginary in Baroque Florence, p. 93 Henderson, John, Florence Under Siege: Surviving Plague in an Early Modern City, p. 134 (sent to the Duke's galleys) and public flogging.

90 Calvi, Giulia, Histories of a Plague Year: The Social and the Imaginary in Baroque Florence, p. 83 and 174.

the faithful participated from their windows.[91] It was during these days that a practically cloistered Cesare Dandini must have begun working out new ideas.[92] The painter now had the time and sufficient resources, which included mirrors, to engage in a subject he hadn't fully explored previously.

91 Henderson, John Florence Under Siege, p. 165, n. 76 (Baldinucci, *Quaderno*, p. 72)

92 Dandini's most successful painting up to this point was his "Saint Carlo Borromeo in Glory and the Saints Lorenzo, John the Baptist, Francesco and Apollonia" in the Church of the Sacrament in Ancona in the Le Marche region. According to Sandro Bellesi, the work was completed around 1629, see Bellesi, Sandro, Cesare Dandini, pp. 56- 57) which several figures were clearly drawn/painted from life. Much of Dandini's work in the 1630s exhibits the same technique and the quarantine period would have been the perfect opportunity for him to initially explore his own features as a reference for *dal vivo* figures as well as for self-portraiture. These figures appeared in many of his paintings from 1630- 1634.

CHAPTER 6

Here and Now

If it wasn't enough for the intellectuals and artists of Florence to cope with the worst health emergency in a century amidst signs of a potential economic collapse, the Roman Inquisition maintained a constant presence in the city. The tribunal was first created in 1542 as a powerful Counter-Reformation measure, but in more recent years, the long-reaching grip of the Inquisition, was never too far from any ideas that challenged church doctrine which, in theory, included artwork that could appear heretical.[1] Local inquisitors acted as the eyes and ears for what had become, at this point, an extension of the papacy.[2] Months earlier, the great astronomer, engineer, physicist, and philosopher Galileo Galilei had completed the most important work of his life, a manuscript entitled *Dialogo Sopra i Due Massimi Sistemi del Mondo* (Dialogue Concerning the Two Chief World Systems), which validated the heliocentric theory of Nicolaus Copernicus.[3] The polymath was compelled to travel to Rome to defend his research almost fifteen years earlier; the church would only acknowledge the

1 Mayer, Thomas, The Roman Inquisition on the Stage of Italy C. 1590-1640, University of Pennsylvania Press, Philadelphia, 2014 (1951 1st Edition), Chapter 1, p. 11
2 Ibid, p. 2
3 Allan-Olney, Mary, The Private Life of Galileo, by Galileo Galilei, Macmillan and Company, London, 1870, *R, Clay, Sons,* and *Taylor,* Printers *Bread Street Hill,* p. 165.

Ptolemaic theory, which placed the earth at the center of the universe.[4] In an attempt to avoid potential controversy, Galileo presented his research as a mathematical hypothesis and created a fictional "dialogue" between three men discussing Aristotle, Copernicus, and Ptolemy.[5] Although he knew the pope to be a scholar and probably thought of him as a friend, Galileo surely understood the risks.[6]

Many years before in Padua, Galileo was advised by his one-time friend and colleague, Aristotelian philosopher Cesare Cremonini, not to relocate to Florence due to a potentially increased Inquisitor presence.[7] It was believed, perhaps incorrectly, that Cremonini had questioned the immortality of the soul, and was himself the subject of several separate investigations by the tribunal; fortunately for him the investigations never led to a formal trial.[8] At one point, Cremonini had famously refused to look through Galileo's telescopic lens when offered the chance.[9] Although Cremonini may have indicated that he had looked through "those glasses" and it had given him a "headache," there was clearly no motivation to witness an enlightening sight that would have contradicted

4 Ibid, Allan-Olney, Mary, The Private Life of Galileo, by Galileo Galilei, p. 82

5 Galilei, Galileo, et al. *Dialogo di Galileo Galilei Linceo, matematico sopraordinario dello studio di Pisa. E filosofo e matematico primario del serenissimo gr. duca di Toscana, doue ne i congressi di quattro giornate si discorre sopra i due massimi sistemi del mondo tolemaico e copernicano, proponendo indeterminatamente le ragioni filosofiche e naturali tanto per l'una quanto per l'altra parte*. Fiorenza, Per Gio: Batista Landini, 1632. Pdf. Retrieved from the Library of Congress, www.loc.gov/item/12018406/

6 Allan-Olney, Mary, The Private Life of Galileo, by Galileo Galilei, Macmillan and Company, London, 1870, *R, Clay, Sons,* and *Taylor,* Printers *Bread Street Hill*, p. 99, the author writes: As Cardinal, Urban had been on such intimate terms with Galileo as to sign himself his "affectionate brother."

7 Hannam, James, The Genesis of Science: How the Christian Middle Ages Launched the Scientific Revolution, Regnery Publishing, INC., Washington, DC, 2011, P. 320

8 Kennedy, Leonard A., Cesare Cremonini and the Immortality of the Human Soul *Vivarium*, Vol. 18, No. 2 (1980), p 144, n. 10 (Cremonini, Cesare, Etude Historique sur la Philophie de la Renaissance en Italie, (Paris, 1881) pp. 322-323, 341-348) and Mayer, Thomas F., The Roman Inquisition On the Stage of Italy, c. 1590-1640, University of Pennsylvania Press, 2014, pp. 66, 124- 135.

9 Biagioli, Mario, Galileo Courtier: The Practice of Science in the Culture of Absolutism, The University of Chicago Press, Chicago & London, 1993, p. 238

Aristotle's perfect moon sphere.[10] Fear had evidently stifled the fervent curiosity that had undoubtedly motivated a young Cremonini to pursue his early studies. The esteemed scholar knew that peering through the eyepiece of Galileo's astonishing device could exacerbate his Inquisition troubles, and a detailed view of the truly rugged lunar surface—the kind of visual access human beings had always dreamt of—would have also discredited some of his previous Aristotelian teachings. Despite his seeming circumspection in Galilean matters, the Inquisition, by order of the pope himself, pursued the philosopher even after his death in 1631 for his "false and heretical propositions."[11]

Due to expanded restrictions, all business in Florence was brought to a halt for a six-month period in 1631, with the exception of a few vital services.[12] Along the walls of a city that was once the jewel of the Italian Renaissance, the stench of death, emanating from the plague burial pits, filled the air.[13] The ancient municipal grid, normally teeming with life, often became a desolate maze of *pietra forte* crowned with *cotto*; this created unfortunate acoustics. The all too familiar sound of tinkling bells from the wheeled carts that carried the dead was occasionally overtaken by lamenting cries.[14] Michelangelo's David, along with the

10 Ibid, p. 238 and N: 70. Gualdo wrote Galileo in July 1611 that he had spoken to Cremonini, who justified his not dealing with Galileo's discoveries in his forthcoming book because "I do not wish to approve of claims about which I do not have any knowledge, and about things which I have not seen, . . . and then to observe through those glasses gives me a headache. Enough! I do not want to hear anything more about this" (GO, vol. II, no. 564, p. 165).

11 Archivum Congregationis Doctrinae Fidei Sanctum Officium Decreta Sancti Officii 1631, fo. 1571 Quoted in Mayer, Thomas F., The Roman Inquisition On the Stage of Italy, c. 1590-1640, University of Pennsylvania Press, 2014, p. 134

12 Cochrane, Eric, Florence in the Forgotten Centuries, p. 198

13 Mentions of the smell and "fetor of rotting bodies" can be found in Henderson, John, *Florence Under Siege: Surviving Plague in an Early Modern City*, Yale University Press, 2019, p. 85, *JSTOR*, https://doi.org/10.2307/j.ctvk8w059.9, n. 5, Baldinucci, Giovanni, *Quaderno*, pp. 66, 67.

14 Ibid, Cochrane, Eric, Florence in the Forgotten Centuries, p. 198, the author used the phrase "tinkling bells."

other gigantic marble figures of an empty Piazza della Signoria, must have appeared like indifferent gods against those echoing mourning wails. Inside Cesare Dandini's studio, it was probably quieter and more active, and the relatively cooler air may have been carrying the scent of red earth pigment and linseed oil.[15] Dandini had been called upon to carry out crucial work. Before the determined Florentine painter, the general shape of a life-size figure of the Virgin Mary may have already been emerging toward the top of his substantial canvas. This underpainting marked the start of a significant commission for Dandini, but much more rested on the success of this painting.

Alphonse Bernoud, "Santissima Annunziata, Florence," albumen print, ca. 1850–1872, National Gallery, Washington DC, United States. The photograph was taken more than two centuries later, but the appearance of the SS. Annunziata had essentially remained the same as it was in 1631.

15 Bailey, Blair, ArtCare Conservation Imaging Analysis Report: Through infrared reflectography analysis of Cesare Dandini's painting "Holy Family with the Infant Saint John" conducted by Blair Bailey in January 2023, it was discovered that Dandini used a red earth pigment for the initial marks for his figures.

The Basilica della Santissima Annunziata (SS. Annunziata), the eventual location for Dandini's commission, was a church of the Servite order blessed with artistic brilliance and by miracles. It is believed that during the mid-thirteenth century, an "Annunciation" fresco was completed by an angel or celestial spirit by painting the face of the Virgin Mary.[16] This was the first of what many believed to be divine interventions associated with the image through the years encompassing aid for both individuals and the community.[17] As a result of the image's purported miraculous power, the basilica was rededicated to the "Most Holy Virgin of the Annunciation."

Since the *quattrocento*, the SS. Annunziata had received patronage and support from several Italian families, at times, with the help of the Medici who maintained a presence at the basilica by commissioning additions through the years, including the chapel for the miraculous image of the Virgin Mary.[18] Along with the influential names of *patricii* carved into stone, paintings from the Early Renaissance through the Mannerist period adorned the interior walls. Celebrated Florentine painters such as Fra Angelico, Filippino Lippi, Pietro Perugino, Bronzino, and Jacopo Pontormo, among others, were represented inside the basilica and during the early *cinquecento*, Leonardo da Vinci and his workshop had used one of the wings of the convent for studio space. The SS. Annunziata not only housed Andrea del Sarto's work but his mortal remains as well.

16 Fantoni, Marcello, Il Culto dell'Annunziata e La Sacralità del Potere Mediceo, Archivio Storico Italiano, Vol. 147, No. 4 (542), Casa Editrice Leo S. Olschki s.r.l, Ottobre-Dicembre 1989, pp. 772, n. 4 (G. Richa, Notizie istoriche delle chiese fiorentine, in Firenze, nella stamperia di P. G. Viviani 1754-1762, tomo Vili, parte IV, p. 9).

17 Ibid, n. 5 (Un esauriente repertorio dei miracoli operati dalla Vergine si trova in G. A. Lottini, Scelta d'alcuni miracoli cit.).

18 Brown, Beverly Louise. "The Patronage and Building History of the Tribuna of SS. Annunziata in Florence: A Reappraisal in Light of New Documentation." *Mitteilungen Des Kunsthistorischen Institutes in Florenz*, vol. 25, no. 1, 1981, pp. 60, 62. *JSTOR*, http://www.jstor.org/stable/27652520.

Cesare Dandini had already contributed work to this sacred place in the past; his "Lamentation of the Angels over the Dead Christ in the Presence of Saints Alesso Falconieri and Filippo Benizzi" was completed in 1625 for the *Cappella Del Fede*, although today it is located inside the church sacristy.[19] As the painter's first public commission, "Lamentation" provided Dandini with the opportunity to finally showcase his skills to a wider audience. It was also a chance for him to hopefully put his past behind him. The result was a complex composition divided into two registers, featuring an asymmetrically deposed Christ figure supported by angels, before two kneeling saints. Unfortunately, Dandini's public work debut hadn't gone as smoothly as hoped. Because the *falegname* (carpenter) fabricated a frame of incorrect dimensions, the Florentine painter filed a lawsuit against "Maestro Rinaldo, Carpenter in Porta Rosso."[20] This error surely delayed the presentation of the finished work and reflected poorly on Dandini; such a lack of communication between artist and frame maker reveals Dandini's limited experience at the time. Dandini eventually fulfilled the contractual agreement, but the completed work exhibits an inconsistent quality and a less than fully developed style. Although the painter himself may have been a work-in-progress in 1625, "Lamentation" was still the important initial public commission he needed at the time.

Nearly six years later and in the midst of a deadly epidemic, a more seasoned Cesare Dandini was once again painting for the SS. Annunziata. The patron was Jacopo Palli a wealthy Venetian merchant who had already commissioned the sculptor Bartolomeo Rossi for his work creating the elaborately carved classical-style marble frame for the

19 Baldinucci, Filippo, p. 136, Quoted in Bellesi, Sandro, p. 53. For information regarding the changes made in the SS. Annunziata regarding the Cappella Del Fede and what is currently the Church Sacristy, see Walter and Elizabeth Valentiner Paatz, *Die Kirchen von Florenz, ein Kunstgeschichtliches Handbuch* 1940, p. 171, n. 358 and cf. Pellegrino Tonini, Il Santuario della *SS. Annunziata* di Firenze Guida Storica-Illustrativa Compilata Da un Religioso dei Servi di Maria, 1876, p. 148.

20 Archivio di Stato Firenze, Acc. Dis. N. 72, cc. 326- 329 r., cited in Contini, Roberto, *Il Seicento fiorentino: Arte a Firenze da Fernando I a Cosimo III*. Exh. cat., Palazzo Strozzi. Florence, 1986, p. 70. See again in A.S.F., Acc. Dis. No. 66, cc. 182-183 r. Quoted in Bellesi, Sandro, Cesare Dandini, p. 53

altar of his family chapel.[21] Dandini's painted centerpiece, "Assumption of the Virgin Mary with Saint James and Saint Roch (with a View of Florence in the Distance)," would be housed in an architecturally stunning vaulted niche to complete the *Cappella Palli*. The apocryphal story of the Virgin Mary's assumption was a well-established art motif of special importance, typically entrusted to painters of the highest regard. The additional presence of Saint Roch, protector against the plague, and the view of Florence expanded the meaning and intended purpose of this "Assumption" commission—there was a need for a kind of apotropaic or spiritually conductive work.[22] Although Dandini's stature had somewhat grown with the success of his painting in Ancona, his only noteworthy public work in Florence was a satisfactory effort from six years earlier.[23] Had the plague not reshaped and subtracted from the painting ranks of the city, would Dandini have been chosen for such an assignment? For him, though, the here and now was all that mattered. Given the severity of the plague, the importance of this charge, and the opportunity, the artist must have felt compelled to venture beyond creative safety; only a resounding call for divine intervention in the form of a masterpiece would do. The SS. Annunziata had once before represented salvation for Cesare Dandini, but at this point in 1631, it was Florence that needed saving.

For those who were not directly touched by the plague, fear was ever-present, as was the growing prospect of poverty. According to author Eric Cochrane, "The economic effects of the plague were still worse than the psychological ones."[24] After the end of the quarantine, business and employment prospects were still limited and in many

21 Baldinucci, Filippo, Notizie, Parte I, p. 140, 141 and Bellesi, Sandro, Cesare Dandini, p. 66, (see Pizzorusso, Claudio, A Boboli e altrove: Sculture e Scultori Fiorentini del Saicento, 1989).

22 Bellesi, Sandro, p. 66 used the word "*apotropaiche.*"

23 Cesare Dandini completed an altarpiece for the Church of the Holy Sacrament in Ancona in 1629, which was his most successful painting up to that point. Baldinucci wrote that other artists (*professori*) liked the painting "very much" and that Dandini received "renown and fame" in Ancona. However, he still hadn't experienced that kind of success with work in Florence. See Baldinucci, Filippo, Notizie, p.138.

24 Cochrane, Eric, Florence in the Forgotten Centuries, p. 198.

cases, nonexistent due to assumptions about how the plague could be transmitted and spread.[25] The proactive young Grand Duke provided jobs for many of the city's unemployed workers at the Boboli Gardens and the Fortezza da Basso, as well as interest-free loans to wool and silk workers to continue production and pay their employees.[26] Although these steps were beneficial, Florence had largely become economically depressed; there were simply too many citizens who couldn't put food on their tables. Of this, Cochrane wrote, "[From the Grand Duke's perspective], the only alternative to mass starvation was the mass distribution of public charity; Ferdinando II distributed some 150,000 *scudi* of it in 1631 alone, not counting his subsidies to monasteries bereft of their usual alms and the special outlays voted by the city magistrates."[27] The payments had an immediate positive impact, but because they were funded by drawing from the state bank, an already fragile Tuscan economy was further stressed.[28]

25 Florence Under Siege: Surviving Plague in an Early Modern City, p. 137, n. 77 (Sanita DP 7, ff. 168v, 176v.).
26 Ibid
27 Cochrane, Eric, Florence in the Forgotten Centuries, p. 198.
28 Ibid

CHAPTER 7

Son of Thunder
Portrait of the Artist

Jacopo Vignali finished his painting, *"Sister Domenica del Paradiso Beseeching the Virgin to Free Florence from the Plague,"* and was paid by the Convent of La Crocetta, located just steps away from the SS. Annunziata.[1] The completed work was presented to Grand Duchess Christina of Lorraine in recognition of her major efforts to Sister Domenica's canonization as well as her many years of support for the convent's expansion; the funding for the commission came directly from the canonization expenditures.[2] It was believed that Sister Domenica established the Convent of La Crocetta at the direction of Jesus Christ, who is said to have appeared to her in visions and instructed her to build for him "a simple place."[3] When the plague arrived in Florence

1 Henderson, John, Florence Under Siege: Surviving Plague in an Early Modern City, p. 163, n. 67, (Slack, The Impact of Plague, ch. 5 and 6; Champion, Londons Dreaded Visitation. CE. G. Alfani and S. Con Jr, Nonontola 1630. Anatomia di una pestilenza e meccanismi del contagio. Con riflessioni a partire dalle epidemie milanesi della prima età modern, Popolazione e Storia, 2 (2007), pp. 99-138).

2 Ibid

3 Callahan, Meghan, Preaching in a Poor Space: Savonarolan Influence at Sister Domenica's Convent of La Crocetta in Renaissance Florence, in Patronage, Gender and the Arts. Essays in Honor of Carolyn Valone, (author) edited by Katherine A. McIver and Cynthia Stollhans, New York: Italica Press, 2015, p. 211 and Notes 2: Archivio del Monastero di Sta. Croce (la Crocetta), Florence, (hereafter AMC); Francesco da Castiglione, Vitae Venerandae Sponsae Christi Sororis Dominicae

in 1527, Sister Domenica asked God "to gather all of the Florentine plague into her body, and then to accept all of her blood, to be poured from her veins, offering all that she had in an exchange."⁴ It appeared that her offer was accepted when Florence was spared the worst for the remaining years of the plague following her death. The painting by Vignali was not only a prestigious commission for the Grand Duchess that honored the new saint, but similar to Dandini's, it was also a call for help—in this case, an appeal for Sister Domenica's protection against the current epidemic. Even amidst the peril and anxiety, the customary competition between artists who remained in the stricken city was a reality. If rival painters weren't vying for the same project, they were invariably positioning themselves for the next, and with each completed work professional reputations were maintained, enhanced or in rarer cases, harmed. Although Jacopo Vignali's painted plague prayer was delivered first, Cesare Dandini's grand effort was underway, and by virtue of the "Assumption" subject, the hallowed public venue, and the scale of his altarpiece, his in-progress painting already corresponded with the *seicento* definition of a work of "magnificence," whereas Vignali's did not.⁵ Chance may have already been on Dandini's side, so now it appeared that creative choices would determine his destiny.

de Paradiso, segnato (hereafter Vitae) , 00v, "Tu ergo O sponsa mea, aedifica mihi locum simplicem, purum, religonem, praeserentem..."; Meghan Callahan, "The Politics of Architecture: Suor Domenica da Paradiso and Her Convent of la Crocetta in Post-Savonarolan Florence" (Ph.D. diss., Rutgers University, 005) , 00; idem, "'In Her Name and with Her Money': Suor Domenica da Paradiso's Convent of la Crocetta in Florence," in Italian Art, Society and Politics: A Festschrift for Rab Hatfield, ed. B. Deimling, J.K. Nelson, Gary Radke (New York: Syracuse University Press, 007), 7–7.

4 Calvi, Giulia, Histories of a Plague Year: The Social and Imaginary in Baroque Florence, Translated by Dario Biocca and Bryant T. Ragan, JR, University of California Press, Berkley, Los Angeles, Oxford, 1989 p. 209 and n 29: Borghigiani, Intera Narrazione, pp. 98-99.

5 Etro, Federico, Marchesi, Silvia, and Pagani, Laura, The Labor Market in the Art Sector of Baroque Rome. Econ Inq, 53: 365-387. https://doi.org/10.1111/ecin.12115), 2015, p. 371.

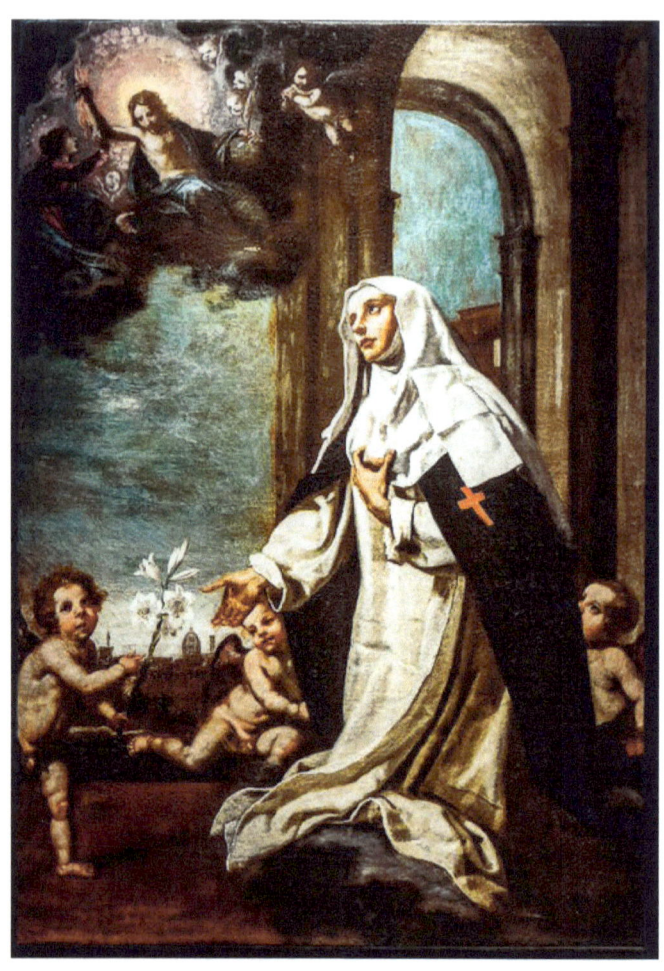

Jacopo Vignali "Sister Domenica del Paradiso Beseeching the Virgin to Free Florence from the Plague," 1631, Monastero San Michele a San Salvi, Florence, Italy (Ex.).

Two large canvases may have kept Cesare Dandini painting more than he had since his days as an apprentice. Besides the "Assumption," he was also painting for Don Lorenzo de' Medici.[6] Regardless of the increased activity, Dandini, along with the few other painters who were actively producing work during the epidemic, likely had no concerns about shortages of art materials. Despite the absence of importation, the apothecaries were probably amply stocked with painting supplies, given the greatly diminished demand in the market.[7] However, a concern for Dandini may have been the extra time he was spending inside his studio; his process reveals a preference for painting within limits, perhaps motivated by health concerns. When Dandini was producing small paintings on copper *alla invenzione* years earlier, his process was simpler and the studio sessions were considerably shorter. Working larger and at least partially from life required more discipline and time. Dandini presumably had some assistance in his studio during this period, possibly in addition to his younger brother Vincenzo. However, it can be inferred that the painter felt obligated to follow a systematic approach in the execution of large canvases.[8] This procedure would have undoubtedly been employed in the painting of two substantial commissions that were in progress simultaneously.

Before any painting took place, particularly in the case of larger projects, Cesare Dandini worked out his ideas by engaging in the traditional preliminary stage of *disegno* (drawing).[9] In those instances,

6 Dandini's "Zerbino and Isabella" is dated to the same period as the "Assumption of the Virgin Mary with Saint James and Saint Roch (with a View of Florence in the Distance)." See Bellesi, Sandro, Cesare Dandini, pp. 70 for this information. The payment for the painting is recorded in a register of the Medici fund, n. Archivio di Stato Firenze, Possesions Medicee n. 4196, c. 68 s.; Evelina Borea, 1977, p. 28.

7 In Cochrane, Eric, Florence in the Forgotten Centuries, p. 198, the author states, 'All communications with the outside world was cut off...".

8 Bailey, Blair, ArtCare Conservation Imaging Analysis Report, 2023, Information derived from the imaging analysis conducted by team of conservators led by Blair Bailey in New York and superficial analysis conducted by conservator Massimo Bonino in Florence, both in 2023: Dandini's painting process, which is discussed in detail in the following paragraphs, is unique and less convenient enough to consider that this was the painter's approach for only larger works.

9 Although there is not an abundance of Cesare Dandini's surviving drawings,

Dandini composed scenes, determined proportions, established his light source, and choreographed poses on paper. Giorgio Vasari authored the unprecedented work *Le Vite de' Più Eccellenti Pittori, Scultori, e Architettori* (The Lives of the Most Excellent Painters and Sculptors), first published in the middle *cinquecento*. In that volume, Vasari famously described *disegno* as "the father of our three arts: architecture, sculpture, and painting."[10] Although the general significance of Renaissance era tradition may have been diminishing by the 1600s, this earliest creative step was apparently important to Dandini. The forethought and effort that went into this preplanning, which may have included all forms of drawing from *schizzi* (sketches) to *cartoni* (cartoons), assured more predictable painting sessions and outcomes for him. The cost of diminished spontaneity and experimentation with his brush was evidently one that Dandini was willing to bear for the reduced painting time that he desired or felt like he needed.

Inexpensive and adaptable, red earth was a staple in most Italian painting studios during the *seicento*. Using it as a ground was more efficient than applying larger amounts of opaque black paint for the dark tones needed for *chiaroscuro* painting.[11] *Chiaroscuro* was the technique that presented strong light and dark tonal contrasts found in nearly

the work that remains reveals an unmistakable reliance and dedication to *disegno*. See the following examples, "Angel with a Violin" and "Angel with a Flute," Gabinetto Disegni e Stampe degli Uffizi, "Head of a Youth," Lille, Musée des Beaux Arts and "Standing Draped Male Figure, His Left Arm Resting on a Pillar," Metropolitan Museum of Art as a small sample of Dandini's more detailed or finished drawings.

10 Devlieger, Lionel. "Deconstructing the Doctrine of *Disegno*". Thomine-Berrada, Alice, and Barry Bergdol. *Repenser les limites : l'architecture à travers l'espace, le temps et les disciplines: 31 août - 4 septembre 2005*. Paris: Publications de l'Institut national d'histoire de l'art, 2005, http://books.openedition.org/inha/1820, n. 2. "The phrase appears at the very opening of chapter XV of the 1568 *Vite*, an opening chapter entirely dedicated to *disegno*, or the art of drawing: "Perché il disegno, padre delle tre arti nostre architettura, scultura e pittura." Giorgio VASARI, Rosanna BETTARINI, and Paola BAROCCHI, *Le vite de' più eccellenti pittori, scultori e architettori, nelle redazioni del 1550 e 1568*, 6 vols., Firenze, Sansoni, 1966–87, vol. I, p. 111.

11 Bailey, Blair, ArtCare Conservation Imaging Analysis Report, 2023: Information derived from the imaging analysis conducted by team of conservators led by Blair Bailey in 2023

all Italian Baroque painting since Caravaggio's earliest exploitations of the method towards the final years of the 1500s. A quicker buildup to darkness was especially of interest to a painter who apparently tried to minimize his exposure to wet oil paint as much as possible.[12] The finished look of Dandini's darkest tones was rich and warm, but the red earth ground contributed most brilliantly to his mid-tones; a disadvantage made advantageous. Although Baldinucci used the term *svelatura*, meaning "unveiling," to describe Dandini's application of paint, perhaps *velatura* or "veiling" applies more accurately.[13] Dandini was actually painting over or "veiling" areas of already dried paint, sometimes thinly enough for the red earth base to come through, creating areas of shadow that appeared almost luminescent.[14]

Beyond his painted ground, it seems that Dandini must have managed his painting sessions with pre-determined objectives in mind, and once they were met, he may have laid down his brushes for the day, at least for one canvas.[15] For a Baroque-era oil painter, this process was atypical, and in this way, Dandini's approach may have outwardly resembled what the frescoists of Italy had always called *una giornata*—the daily fixed painting interval for applying pigments to a section of wet plaster on a wall or ceiling before it dried. The motivation behind the oil painter's fixed intervals, was of course different than that of the painters of *buon fresco*. Dandini waited for general areas of color to dry before continuing and seems to have done so without the aid of mediums such as litharge: a popular lead oxide used to expedite the drying time of oil paint.[16] Time was money for all seventeenth-century European painters, and drying mediums allowed for a much sooner superimposition of the finishing layers of transparent hues. However, Dandini may have considered the toxic nature of these mediums as being particularly dangerous to him, thus his was a lengthier operation,

12 Ibid, Bailey, Blair, ArtCare Imaging Analysis Report, 2023
13 Baldinucci, Filippo, Notizie, p. 141
14 Ibid, Imaging Analysis Report; Blair Bailey, New York, 2023
15 Bailey, Blair, ArtCare Conservation Imaging Analysis Report, 2023.
16 Bonino, Massimo, New Research, Information derived from the surface inspection (with considerations made to the report from Blair Bailey of ArtCare Conservation) in Florence in 2023.

calling for patience, from painter and patron alike.[17] It does appear that Dandini may have been sensitive about the unique procedure he adopted, contributing to his intolerance for anyone's criticism of another painter's work or technique. In response to those who referred to the work of other painters as being inferior, Dandini is quoted as angrily saying, "It is necessary for you to first learn to work in the form that the artist had worked, and then to try your hand at the craft of estimating (their) paintings."[18] Although Dandini's painting process may have been his best attempt to balance health and productivity, he must have known that his strategy was anything but foolproof. All painters were resigned to the occupational hazards of their profession—it is thought that Raphael and Correggio may have suffered from lead poisoning, and Michelangelo was never physically the same after completing his Sistine Chapel ceiling work[19]—but a painter with a respiratory disease would have to walk an even thinner line.

The ancient world had long since passed, but the reminders existed in every direction, in the enduring form of the physical city plan itself, largely unchanged since antiquity. Old beliefs that Protestants surely perceived as idolatry and superstition also endured. Many *seicento* Florentines, particularly outside of certain academic circles, still believed in the miraculously protective or curative power of images, so when the decrease in plague fatalities nearly coincided with the start of Dandini's work on his "Assumption" painting, it must have been interpreted as a positive omen.[20] However, only time would tell if Cesare Dandini's work was to be considered another *immagine miracolosa* of Florence. Throughout the centuries, cults devoted to specific images, primarily those depicting the Virgin Mary, emerged, but faith was not easily earned, and although such

17 Ibid, Bonino, Massimo, Florence, 2023.
18 Baldinucci, Filippo, Notizie, p. 144.
19 King, Ross, Leonardo and the Last Supper, Ross King Bloomsbury publishing, p. 107.
20 Mentions of declining fatalities during this time can be found in Henderson, John, Florence Under Siege, pp. 41, 42, 145.

devotion could occur quickly in Florence, this type of official venerated recognition had taken years, if not decades, in some cases.[21] And as of the late sixteenth century, there was a criterion for works of art if they were to be considered sacred.[22] Archbishop Gabriele Paleotti of Bologna wrote in his 1582 *Discorso Intorno alle Immagini Sacre e Profane* ("Discourse Around the Sacred and Profane Images") that an image could be regarded sacred if it made contact with "our Lord or one of his saints."[23] In other cases, images could be considered sacred if they were "made by a holy person," such as when Saint Luke purportedly painted the Virgin Mary and Christ Child, which many believed resulted in the "Madonna of Impruneta."[24] Although the painted panel was most likely from the twelfth or thriteenth century, legend has it that the painting was buried at the site in Impruneta by Saint Luke and only discovered when digging began for the building of a church dedicated to and "approved" by the Virgin Mary.[25] The work of art was thought to provide powerful protection ever since. Images could also be considered sacred if they were created in a "miraculous manner," such as the aforementioned face of the Virgin Mary in the SS. Annunziata fresco.[26] The final category for holy images, and the only one that could possibly apply to Dandini's painting, were cases when "God performed manifest

21 Holmes, Megan, the Miraculous Image in Renaissance Florence, Yale University Press, New Haven and London pp. 40. The image cult for the SS. Annunziata Miraculous Annunciation painting formed by the 1360s, but the painting was created nearly 100 years earlier; see the Table 1 graphic for the dates of the formation of image cults.

22 Holmes, Megan, the Miraculous Image in Renaissance Florence, Yale University Press, New Haven and London p. 6, n. 10 (Paleotti, Gabriele, *Discorso intorno alle immagini sacre e profane, 1582*, ed. S. Della Torre (Rome: Liberia Editrice Vaticana, 2002, pp. 58- 61).

23 Holmes, Megan, Ibid

24 Ibid

25 Holmes, Megan, the Miraculous Image, p. 139, n. 121 (Boskovits, Miklós, A Critical and Historical Corpus of Florentine Painting: The Origins of Florentine Painting 1100-1270, Florence: Giunti Barbèra, 1993, section 1, vol. I, 198-205); see 203-s for the bibliography on the panel and p. 121 n. 65 (*Capitoli della Compagnia della Madonna dell'Impruneta*, 10-11).

26 Ibid, Holmes, Megan, p.6 n. 10 (Paleotti, Gabriele, *Discorso intorno alle immagini sacre e profane, 1582*, ed. S. Della Torre (Rome: Liberia Editrice Vaticana, 2002, pp. 58- 61).

signs and miracles in that image."²⁷ The most well-known example of this type of sacred image is Bernardo Daddi's "Madonna of Orsanmichele," also known as the "Miraculous Virgin and Child." Daddi's 1347 work was actually the third rendition of this motif at the Orsanmichele, the city's grain market at the time; the original image created in 1292, which had also been credited with miraculous healings, was destroyed when the entire building burned down in 1304.²⁸ Unknown circumstances led to the substitution of the second iteration with Daddi's more sizable painting, although it appears that some individuals held the opinion that the second version was not capable of "working wonders."²⁹ It was believed that even when sacred images were created by human hands that God was the force behind them which was an extension of the centuries-old concept of *deus artifex*: the metaphor that likened the creative skills of an artist to those of God, the ultimate creator.³⁰ If Florentine history was any indication, Dandini might not know within his lifetime whether his "Assumption" was worthy of a dedicated cult, but the painter was probably focused on the more immediate results of his endeavor, mainly the professional impact of the completed painting. In any case, the painter most likely held no such reveries regarding a sacred designation; according to other passages in Archbishop Paleotti's Discorso, some of Dandini's ideas for the commission may have aligned more with *il profano* and less with *il sacro*.³¹ Whatever the consequence, the die for his bold vision had already been cast, in this case, even before the earliest stages on paper.

27 Holmes, Megan, the Miraculous Image in Renaissance Florence, Yale University Press, New Haven and London pp. 6, n. 10 (Paleotti, Gabriele, *Discorso*, pp. 1582, pp. 58- 61), pp. 146 and 148.

28 Ibid, pp. 146 and 148.

29 Ibid, p.148.

30 Holmes, Megan, the Miraculous Image in Renaissance Florence, Yale University Press, New Haven and London p. 262.

31 Paleotti, Gabriele, *Discorso intorno alle immagini sacre e profane (1582)*, ed. S. Della Torre, Milan, 2002, p. 163

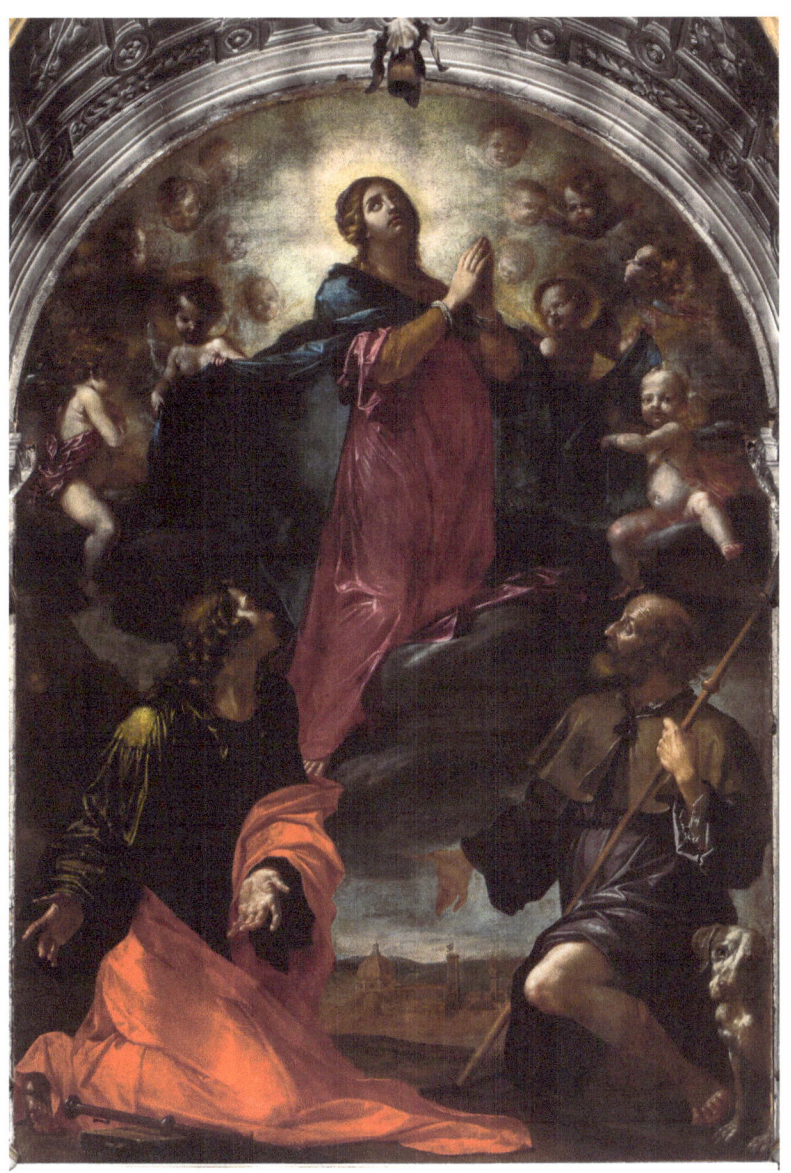

Cesare Dandini, "Assumption of the Virgin Mary with Saint James and Saint Roch (with a View of Florence in the Distance)," oil on canvas, 1631-1632, Basilica della Santissima Annunziata (SS. Annunziata), Florence, Italy.

When conceiving of his own "Assumption," Dandini presumably referenced "Assumption of the Virgin" in the Church of Santa Maria all'Antella in Bagno a Ripoli, a painting executed by his former master, Domenico Passignano. Dandini, however, was unquestionably creating a distinct interpretation of the subject. A little more than a year earlier, he had painted "Saint Carlo Borromeo in Glory with Saints Lorenzo, John the Baptist, Francis, and Apollonia" for the Church of the Holy Sacrament in Ancona, in the Le Marche region, and it was thought to be his most successful work up to that point.[32] The visual stability of the pyramidal arrangement, effectively utilized by Passignano in Bagno a Ripoli and by Dandini in Ancona, was employed again for his "Assumption," but with considerably far fewer figures than in either of those paintings. In between his artistic endeavors in Ancona and receiving his second SS. Annunziata commission, Dandini began producing predominantly solitary painted figures that were surrounded by darkness. Some of these works were commissioned, while others were painted studies, particularly during the onset of the plague. However, each of these works necessitated a heightened concentration on each individual human being. In lieu of additional figures, Dandini made the choice to infuse his "Assumption" narrative with complex psychological elements and unforeseen emotion, leading to a departure from conventional norms.

At the apex of the composition, Dandini's Virgin Mary looks heavenward with hands piously clasped as she is lifted up on a cloud by cherubic angels. However, the Virgin Mary's body and soul translocation appears to dismay rather than awe Saint James and Saint Roch. The spirited expressions and poses Dandini chose for his two kneeling saints were conceived from the pain inflicted upon the city of Florence, but they may have also bordered on impiety, turning this into one of the most unique "Assumption" works ever painted. And Dandini's daring was far from over.

32 Bellesi, Sandro, Cesare Dandini, pp. 56, 57 from information derived from C. Fero, 1884, p. 19 and Baldinucci, Filippo, Notizie, Parte I, p. 137, 138.

Cesare Dandini "Assumption of the Virgin Mary with Saint James and Saint Roch (detail of Saint James)," 1631-1632, SS. Annunziata, Florence, Italy.

The inclusion of Saint James was personal on two fronts, and other elements of the painting presumably had significance for the artist as well. At the request of the patron Jacopo Palli, his name saint, *San Jacopo* (Saint James), was included in the painting. The unexpected emotion and hand gestures of Dandini's Saint James demonstrate a passionate imploration for the Virgin to stay and save the people of Florence. Given the miraculous Marian interventions that had famously taken place at the SS. Annunziata, James' discontent surely was directed at the power that drew the Virgin Mary away, the Almighty, who most believed brought this wrath. In Mark 3:17 it's written that James and his brother John received the nickname *Boanerges* (Sons of Thunder) from Jesus Christ.[33] The brothers were described as having a "fiery temperament" in Luke 9:49, but perhaps their personalities are best expressed in Luke 9:53-56: But the (Samaritans) would not welcome him, because he was set on going to Jerusalem.[34] When James and John, followers of Jesus, saw this, they said, "Lord, do you want us to call fire down from heaven and destroy those people?"[35] But Jesus turned and scolded them, "You don't know what kind of spirit you belong to. The Son of Man did not come to destroy the souls of people but to save them."[36]

Cesare Dandini elected to emphasize this facet of James' personality, portraying him as a forceful, dynamic presence vitalizing the lower left corner of the large canvas. But by adding Saint James, Dandini wasn't just fulfilling the patron's wishes or balancing his composition; he was also seizing the moment—Dandini's Saint James is a self-portrait. The likeness of this rare beardless Saint James figure is a match for Giovanni Battista Cecchi's eighteenth-century engraved portrait of Cesare Dandini. The veracity of Cecchi's series of portraits of seventeenth-century painters has never been questioned, so this should be considered a most reliable reference. Beyond physiognomy, the painter's nature, or at least the way that he perceived himself, was also being presented in

33 Bible, King James Version, Mark 3:17, www.kingjamesbibleonline.org, 2007
34 Bible, King James Version, Luke, 9:49 and 9:53-56, www.kingjamesbibleonline.org, 2007
35 Ibid
36 Ibid

Giovanni Battista Cecchi, "Portrait of Cesare Dandini", engraving, ca. 1774, British Museum, London, England.

his zealous Saint James of the "Assumption." Even the painted view of Florence may have been of special significance to Dandini. The view of the city in the distance reveals a vantage point from the *Colline di Careggi* (Careggi Hills), and it may have been the very sight Dandini

gazed upon with longing during his brief exile, wondering if he'd ever enter the city walls again as a free man. Although the painter had become familiar with the countryside from his days spent hunting, this particular location offered something unique. Careggi would have been a logical choice for Dandini's hideaway, considering it was where Villa Medici stood since the fifteenth century.

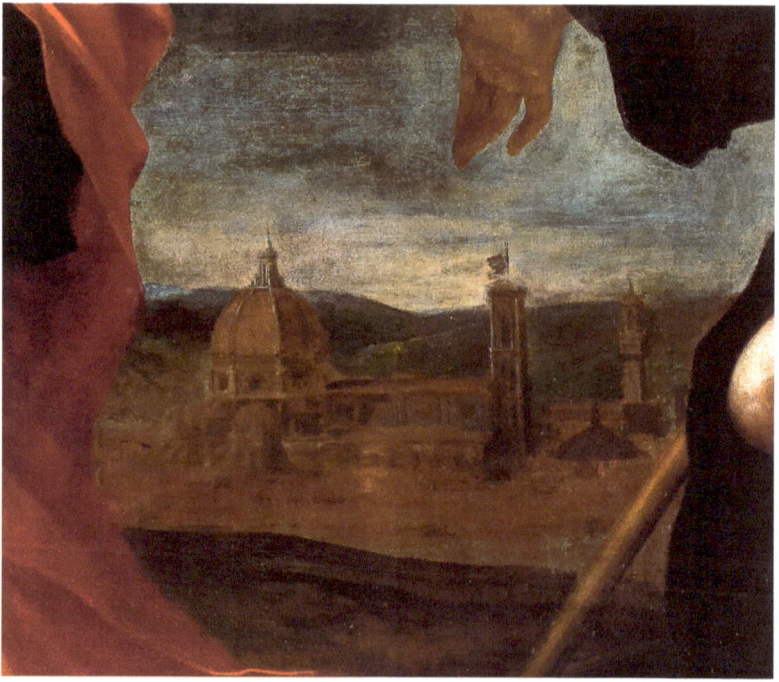

Cesare Dandini "Assumption of the Virgin Mary with Saint James and Saint Roch (detail of Florence as seen from the Careggi Hills)," 1631- 1632, SS. Annunziata, Florence, Italy.

An almost equally animated Saint Roch appears to urge the Virgin to assist Florence before she leaves the earth or admonish her to intercede once she has entered the realm of God. Saint Roch desperately motions with his right hand toward the ailing city of Florence in the distance, implying that this scourge was too much for even him. The bearded older model for Saint Roch is one that Dandini used extensively from

the late 1620s through the mid-1630s; he had already posed as the monk Beato Homodei Ordelaffi, Saint Jerome, Saint Paul, Saint Luke among other subjects. Later on, the aging but serviceable trouper appeared as Joseph in Dandini's "Holy Family" paintings.

Cesare Dandini "Assumption of the Virgin Mary with Saint James and Saint Roch (detail of Saint Roch's dog)," 1631-1632, SS. Annunziata, Florence, Italy.

The small furry figure at the edge of the same right-side corner of the canvas suggests that Dandini may have also had the four-legged victims of the plague in mind. According to legend, Saint Roch's own

plague sores were cured by the licks from his dog, making the dog a common attribute of the saint. However, the canine's sorrowful gaze towards the viewer presents a possible dual meaning. In certain districts of the city, there was not enough food to share with dogs, so some of the starving animals began to dig through the plague pits in search of human remains.[37] Fences were erected as a preventative measure, but it was believed that dogs had become potential carriers of *la peste*, resulting in a decree stating that all untethered dogs within the city and the *contado* could be shot with a financial incentive of one *giulio* per dog.[38] Although the primary rationale for enacting the decree was likely a perceived health concern, there was also great motivation to prevent the further desecration of dead bodies.[39] Nevertheless, the bounty proved too tempting for some during such dire economic times; as Dandini painted his "Assumption," it was known that hundreds of dogs had been killed.[40]

Andrea del Sarto, referred to by Giorgio Vasari as the "painter without errors," included self-portraits in three of his own "Assumption" paintings about a century earlier. The "Panciatichi Assumption" was part of the Medici collection during this time, and Dandini would have had nearly unlimited access to the painting.[41] Sarto was one of the

37 Cochrane, Eric, Florence in the Forgotten Centuries 1527- 1800, University of Chicago Press, Chicago, London, 1973, p. 198 and Sanità, Rescritti 37, I. 337 (, 9.x.1630, quoted in Henderson, John, Florence Under Siege p. 128.

38 Targioni, 'Relazione della Peste, p. 307; Rondinelli, Relazione, p. 56 and Sanità, Rescritti 37, f. 190r, 26.viii. 1630, quoted in Henderson, John, Florence Under Siege p. 128.

39 Sanità, Rescritti 37, I. 337 (, 9.x.1630, quoted in Henderson, John, Florence Under Siege p. 128.

40 Baldinucci, Giovanni, *Quaderno*, p. 71, quoted in Henderson, John, Florence Under Siege p. 128.

41 Regarding the date for Medici ownership of Andrea del Sarto's "Panciatichi Assumption," see Waldman, Louis Alexander, A Document for Andrea del Sarto's "Panciatichi Assumption," The Burlington Magazine, Vol. 139, No. 1132 (Jul., 1997), pp. 469-470Published by: Burlington Magazine Publications Ltd.Stable URL: http://www.jstor.org/stable/887506, n. 6: The date of 1548 for Cosimo's confiscation is frequently repeated in the literature, although that date was correctly given as the date of the villa's acquisition by the Salviati in M. MARANGONI: La villa del Poggio Imperiale, Florence [n.d., c.1922], p.5. The error probably arose

most influential painters in Florence both during and after his lifetime and this would not be the last time Dandini referenced the celebrated Renaissance master. Much had changed since Sarto's "Assumption" paintings were created, however, including the establishment of a late sixteenth-century Counter-Reformation directive that prohibited using the features of known secular beings for saints or sacred figures in artwork. As stated by Cardinal Carlo Borromeo, Archbishop of Milan, "In the case of saints' images, one must be as true as possible to their real likeness and must be careful to not deliberately reproduce the portrait of another man, living or dead."[42] Archbishop of Bologna Gabriele Paleotti's *Discorso Intorno alle Imaginini Sacre e Profane* also provided clear rules for images; in his *Discorso*, it was warned that saints "should never be portrayed with the likeness or characteristics of known earthly persons . . ."[43] Dandini, like all *seicento* painters in Italy, was aware of these reforms and that he risked being considered anathema in the eyes of the church. Given his lengthy process, there had been ample time to reconsider this choice, even after his first layers of paint had dried. But safety wasn't a consideration.

The prevailing narrative about the enigmatic Dandini had to include mention of his skill, but his temperamental nature, as well as the fact that he had killed a man, were also well known. Certainly, there was more to Cesare Dandini, and Filippo Baldinucci endeavored to make his subject more approachable through the inclusion of a few details. Two instances in which Dandini jokingly commented on gifts he received from patrons are documented, and one such incident involved the delivery of decaying legs of game animals; Dandini referred to them as "gifts from lions."[44] Another involved the delivery of silk stockings that were notably undersized for Dandini's larger

from the fact that 1548 was the year in which Cosimo passed the law under which the confiscation was made, the famed lexpolverina, which entailed to the state all properties of rebels. For Alessandro and Piero Salviati, see p. HURTEBISE: Unefamille-timoin, les Salviati, Vatican City [1985], especially pp.204, 217, 498.

42 Borromeo, Carlo, *Instructionum Fabricae et Supellectilis Ecclesiasticae: Libri II*, ed. M. Marinelli p. 70, Vatican City, 2000.

43 Ibid, Paleotti, Gabriele, *Discorso (1582)*, ed. S. Della Torre, Milan, 2002.

44 Baldinucci, Filippo, Notizie, pp. 144, 145.

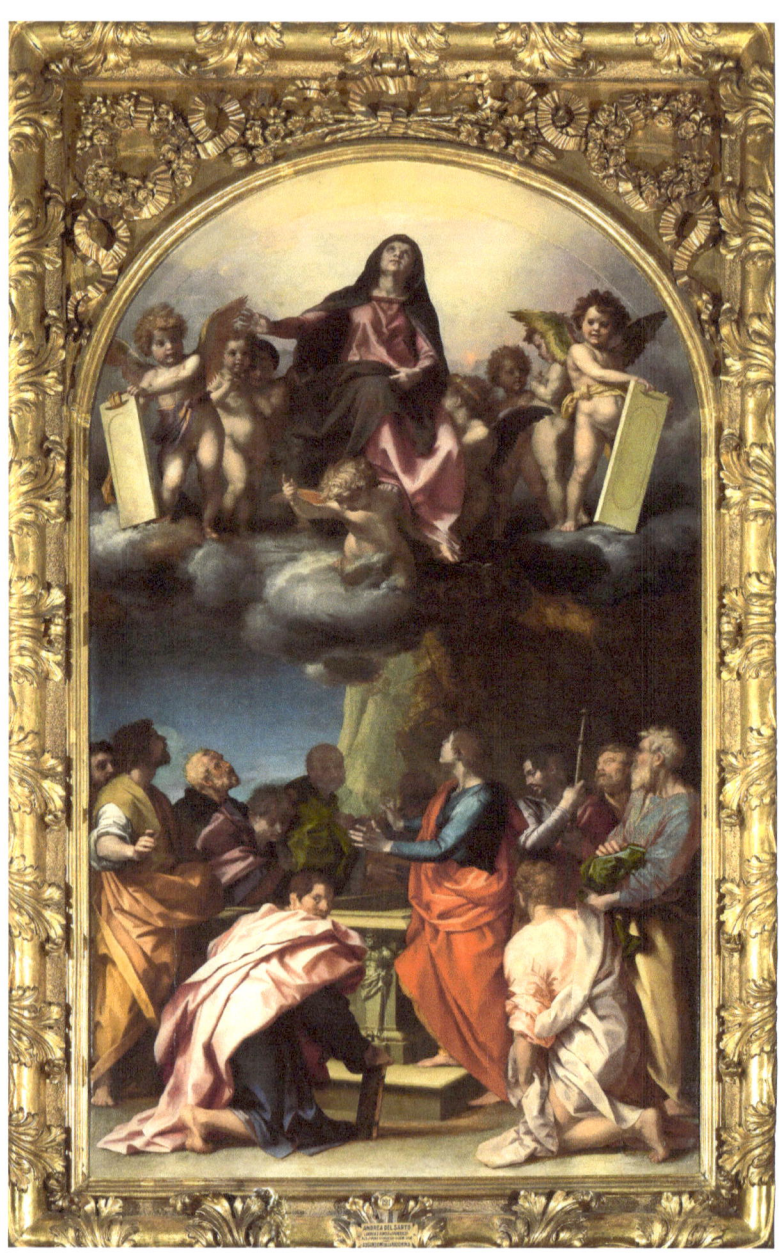

Andrea del Sarto, "Panciatichi Assumption," oil on panel, 1522-1523. Palazzo, Pitti, Florence, Italy. Sarto's self-portrait appears in the fifth figure from the left.

legs.⁴⁵ Considering Baldinucci's biographies were fairly concise, it can be inferred that Dandini's sense of humor was noteworthy, so those closest to him were likely acquainted with what may have been a wry kind of wit, which seems consistent with his other known personality traits. Those who worked in Dandini's studio, particularly his students and his brother Vincenzo, were surely familiar with his protective nature.⁴⁶ What also may have been less known was the financial assistance that Dandini provided to the father of the man he murdered, presumably for as long as the man lived—perhaps an example of imposed reparations, but just as likely, evidence of a complex, moral character.⁴⁷

Correspondingly, had Dandini begun exercising a creative method of self-disclosure? Beyond his "Assumption" painting, he continued to explore self-portraiture in the guise of courageous, righteous figures, such as archangels and saints. The painter may have been revealing how he saw himself, or how he wished to be recognized: as a principled but nevertheless imperfect warrior, and in more modern-day terminology, a kind of anti-hero. The swords and daggers depicted in several of these works were almost certainly not mere symbols or props; the artist was quite adept at handling weapons, and they probably came from his own collection. Although each of these paintings was an opportunity to showcase Dandini's best side, none were entirely idealized —the dark shadows are all around and some may have crept within. Even a deaged self-portrait as a victorious David appears unexpectedly rueful as he engages the viewer, complicating the legendary motif. Perhaps Dandini had found another subject of personal significance in the young shepherd who vanquishes a seemingly insurmountable foe, ascends to royalty, and displays a divinely guided artistry—in David's case, composing music dedicated to God. While it is unlikely that Dandini had the opportunity to personally view Caravaggio's painting titled "David Holding the Head of Goliath" because it was executed in Naples, it is worth noting that both artists strategically positioned themselves, through the use of self-portraiture, on opposing sides of the killing. Caravaggio experienced a tumultuous period towards

45 Ibid
46 Ibid, pp. 143- 145.
47 Ibid, p. 135.

the end of his life, during which he became a fugitive following his involvement in a previously mentioned fatal altercation. The artist's well-documented proclivity for violence resulted in numerous arrests and contributed to the development of the Caravaggesque legend, portraying him as an outlaw artist—mostly an oversimplification.

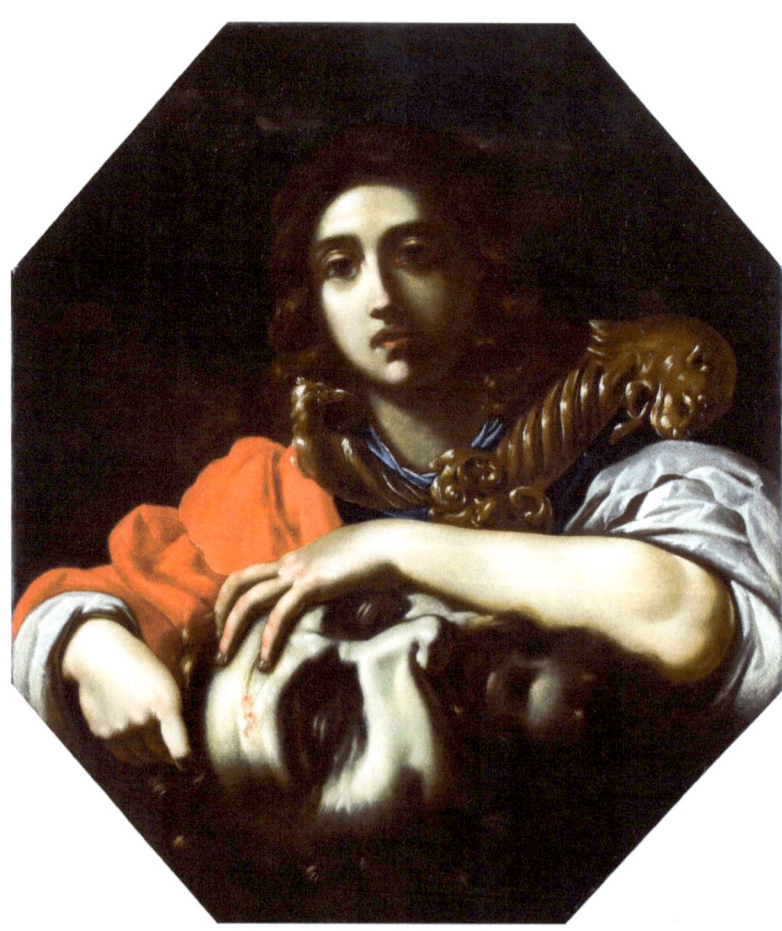

Cesare Dandini, "David with the Head if Goliath," oil on canvas, 1632-1635, Piacenti Fine Art, London, England.

However, Caravaggio's depiction of himself as the decapitated head of Goliath suggests his own notion that meeting a fate such as death by the sword was an unavoidable or a potentially just outcome. In contrast, Dandini assumes the role of the victor as David, but with consideration given to his expression and bloodied hand, had the Florentine painter also drawn from his own experience, in this case, when he took another man's life?

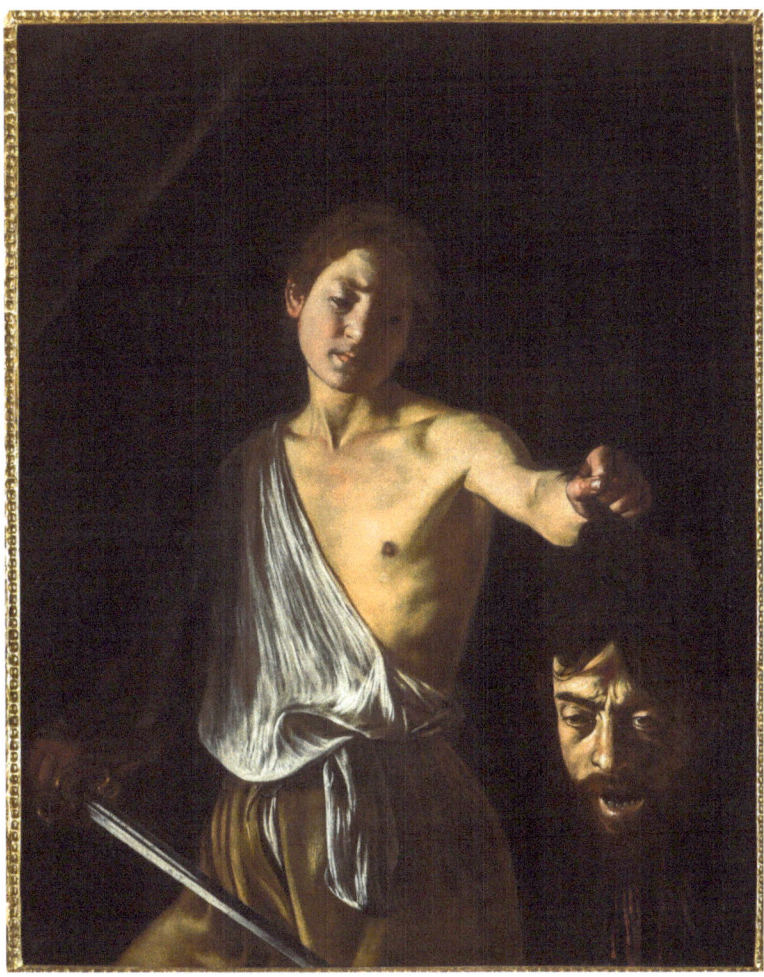

Caravaggio "David Holding the Head of Goliath," oil on canvas, 1609-1610, Galleria Borghese, Rome, Italy. Photo credit: Mauro Coen.

The striking male figure with wavy brown hair who matched Cecchi's engraving and corresponded with Filippo Baldinucci's description of the artist as having "beautiful proportions of the face" first appears in Dandini's paintings after the outbreak of the epidemic, when access to models was limited. While the artist appears to have turned to self-portraiture, at least partially out of necessity during the early, worst days of the plague, the "in-guise" portrayals might have become a vehicle for self-expression and an attempt to counter the prevailing narrative, if only for himself.

During the fifteenth century, Leonardo da Vinci wrote "Ogni dipintore dipinge se," which translates to "Every painter paints himself." Although the brilliant Renaissance man didn't coin the phrase—it was actually attributed to Cosimo de' Medici, who evidently applied his keen patron's perspective—Leonardo may have contemplated the inherent convenience, possibilities, and even limitations encapsulated in this maxim.[48] When the great Baroque sculptor Gianlorenzo Bernini needed to better express the determination on the face of his sculpted "David" (1623-24), it is thought that he picked up a mirror and worked from his own features. In executing this artistic choice, Bernini did not explicitly intend to transform his sculpture of "David" into a self-portrait. Rather, he was referencing the most reliable and accessible source material at his disposal.

In other cases, however, artists displayed their own features as secondary figures in paintings to serve as a kind of signature while showcasing their portraiture skills. Still others took the opportunity to portray themselves "in-guise" as protagonists to suggest some of their own qualities. Fellow Academy member Artemisia Gentileschi, the pioneering female Roman painter who lived and worked in Florence from 1612 (or 1613) to 1620, famously applied her own features to heroines, including Judith and Saint Catherine of Alexandria. During her time in Florence,

48 According to fifteenth-century writer Angelo Poliziano, the full quote from Cosimo de' Medici was "One would rather forget a hundred charities than one insult and that the offender never forgives and that every painter paints himself." Poliziano 67; Chastel 102 n 4, quoted in Land, Norman E., "Giotto as an Ugly Genius: A Study in Self-Portrayal," Explorations in Renaissance Culture, Vol. 23, South Central Renaissance Conference, Memphis, 1997.

Artemisia cultivated a circle of friends that included some of Cesare Dandini's acquaintances. Among them were fellow Academy members, including Galileo Galilei and Dandini's momentary teacher Cristofano Allori, who was the godfather to Artemisia's son Cristofano (thought to be named after Allori). Surely Dandini was familiar with Artemisia's work, and he, in particular, must have appreciated her fearlessness.

Artemisia Gentileschi "Self-Portrait as Saint Catherine," oil on canvas, 1615-1617, National Gallery, London England.

Cristofano Allori, one of the renowned Florentine painters of the day, was also an actor, and one of his most famous "in-guise" self-portraits in "Judith with the Head of Holofernes" could certainly be described as a painted still performance. Based on the apocryphal story,

Judith gained access to the tent of the Assyrian General Holofernes, who threatened the sovereignty of the people of Bethulia, by exploiting his desire towards her. Subsequently, Judith used the sword of the Assyrian General to fatally attack him while he lay in a state of intoxication on his bed. Allori used his own features for those of his vanquished villain, who's decapitated yet expressive head is held by the hair in the hand of the Jewish widow-turned-champion. Filippo Baldinucci acknowledged the probable autobiographical nature of the painting, which may have been inspired by Allori's failed love affair; Judith resembles Allori's ex-lover, and Abra, the attendant, resembles her mother.[49] The typical primary objectives of the artistic portrayal of the "Judith and Holofernes" theme were to emphasize the heroism of Judith and the ultimate triumph of good over evil.In this specific case, it appears that Allori may have been motivated to express a self-perceived mistreatment or, possibly, his acknowledgment of a justifiable, albeit figurative in nature, repercussion. In recent years, there has been conjecture surrounding the possibility that Cesare Dandini copied the painting and created a study of the face of the Judith figure during his very limited tenure in Allori's workshop. This is a theory based solely on the manner of the copies which resemble Dandini's style and is by no means a certainty. Whether or not Dandini copied Allori's masterpiece, it seems plausible that the renegade pupil took notice of the master painter's dramatic, intimate assimilation of his own features during his brief time in the workshop. Leonardo da Vinci elaborated on this topic, "I have known some who, in all of their figures, seem to have portrayed themselves from life, and in these figures are seen the motions and manners of their creator."[50] Although Leonardo's statement pertained to a persistent use of self-portraiture by some in his era, the practice was unquestionably alive and well in seventeenth-century Florence.

 The commission for Don Lorenzo de' Medici was a painting entitled "Zerbino and Isabella" and it was created for his estate

49 Baldinucci, Filippo, Notizie Parte III (Internet Archive), p. 271.
50 McMahon, Philip A., A Treatise on Painting by Leonardo da Vinci, J. B. Nichols and Son, London, p. 86, 1835.

Cristofano Allori "Judith with the Head of Holofernes," oil on canvas, 1613, Royal Collection Trust, London, England.

outside of Florence, Villa della Petraia.[51] Even though the scene was tragic, it was a fantasy set in a distant time and place, far removed from the reality unfolding in Florence. The subject was based on the popular poem "Orlando Furioso" by the sixteenth-century poet Ludovico Ariosto.[52] Although the two themes differed in concept, the

51 Bellesi, Sandro, Cesare Dandini p. 69, n. (A.S.E, *Guardaroba Medicea* n. 628, c, 4 r.: E. Borea, 1977, p. 28).
52 Ibid

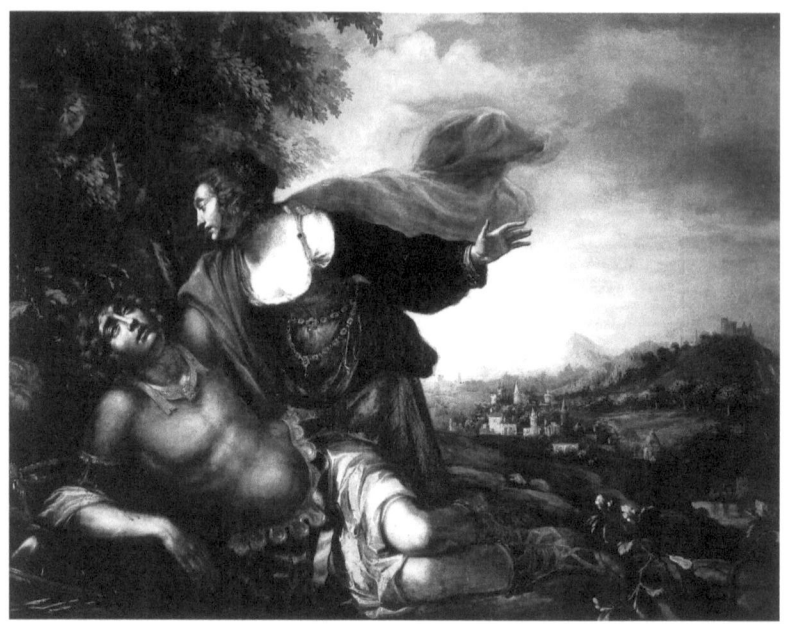

Cesare Dandini "Zerbino and Isabella" oil on canvas, ca. 1631, Uffizi Galleries, Florence, Italy.

synchronicity between "Zerbino and Isabella" and "Assumption" is unmistakable; in addition to using his own likeness in both works, Dandini also included a cityscape in the distance in Don Lorenzo's painting. However, the painted view in "Zerbino and Isabella" certainly was not based on personal experience or the painter's time on the run; the round-towered architecture layered in front of a mountainous Alpine backdrop represents the Florentine painter's perception of early medieval France, the location of the written narrative. The subject of the dying warrior Zerbino provided Dandini with his most dramatic "self-portrait-in-guise" opportunity, but the features of Isabella also resemble the painter, presumably resultant from a lesson learned more than two decades earlier. Filippo Baldinucci recounted that when Dandini was a student, his first teacher, Francesco Curradi, sometimes used the boy's "beautiful" face as a model to paint female figures.[53] Considering the histrionic poses of both painted figures, this

53 Baldinucci, Fillipo, Notizie. p. 129.

work also appears to provide additional evidence of the influence of his second teacher, Cristofano Allori, as a painter and an actor. Don Lorenzo, who later provided a theater workshop for actors inside his own city residence on via del Parione, may have been the most passionate supporter of the performing arts in all of Florence, so the heightened theatricality must have especially appealed to him.[54] There were no receptions to organize, nor were there any productions to support; instead, Don Lorenzo, along with his brother Cardinal Carlo de' Medici, had been charged with tending to the needs of the *contadi* and making sure that plague protocols were properly observed.[55] In the absence of the performances he adored, "Zerbino and Isabella" must have provided Don Lorenzo with some enthralling moments and a much-needed emotional diversion. The sessions spent working on the painting may have had a similarly gratifying effect on Dandini.

The "Assumption of the Virgin Mary with Saint James and Saint Roch (with a View of Florence in the Distance)" was unveiled towards the end of 1631 or not long after the beginning of 1632, and at that point, the plague had seemingly left the city.[56] None could have known for sure if Dandini's painting had contributed to this outcome, but there was little doubt about the quality of the work. In his second painting

54 For establishing that "L'Accademia dei Concordi" met in Don Lorenzo's via del Parione residence in Florence see: Martinelli, Elsa, *Nei panni dell'eroe: costumi e protagonisti di due drammi per musica dati a Firenze nel 1760*, Fashioning Opera and Musical Theatre: Stage Costumes from the Late Renaissance to the 1900, Valeria De Lucca (cura) e Centro Studi per la Ricerca Documentale sul Teatro e il Melo drama Europeo, Fondazione Giorgio Cini Onlus, Venezia, 2014, p. 149, n. 7 (cfr. Melodramma, spettacolo e musica nella Firenze dei Lorena, cit., p. LIII e sgg. Cfr. anche Francesco Lumachi, Firenze, nuova gui-da illustrata, storica –artistica –aneddotica della città e dintorni, Firenze, Società Editrice Fiorentina, 1929, e Caterina Pagani, Vocazione teatrale e professionismo impresariale dell'Accademia degli In-fuocati di Firenze, in «Medioevo e Rinascimento», Annuario del Dipartimento di Studi sul Me-dioevo e il Rinascimento dell'Università di Firenze, XXI, n. s. XVIII (2007), pp. 275-297.)
55 Florence Under Siege: Surviving Plague in an Early Modern City, p. 143.
56 Bellesi, Sandro, Cesare Dandini, p. 66.

for the SS. Annunziata, an artistic maturation was evident. Although Dandini's visual language had already included *chiaroscuro*, there was a distinct gloom in the "Assumption" that wasn't present in the painter's earlier work: a possible attempt to capture the emotions associated with the entire Florentine milieu.

Cesare Dandini, "Saint John the Evangelist," oil on canvas, 1631-1632 (?), formerly Collezione Guidi Bruscoli.

During or shortly after his work on the "Assumption," Dandini created several representations of himself as Saint John the Evangelist, the similarly fiery brother of Saint James, including a painted oil study and a drawn study. Dandini may have felt affinity with both saints, but Saint John, the author of the Three Epistles of John, the Book of Revelation, and the Gospel of John, likely provided a depiction of the intellectual and dedicative traits to which the painter must have also related.

Cesare Dandini, "Saint John the Evangelist (painted study)," oil on paper transferred onto canvas, 1631-1632 (?) Collezione Federico Berti.

Perhaps the most engaging of all of the works in this series is the smallest. Although there is no known painting that corresponds with this full-body depiction in black chalk on a small to medium-sized sheet of brown-washed paper, Dandini's effort in producing the drawn study implies its significance to him. The subject, suggested here to be a self-portrait as Saint John the Evangelist, assumes a position that is quite consistent with Renaissance and Mannerist era portraiture, facing the observer with his left elbow resting on a pillar and his hand contemplatively supporting the head, with his right hand on his hip, presumably clutching a book or a bag.[57] The face, hair, and clothing are all in keeping with the Saint John (and Saint James) paintings, and other distinguishing attributes are featured as well. Dandini did not choose the figure's support at random: Saints Peter, James, and John were known as the "pillars" of Christianity. Among other sketched concepts also included on the sheet is a rear-view sketch of the same pose, showing a now barely detectable feather, or in this case, a feather quill pen, in one hand of the figure, further establishing the author-saint's identification. Although there is no formal grin, the eyes of Dandini's Saint John emit a kind of Duchenne smile, possibly suggesting a sense of pride for the figure, and in this case, the artist, or a moment of self-acknowledgment. As a result of his latest works, Dandini was being acknowledged in a manner he had never been before, by both admirers and detractors.

Filippo Baldinucci wrote of the acclaim for Dandini's "Assumption," but also added that some painters in the city made a rather grave prognosis for this work, claiming that the painting would have a "short life."[58] It remains uncertain exactly what the statement pertained to, but there are some likely considerations. Was this a reference to the physical state of the painting, insinuating poor execution? Naturally, considering the departure of apprentices and the graduation of students

57 For reasons presented in the corresponding passage and throughout this book, it is my suggestion that the drawing, "Standing Draped Male Figure, His Left Arm Resting on a Pillar" from the Metropolitan Museum of Art, New York City, is a self-portrait as Saint John the Evangelist. https://www.metmuseum.org/art/collection/search/338599

58 Baldinucci, Fillipo, Notizie de' Professori del Disegno, Parte I, P. 141.

Cesare Dandini, "Standing Draped Male Figure, His Left Arm Resting on a Pillar," black chalk on dark brown washed paper, ca. 1631-1632 (?) Metropolitan Museum of Art, New York, United States.

from the workshop, Dandini's peculiar painting method was no secret in Florence. Or perhaps, the very light flesh tones he utilized, notable enough for Baldinucci to make mention of, were seen by some as a style that would fall out of favor. The process in which he applied paint may have been directed by his health, but was the pallor of Dandini's painted figures influenced by it as well? At various times, the painter's complexion may have reflected either low blood oxygen levels (hypoxemia), low oxygen levels in his body tissue (hypoxia), anemia, a low blood count, or the possible combination of more than one.[59] When Dandini began analyzing himself as a painted subject, the reflection in the mirror could have revealed the appearance of a hypoxic asthmatic, prompting him to create mixes with less color to paint his own flesh tones.[60] Asthma sufferers often fail to notice the gradual but growing difficulty in breathing, as well as the drained appearance that can develop with what would later be referred to as "silent hypoxia."[61] It is plausible that the artist's preference for a lighter range of skin tones in his self-portraits may have potentially influenced his depiction of other painted figures, especially if he continued to use himself as a reference for poses and faces.

Another possible explanation behind what may have been a wishfully pessimistic prediction from other Florentine painters was a reaction to Dandini's potentially problematic portrayal. The first to notice Dandini's rebellion against the Counter-Reformation reforms would have been fellow painters who were also required to adhere to these rules and, of course, church officials. In the short term, though, and especially from a local Roman Catholic standpoint, one could have argued that the painting may have proven beneficial—as previously indicated, mortality had fallen roughly at the time of the project's inception.[62] And of course, that was the commission's

59 Professional, Cleveland Clinic Medical. "Hypoxia." *Cleveland Clinic*, my.clevelandclinic.org/health/diseases/23063-hypoxia.

60 Ibid

61 Colarossi, Jessica. "Three Reasons Why COVID-19 Can Cause Silent Hypoxia." *Boston University*, 5 Apr. 2023, www.bu.edu/articles/2020/3-reasons-why-covid-19-can-cause-silent-hypoxia.

62 Declining fatalities in Henderson, John, Florence Under Siege, pp. 41, 42.

initial aspirational objective. It is also conceivable that the nearly unprecedented circumstances overshadowed any potential controversy associated with Dandini's figures and subject matter from the perspective of the church. Or, perhaps, in this instance, the means were deemed justifiable.

It is reasonable to believe that the painters who forecasted a "short life" for the painting were at least partially moved by feelings of envy towards Dandini's achievement, which was now hanging in the sacred basilica. The competitiveness within the artistic community surely led to insecurity and resentment, and even the greatest of artists were not immune. According to Giorgio Vasari, when shown the work of a talented painter, Michelangelo would say, "This is by a rogue, a real wretch," but of mediocre painters, he said, "This is by a good fellow who will give no one any trouble."[63] Dandini may have had a questionable reputation and been from outside of their circle, but the "Assumption" served as a declaration of his abilities, positioning him near the esteemed ranks of the city's leading *dipintori*.

63 Sohm, Philip Lindsay, The Artist Grows Old: The Aging of Art and Artists in Italy, 1500-1800, Yale University Press, New Haven, p. 44, 2007.

CHAPTER 8

Redux

Although the contagion was known to still be in Livorno and as close as Monticelli (a mere twenty-minute walk from the city walls), it had been months since it was detected in the city.¹ There was hope that perhaps Florence would be spared further difficulties. Business between artists and patrons appeared to increase, surely one of the indicators that a kind of normalization of city culture was occurring. One of the transactions that seems to have taken place during this time was between the painter Francesco Furini and the wealthy banker Agnolo Galli for a mythological work on canvas, "Hylas and the Nymphs."² The sensual nature of this subject indicates that the painting was probably planned for display in Galli's *camera* (bedroom) and it demonstrates that at least some were ready to entertain lighter more amorous thoughts.

Three veteran painters, Matteo Rosselli, Jacopo Vignali, and Giovanni Bilivert, had all received commissions from Count Francesco Bonsi to paint the interior of his family's Capella della Croce within one of city's newest churches, the Church of San Michele e Gaetano,

1 Baldinucci, Giovanni, Quaderno, pp.80-82, quoted in Henderson, John, Florence Under Siege: Surviving Plague in an Early Modern City, p. 277.

2 Numerous sources arrive at 1632 for this painting and while some others consider a later date. I find "Hylas and the Nymphs" less consistent with the work Furini produced in the last part of his career, after becoming a priest. The following source is referred to for the 1632 date: Bisceglia, Anna, *Ila And the Nymphs by Francesco Furini 1632c | Artworks | Uffizi Galleries*. www.uffizi.it/en/artworks/hylas-and-the-nymphs.

which was still under construction.³ Giovanni Bilivert was one of the renowned Florentine painters, but like most artists, his career was interrupted by the epidemic. This commission was to be his most important in more than a year and a half, since he painted "Apollo and Daphne" for Don Lorenzo de' Medici just before the plague struck Florence.⁴

The eventual resumption of conventional practices finally resulted in the publication of Galileo Galilei's *Dialogo*.⁵ Unfortunately for the polymath, his work had apparently not been well-received in Rome and soon after it was printed, the circulation of the book was terminated by the pope.⁶ Many years earlier, it was thought that Pope Urban VIII, then-Cardinal Maffeo Barberini, had actually recommended presenting this work as a hypothesis, to which Galileo appeared to have complied.⁷ However, the devil may have been found in the details of the *Dialogo*: Galileo used his "fictional" character named Simplicio (Simpleton) to make the argument of God's omnipotence, which Cardinal Barberini himself had presented to Galileo years earlier.⁸ Throughout the book, Simplicio's Aristotelian viewpoints had also been thoroughly discredited.

3 Pagliarulo, Giovanni, La Devozione della Famiglia Bonsi e le Commissioni per San Gaetano di Firenze, Sansoni, Firenze, 1982, for Rosselli's commission, see p. 34, for Vignali's commission, see pp. 20, 29 and for Bilivert's commission: Contini, Roberto, Bilivert: Saggio di ricostruzione, monograph, p. 117, quoted in Courtney Smotherman, Seminar in Sixteenth and Seventeenth Century Old Master Works on Paper pg. 19.
4 Borea, Evelina, Trofani, Annamaria Petrioli, Langedijk, Karla, Italia Soprintendenza ai beni artistici e storici per le province di Firenze e Pistoia, La Quadreria di Don Lorenzo de' Medici: Villa Medicea di Poggio a Caiano, Centro Di, Firenze, 1977, pp. 144, 146.
5 Allan-Olney, Mary, The Private Life of Galileo, by Galileo Galilei, Macmillan and Company, London, 1870, *R, Clay, Sons,* and *Taylor,* Printers *Bread Street* Hill, p. 205.
6 Ibid, p. 209
7 Ibid, p. 212
8 Ibid, Galilei, Galileo, et al., *Dialogo,*1632. Pdf. Retrieved from the Library of Congress, www.loc.gov/item/12018406/ and for how the pope may have felt betrayed and insulted by the character of Simplicio see Allan-Olney, Mary, The Private Life of Galileo, by Galileo Galilei, Macmillan and Company, London, 1870, *R, Clay, Sons,* and *Taylor,* Printers *Bread Street* Hill, p. 211 and 217-218.

Was this an intended insult of the pope or a misinterpretation? Either way, Galileo's latest troubles had only begun.

Francesco Furini "Hylas and the Nymphs," oil on canvas, ca. 1632. Uffizi Galleries, Florence, Italy.

Although it had been nearly fifty years since the great Venetian painter Paolo Veronese was summoned to Rome to explain his "Last Supper," for which he was ultimately ordered to change the title to "Feast in the House of Levi," there was likely an antecedent uneasiness within the artistic community long before the current escalation of Galileo's situation.[9] In addition to the potential concessions he may have already been obliged to make, Cesare Dandini was certainly familiar with the particular influence exerted by the Inquisition on artistic liberty. His last teacher, Domenico Passignano, was a good friend of Galileo's, and all three men were members of the *Accademia delle Arti del Disegno* (Academy of Drawing Arts), as per the original

9 Grasman, Edward. "On Closer Inspection - The Interrogation of Paolo Veronese." *Artibus et Historiae*, vol. 30, no. 59, 2009, pp. 125–34. *JSTOR*, http://www.jstor.org/stable/40343668.

academy mission which fostered the union of the liberal arts: fine art, philosophy, mathematics, and science.[10] Many years earlier, in 1611, Passignano painted what was probably the first representation of a moon containing craters, otherwise known as a Galilean moon, in the history of art.[11] The fresco entitled "Virgin of the Immaculate Conception with Saints and Angels" was completed by Passignano on the Baptistery ceiling of the Basilica of Santa Maria Maggiore one year after Galileo's *Sidereus Nuncius* ("Starry Messenger") was published in which his discovery of the moon's imperfect surface was presented.[12] The notion of a smooth moon sphere was not only consistent with Aristotelian philosophy, but it was often associated with the purity of the Virgin Mary.[13] The craters on Passignano's moon could have been construed as a challenge to both concepts, but his imperfectly painted moon may have also revealed Passignano's affinity for the astronomer's work and that he may have even looked through Galileo's telescopic lens. Sometime after the painting was completed, the craters were painted over and hidden, only to be revealed after a restoration of the work took place more than three centuries later.[14]

Curiously, the painter Ludovico Cigoli, a friend of both Galileo's and Passignano's, also painted the Virgin Mary standing atop a moon with craters in his own "Immaculate Conception" in the cupola of the Papal chapel of the same basilica, Santa Maria Maggiore, one year later, in 1612.[15] Cigoli's Galilean moon was never covered, and there is no evidence that this work was ever denounced. Cigoli's

10 Da Silva, Josie Agatha Parrilha, and Marcos Cesar Danhoni Neves. "DOMENICO CRESTI (PASSIGNANO) AND THE FIRST ARTISTIC REPRESENTATION OF THE GALILEAN TELESCOPIC MOON." *International Journal of Research -GRANTHAALAYAH*, vol. 6, no. 6, Granthaalayah Publications and Printers, June 2018, pp. 260–80. *Crossref*, https://doi.org/10.29121/granthaalayah.v6.i6.2018.1372.
11 Ibid
12 Ibid
13 Ibid
14 Ibid
15 Ostrow, Steven F., (1996). Cigoli's Immacolata and Galileo's Moon: Astronomy and the Virgin in Early Seicento Rome. *The Art Bulletin*, 78(2), 218–235. https://doi.org/10.2307/3046173 p. 230.

Galileo Galilei "Sketches of the Moon," engraving, ca. 1609-1610.

work on the *Immacolata* fresco was apparently approved by Cardinal Jacopo Serra, who was charged by Pope Paul V with overseeing the

project.[16] The artist's sudden death the following year, in 1613, may provide an explanation as to why he personally never had to answer for his creative decision, but surely his painting could have been altered posthumously had it been eventually deemed problematic. One probable contributing factor was that the details were simply difficult to see on the inside of the cupola base and from the distance of looking up from the basilica floor, especially without the benefit of a visual aid; perhaps a telescope would have helped. Those who did take note of Cigoli's lunar imperfections, apparently did not associate them with Galileo's research.[17] One seventeenth-century observer wrote that the "blemishes" of Cigoli's painted moon "signifies the failings and faults of corrupt nature; therefore, the victorious Virgin rightly crushes the moon beneath her feet."[18] A theologian named Andrea Vitelli published a volume on the Papal Chapel that described each painted image.[19] Regarding Cigoli's moon, he wrote that it contained the "defect of corruption" and, therefore, was placed below the Virgin.[20] Vitelli also associated the moon with "insanity of mind" and thought that it was symbolic of the serpent, an emblem of sin and evil, over which the Virgin triumphed.[21]

Domenico Passignano's cratered moon was never to be seen again. Conceivably, Passignano may have had second thoughts about his moon after its completion and painted over it to avoid becoming an Inquisition target. Or, it was hidden by others who believed the fresco to be problematic because it was more visually accessible than Cigoli's less conspicuous cupola work. Surely, *seicento* artists understood the obligation to pursue the creation of potentially career-defining work within the church's conservative scope. However, subjective interpretations and inconsistencies served as reminders that the gatekeepers of righteousness were of flesh and blood.

16 Ibid, p. 230, n. 60 (Ostrow, as in n. 1, chap. 3)
17 Ibid, pp. 230- 234.
18 Ibid p. 233, n. 85 (J. da Sylveira, Commentarii in Apocalypsim, Lyon, 1694, II, 2).
19 Ibid, n. 86 (Vittorelli, as in n. 14, 224-28. On Vittorelli and his text, see Ostrow, as in n. 1, chap. 4.).
20 Ibid
21 Ibid

Throughout the nearly two years of the plague, Cesare Dandini had never stopped working, and by 1632, some may have even recognized virtue in the life he was living. Through the lens of humanism, some Florentine scholars may have viewed Dandini's activities as a working artist fulfilling both public and private commissions as consistent with civic duty as well as the duty to the self, which was fundamental within classical human ethics.[22] The Christian concept of the *vita activa* (active life) was generally regarded as an honorable existence for those who worked in the service of God, but this clearly did not directly correspond with Dandini's situation. It is possible that some *seicento* theologians could have argued that the production of religious-themed artworks, prevalent subjects among many painters in the city, could perhaps fall within a broader interpretation of the term.[23] The Aristotelians may have perceived the painter as outwardly, and finally, pursuing *arête* (excellence) through his actions.[24] However, while Dandini certainly seemed to now have a sense of direction and appeared to be fulfilling his potential, the Aristotelians' comprehensive understanding of the breadth of excellence could have, in theory, prompted them to call the excellence of his character into question.[25] Aristotle explained that the best life and the ideal state of character consisted of a life without conflict

22 O'Donnell, J. Reginald, and Berthold L. Ullman. "The Humanism of Coluccio Salutati." *Phoenix*, vol. 19, no. 1, JSTOR, 1965, p. 90. *Crossref*, https://doi.org/10.2307/1086695 and Bonnell, Robert A. "An Early Humanistic View of the Active and Contemplative Life." *Italica*, vol. 43, no. 3, University of Illinois Press, Sept. 1966, p. 225. *Crossref*, https://doi.org/10.2307/477732.

23 Załuski, Wojciech. "On the Relations between Vita Contemplativa and Vita Activa." AVANT. The Journal of the Philosophical-Interdisciplinary Vanguard 10.1 (2019): pp. 20- 23, 2019, Academia.edu. Załuski presents the argument that the Vita Activa may have been reconsidered from and within a contextual Christian perspective: "Accordingly, Aristotle's argument 'from' the divine character of contemplation for the superiority of (Vita Contemplativa) over VA becomes less convincing within the Judeo-Christian tradition, which assumes that God not only contemplates, but also (or above all) performs ethical acts."

24 Urmson, J. O. "Aristotle on Excellence of Character." *New Blackfriars*, vol. 71, no. 834,1990, pp.33–37. *JSTOR*, http://www.jstor.org/stable/43248477. Accessed 25 Aug. 2023. p. 35.

25 Ibid, Urmson p. 33.

or friction, in which actions or even virtuous deeds are not forced.²⁶ In the case of Dandini, it is difficult to determine with certainty whether he was happy with his increased workload or merely felt obligated. Evidence of the former may be found by looking back at the years after he was cleared to return to the city and before the onset of the plague. Dandini demonstrated commendable productivity over that period and eventually achieved his best result in Ancona, but he had not displayed this kind of dedication or desire, or, as Aristotle would have referred to it, *epithumia*.²⁷ Years earlier, notions of virtue or excellence were unlikely to have been associated with Dandini. Those who viewed the painter from a greater distance when he was known to spend more time with his armed hunter companions than in his studio, may have dismissed him as being more of a *bravo* than an artist.²⁸ Regardless of what Dandini's detractors could have said in the past, and whether or not it was warranted, the change in the painter's lifestyle and the recent output from his studio could not have gone unnoticed. Although some friction may have remained, it appears there had been a moment of revelation.

Another commission for Don Lorenzo de' Medici was completed by Dandini: a portrait of the teenage musician of the Grand Ducal Court, Bartolomeo Landi.²⁹ Along with a primary version, he also painted a duplicate of the Landi portrait.³⁰ The Italian word for portrait is *ritratto,* but during Dandini's time, the highest quality copy of a primary work, regardless of the subject, was also referred to as *un ritratto*. The expanded use of the term during the *seicento* implies that nearly exact duplicates or copies had become highly desired and had

26 Ibid
27 Ibid
28 Regarding Baldinucci's description of Dandini's earlier years: Baldinucci, Filippo, Notizie, p. 132.
29 Bellesi, Sandro, Cesare Dandini pp. 70, 71, 74-76, n. (Arichivio di Stato Firenze, Guardaroba Medicea n. 628, c. 8 r.; cit. in E. Borea, 1977, p. 31). The subject of the painting "Ritratto di Giovinetto con Cuscino Rosso," was identified by Sandro Bellesi as probably being Bartolomeo Landi and this work was part of the collection of Don Lorenzo de' Medici.
30 Ibid pp. 70, 71, 74-76.

Cesare Dandini "Portrait of a Young Man with a Red Cushion (Portrait of Bartolomeo Landi)" oil on canvas, ca. 1632. Palazzo Pitti, Florence, Italy.

increased in value.[31] Rather than being considered lesser examples, these works were looked at as "portraits" of images, provided that they were

31 Holmes, Megan, The Miraculous Image in Renaissance Florence, Yale University Press, New Haven and London, 2013, p. 270, n. 44 (Allori, Alessandro, *I Ricordi*, ed. Igino B. Supino, Florence: Barbera, 1908, pp. 9 and 29).

executed by the master of the workshop.³² An apprentice also created a workshop copy of the Bartolomeo Landi portrait, which was available for purchase at a significantly lower price.³³ This manner of working—the production of multiple copies that could be looked at as the parts that comprised one whole project—would become quite customary in the Dandini studio for decades. More importantly, such an enterprising system partly counterbalanced the master's slower *velatura* (veiling) painting method by creating several works for sale at roughly the same time, all stemming from one established visual concept.

The plague's apparent exit from the city in 1632 may have afforded the opportunity for Cardinal Carlo de' Medici to approach Cesare Dandini about a painting for the *Casino Mediceo de San Marco* (Casino Medici).³⁴ Although records show that Dandini was eventually paid for the completed commission almost two years later,³⁵ the timing, subject matter and circumstances around two unfinished works of the same theme may indicate an earlier start on the project. As for the proposed venue, the Cardinal called the palatial residence home, but it was at Casino Medici, where the family had hosted distinguished visitors ever since construction was completed in 1574.³⁶ At this location, Dandini's work would be admired by connoisseurs inside and outside the Medici circle.

32 Ibid p. 270, n. 44 (Allori, pp. 9 and 29).

33 Sandro Bellesi describes some of the versions of the "Ritratto di Giovane con Giubotto Trinciato e Berretto 'a Tagliere," painting as workshop copies: Bellesi, Sandro, Cesare Dandini pp. 70, 71, 74-76.

34 Henderson, John, Florence Under Siege p. 277, n. 2 (Baldinucci, Giovanni, *Quaderno*, pp. 80-82)

35 For the year of completion for this work see: Archivio di Stato Firenze, Possessioni Medicee n. 4170, c. 171 s.; cited in Contini, Roberto, *Il Seicento fiorentino: Arte a Firenze da Fernando I a Cosimo III*, 1986, p. 300; si veda anche A.S.F, Mediceo n. 5279, ins. 107, c.n.n. con datazione al 24 luglio 1634, quoted in Bellesi, Sandro, p. 73.

36 For completed date of construction see Covoni, Pierfilippo, Il casino di San Marco costruito dal Buontalenti ai tempi Medicei, Tipografica Cooperativa, Firenze, 1892, p. 19.

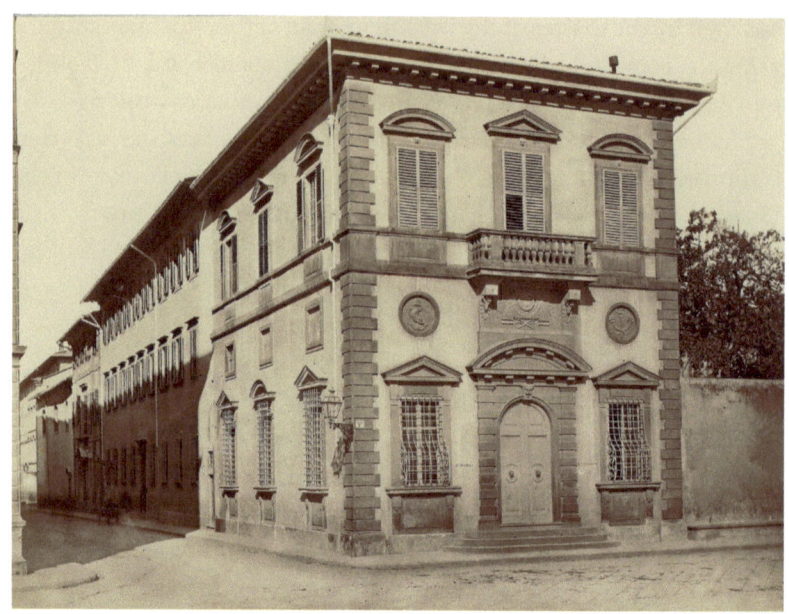

Giacomo Brogi, "Florence: Casino Mediceo (Via Cavour)", No. 3062, Albumen print mounted on cardboard, ca. 1870-1880, Städel Museum, Frankfurt am Main, Germany. This photograph from the nineteenth century depicts Casino Medici as it would have likely appeared in the seventeenth century.

For a Florentine artist with a sense of history, the site may have also been considered hallowed ground. Dandini likely first learned of its significance from his father. Prior to the restructuring and additional building that took place on the land, and long before the late-sixteenth-century architectural designs of Bernardo Buontalenti, it is believed that the site bordered, if not included, the property of Lorenzo de' Medici's legendary academy for young artists, the *Accademia degli Orti Medicei*.[37] There, in the sculpture garden at San Marco, it was believed that the most promising young artists of the city studied the work of the ancients from the Medici collection and compared their own creative ideas under the vigilant eye of *Lorenzo il Magnifico*. The premise of Eden, described

37 Elam, Caroline. "Lorenzo de' Medici's Sculpture Garden." *Mitteilungen Des Kunsthistorischen Institutes in Florenz*, vol. 36, no. 1/2, 1992, pp. 41–84. *JSTOR*, http://www.jstor.org/stable/27653323. P. 61.

Johannes Stradanus (design), unknown weaver "Lorenzo de' Medici in the Sculpture Garden," tapestry, ca. 1600. Museo Nazionale di Pisa, Pisa, Italy.

by Ezekiel as "the garden of God," was accompanied by ancient Italic traditions linking gardens with the divine.[38] Such associations were subsequently adopted by some of the prestigious *orti* of Renaissance Italy; a flourishing, fertile garden during the fifteenth and sixteenth centuries could have been perceived as being analogous to the attributes of deities such as Ceres, Tellus, and especially Venus.[39] One of Sandro Botticelli's masterpieces, "*La Primavera* (The Spring)" ca. 1482, which was thought to be a grand adornment for a Medici family wedding,

38 Ezekiel 28:13, https://www.kingjamesbibleonline.org/Ezekiel-28-13/ and Farrar, Linda. "Roman Gardens." *Gardens and Gardeners of the Ancient World: History, Myth and Archaeology*, Oxbow Books, 2016, pp. 138–84. *JSTOR*, https://doi.org/10.2307/j.ctv13gvgxf.13. pp. 139, 140.

39 Ibid, Farrar, Linda, "Roman Gardens," p. 139, 140.

depicted Venus in a Garden of Hesperides-like setting.[40] However, instead of an orchard that grew golden apples, Botticelli's setting was an orange grove; the *mala medica*, an orange that grew in Tuscany, and due to the play on the Medici name, oranges had become a symbol of the family.[41] The fertile terrain of the *Accademia degli Orti Medicei* was acclaimed for cultivating artists, beyond the significance of fruit-bearing trees and brambles. The romantic notion of young artists learning, developing, and creating lifelike works in Lorenzo's garden academy grew and assumed an almost mythical quality over the years, undoubtedly by the time a new generation of adolescent Florentine artists-in-training began their formal education during the early *seicento*.

The subject of Dandini's forthcoming Medici commission was an allegory of Christian charity, a direct reference to the Florentine value that proved essential for the city throughout the plague. Early Christian theologians engaged in the interpretation of scripture with the intention of highlighting the fundamental role of charity among the theological virtues, while also emphasizing its significance in relation to salvation.[42] Within the First Epistle to the Corinthians, the apostle Paul delineated the virtues as "faith, hope, and charity; these three; but the greatest of these is charity."[43]

Throughout the history of Florentine art, allegories of charity were as interpretive and adaptable as any other, as evidenced by past examples. Piero del Pollaiolo's painting from 1469–1470 for the audience chamber of the *Tribunale di Mercanzia* in Piazza della Signoria presented a regal maternal figure with a nursing male child on her lap analogous to both the *Sedes Sapientiae* (Seat of Wisdom) motif and the

40 Tacconi, Marica S., Cathedral and Civic Ritual in Late Medieval and Renaissance Florence: The Service Books of Santa Maria del Fiore, Cambridge University Press, 2006, p. 187.

41 Ibid

42 Bailey, Meryl. "Charity as Act and Allegory in Venetian Art." *Studies in Iconography*, vol. 40, 2019, pp. 234. *JSTOR*, https://www.jstor.org/stable/27099506.

43 Ibid, p. 234, n.11 (1 Corinthians 13:13).

Madonna Lactans (Nursing Madonna) theme.[44] The phrase "Seat of Wisdom" is attributed to Saint Augustine and it was used to describe the Virgin Mary, a phrase that inspired countless paintings and sculptures beginning in the Middle Ages that depicted the Christ Child seated on the lap of his mother, who served as his throne and earliest source of knowledge. Andrea del Sarto painted a "Charity" work sometime shortly before his death in 1530 and presented four allegorical figures of charity in a more relatable rustic domestic setting.[45] The artist successfully reproduced the same overall composition, including two identical figures, in order to create a painting depicting the "Holy Family." In 1603, the influential illustrated version of Cesare Ripa's book *Iconologia* described *Carita* (Charity) as "a woman dressed in red, who has a burning flame on the top of her head, will hold in her left arm a child, to whom she will give milk and two others will be joking at her feet, one of them will hold said figure embraced her right hand."[46] Ripa's publication, which also included woodcut images, was thought to be based on his own research of ancient icons and symbolism and it provided many visual artists with a conceptual starting point for depicting their own interpretations of the Christian Virtues.

One somewhat infamous adaptation of the theme was created some years prior to the plague by the painter Giovanni da San Giovanni; the results shocked the monastic order who commissioned him to execute a painted "Allegory of Christian Charity."[47] When the patrons unwrapped what they thought was the completed work they had paid for, they discovered a depiction of two donkeys: an attempt to either deride the monastery, irrelevantly satirize the "greatest" of Christian virtues, or both.[48]

44 *Charity* by Piero Del Pollaiolo | Artworks | Uffizi Galleries. www.uffizi.it/en/artworks/charity-piero-pollaiolo. Gallerie degli Uffizi website, Charity Piero del Pollaiolo or Pollaiuolo (Florence 1441 - Rome 1496).
45 *Charity* by Andrea Del Sarto | *Artworks* | *National Gallery.* www.nga.gov/collection/art-object-page.43724.html.
46 Ripa, Cesare, Iconologia (Moral Emblems), Benj. Motte, London, 1709, p. 12.
47 Cochrane, Eric, Florence in the Forgotten Centuries, p. 207.
48 Ibid

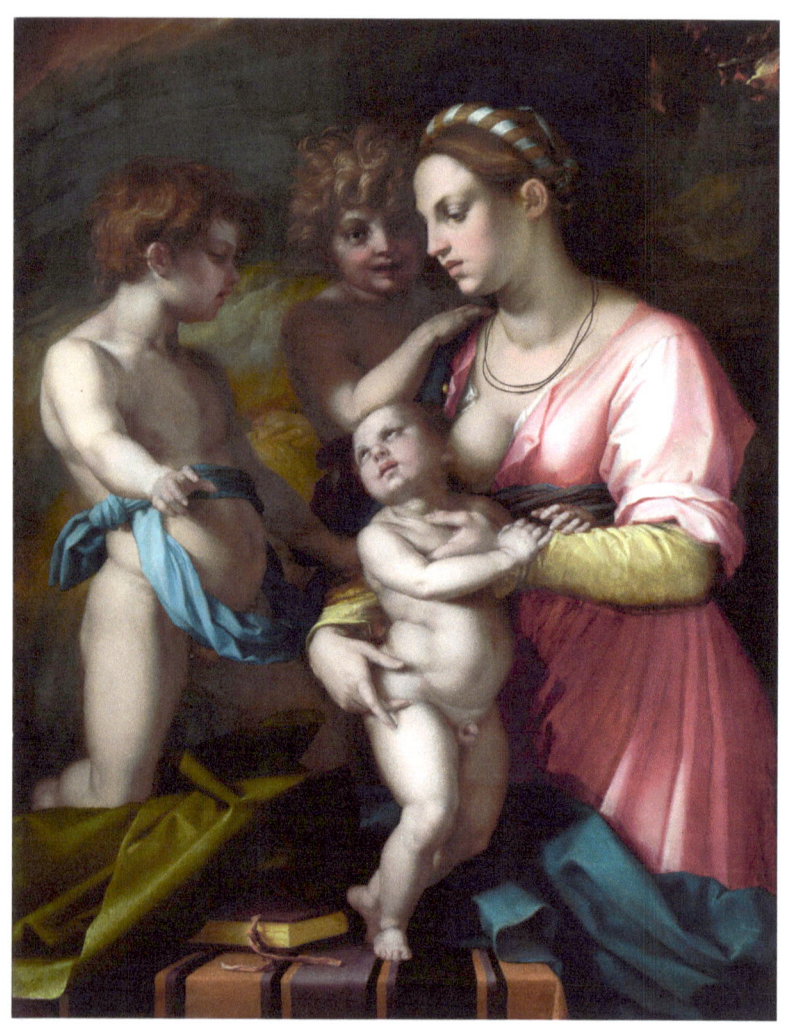

Andrea del Sarto, "Charity," oil on wood, ca. 1528-1530, National Gallery of Art, Washington, DC, United States.

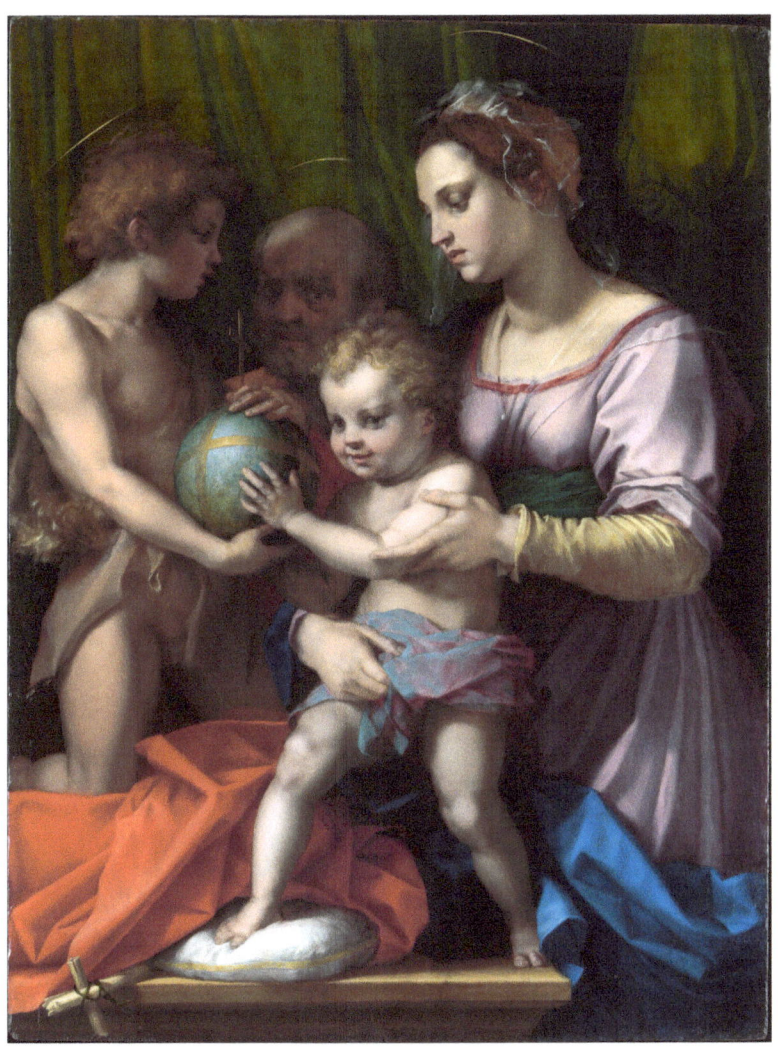

Andrea del Sarto, "Holy Family with the Young Saint John the Baptist," oil on wood, ca. 1528, Metropolitan Museum of Art, New York, United States.

Cesare Ripa, "Carita (Charity)" from "Iconologia (Moral Emblems)," engraving, 1630, Metropolitan Museum of Art, New York, United States.

By September of 1632, the first new cases of plague were detected in the Borgo San Frediano district, causing an abrupt disruption to Florence's gradual restoration of normal conditions.[49] The main street led directly to the Porta San Frediano, the wall exit and entry to and from Monticelli.[50] Whether or not this setback was the result of one citizen who purportedly visited a shrine of the Madonna in the still-afflicted area and then reentered the city walls,[51] for many, there were evidently still some smoldering embers of God's anger. The revelation that the plague had returned to Florence "created great

49 Henderson, John, Florence Under Siege, p. 278.
50 Ibid
51 Ibid

alarm" according to Giovanni Baldinucci.[52] This unfortunate reality was compounded the following month with disheartening but mostly expected news from Rome: Galileo had been summoned to appear before the Inquisition.[53]

The general atmosphere in Florence must have undergone a swift and notable deterioration. However, if the Casino Medici project was initiated before the unexpected return of the plague, some requisite particulars would have been established from the earliest interactions between Cardinal Carlo de' Medici and Cesare Dandini. Those particulars may not have encompassed any additional elements apart from the following information: a depiction on canvas of a charity figure with three putti, with an understanding that the painting would hang high, if not directly, on one of the remaining empty ceiling spaces in Casino Medici, requiring the use of "di sotto in su" perspective. Interestingly, two charity-themed paintings that met those exact conditions were left unfinished in Dandini's studio, only to be completed and sold by his younger brother Vincenzo after Cesare's death many years later. One of these paintings was identified centuries later, and it is suggested here that the other work that was finished by Vincenzo Dandini may be a fairly well-known work that, as of this writing, still bears an attribution to Cesare Dandini as the sole artist.[54]

The reasons why Cesare Dandini chose not to complete the two "Charity" paintings have remained unknown, but a possible explanation may lie within the context of the years 1632-1633. To begin with,

52 Henderson, John, Florence Under Siege, p. 277, n. 2 (Baldinucci, Giovanni, *Quaderno*, pp. 80-82).

53 Allan-Olney, Mary, The Private Life of Galileo, by Galileo Galilei, Macmillan and Company, London, 1870, R, Clay, Sons, and Taylor, Printers Bread Street Hill, p. 220.

54 The first identification of one of the two "unfinished" works was suggested by Mina Gregori and for this, see: Spike, John T., Italian Baroque Paintings from New York Private Collections, The Art Museum, Princeton University in association with Princeton University Press, New Jersey, 1980, p. 50, n. 2 (Gregori, Mina p. 46). Based on the relationship and inconsistencies with the other "connected" paintings concerning the depiction of hands, overall tonality, and color palette, I propose that the "Charity" painting presently in the collection of the Metropolitan Museum of Art in New York City be considered as the other work that was finished by Vincenzo Dandini.

Dandini was not known for abandoning works in progress, nor was he known for failing to fulfill professional obligations. The same painter who tried to extract as much as possible from his visual concepts would likely have found such a waste of materials and poor business practice unacceptable; surely, circumstances must have changed. The same duplication process that was becoming standard in Dandini's studio had already begun as evidenced on both of the canvases, explaining why two paintings and not just one were left unfinished—it appears that the concept would have either worked for both or not at all—obviously alluding to a reassessment that occurred while the paintings were in progress. If Dandini had started the two paintings in 1632, the plague's revival would have been a reason to pause the project. Beyond a delay, however, thoughts about the work had apparently shifted so drastically that the already-initiated construct had become no longer applicable and, apparently, unsalvageable to the painter. Clearly, this was not due to his dissatisfaction with the painted figures; Dandini greatly valued his maternal charity figure, as evidenced in his "Saint Agnes," "Allegory of Astronomy," and two "Holy Family" paintings. The nursing child appearing in one of the "Charity" paintings was also reused as the infant Christ in his "Holy Family" paintings. While duplicating work had become more popular during Dandini's time and his workshop may have been at the front of this trend in Florence,[55] the repurposing of figures for inclusion in other paintings could be traced back to the *quattrocento*, most famously to Pietro Perugino. In this case, though, a fairly more recent historical source of inspiration (more recent by a century) may have once again been Andrea del Sarto and his aforementioned "Charity" and "Holy Family" paintings.

Without historical documentation or mentions, it is difficult to say with certainty which technique Dandini and his workshop consistently used to replicate figures or portions of compositions. The *spolvero* method—pouncing charcoal dust through the small pricked holes of a *cartone* (cartoon) to form charcoal outlines of shapes on a desired painting surface—was a well-known option, but multiple reuses could, in theory, have proved too demanding for a paper cartoon. There were

55 Holmes, Megan, The Miraculous Image in Renaissance Florence, p. 270, n. 44 (Allori, *I Ricordi*, ed. Igino B. Supino, 1908, pp. 9 and 29).

various ways of transferring imagery, and the Dandini workshop may have utilized any one depending on the subject and scale. One of the techniques Dandini employed was transferring or tracing from finished paintings, or at the very least, from completed sections, a method that had become a widespread means of making copies during the *seicento*.[56] An outline of the subject intended to be transferred may have been applied in one of the following ways: Dandini or an assistant may have placed a very thin cloth or a sheet of paper made nearly transparent through an oiling procedure against an already painted face so that a red or black chalk tracing could be made.[57] On the reverse side of the cloth or paper, a somewhat cool temperature red oil paint, perhaps of the lake variety, would have been used to outline the image, which would then be transferred directly onto the new painting surface.[58] Alternatively, a cloth or sheet of paper with slits could have acted as a stencil, allowing for the nearly perfect placement of cool-red lines of the desired shape.[59]

56 Bauer, Linda, "Van Dyck, Replicas and Tracing," Flemish and Dutch Art, Burlington Magazine Publications Ltd., Feb. 2007, The Burlington Magazine, pp 99, n. 4 (L.F. Bauer: 'A letter by Barocci and the tracing of finished pictures', the Burling ton magazine 128 (1986), pp.355-57; idem with S. Colton: 'Tracing in some works by Caravaggio', ibid. 142 (2000), pp.434-36, with earlier bibliography; and most recently M. Falomir: 'Titian's replicas and variants', in D. Jaffe et al, eds.: exh. cat. Titian, London (National Gallery) 2003, pp.60-68) and Bailey, Blair, ArtCare Conservation report, 2023.

57 Ibid, Bauer, Linda, p. 100, n. 6 (For Symonds's notes on his conversation with Leemput, see M. Beal: A study of Richard Symonds: His Italian notebooks and their relevance to seventeenth-century painting techniques, New York and London 1984, pp.295 and M.K. Talley, Portrait Painting in England: Studies in the Technical Literature Before 1700, London, 1981, p. 193.) and H.V.S. Ogden and M. Ogden: 'A bibliography of seventeenth-century writings on the pictorial arts in English', Art Bulletin 29 (1947), pp. 198-201; and for an important discussion of some of them, including Bate and Salmon, in relation to portrait practice, see Talley, op. cit. n. 6).

58 Ibid Bauer, Linda and Bailey, Blair, ArtCare Conservation report, 2023. It was determined that Dandini transferred images in one of these ways based on the report from Blair Bailey of Art Care, research by Thomas Ruggio and discussions between Bailey and Ruggio. Regardless of whether Dandini employed a stenciling technique, or a kind of transfer method, the painter certainly transferred images in one of these or a similar manner.

59 Ibid, Bailey, Blair, 2023.

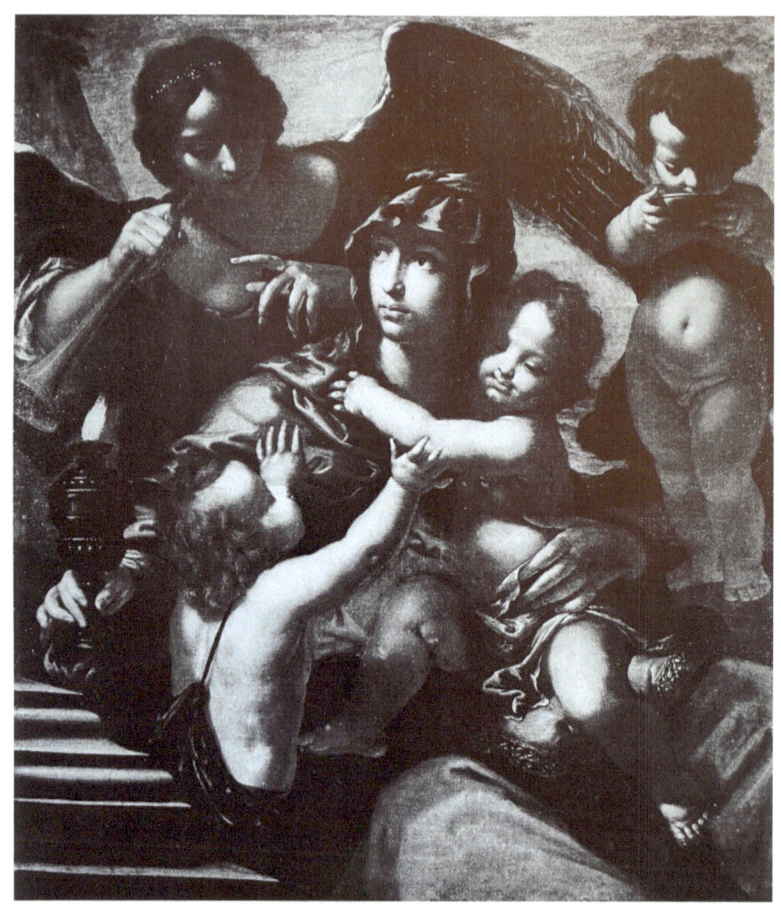

Cesare Dandini, "Charity" oil on canvas, 1632 (?) and after 1658 (?), former Ganz family collection.

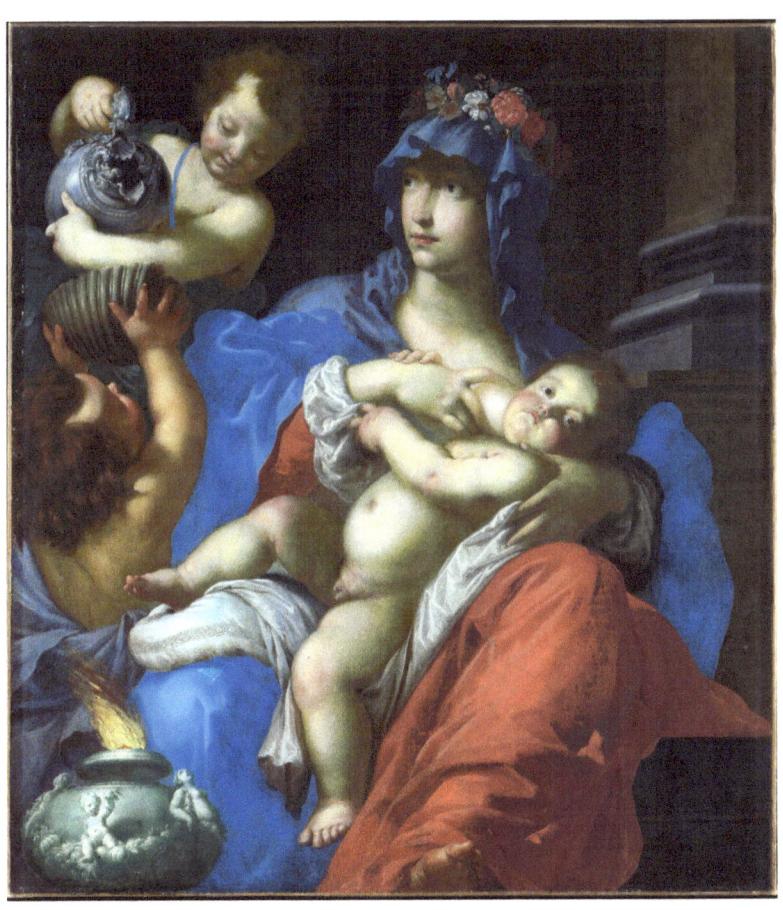

Cesare Dandini, "Charity" oil on canvas, 1632 (?) and after 1658 (?), Metropolitan Museum of Art, New York, United States

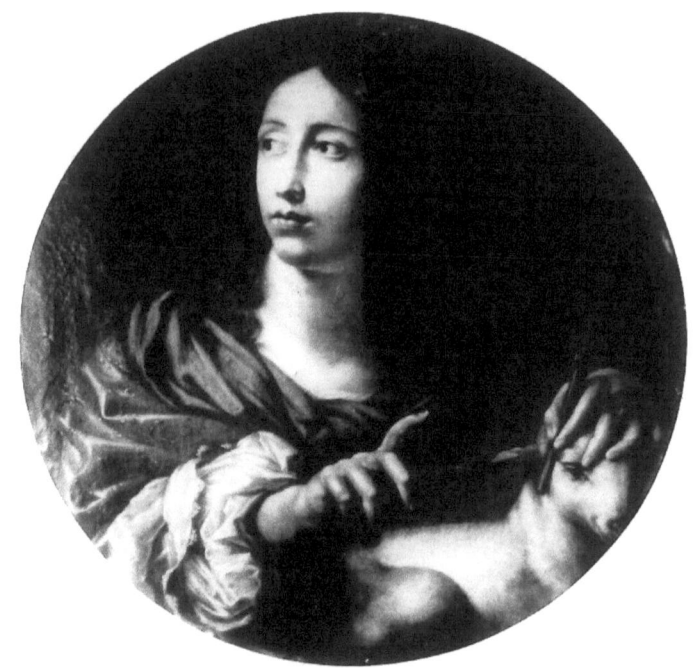

Cesare Dandini "Saint Agnes" oil on canvas, 1632-1634 (?), Palazzo Arcivescovile di Siena, Cappella di San Biagio, Siena, Italy.

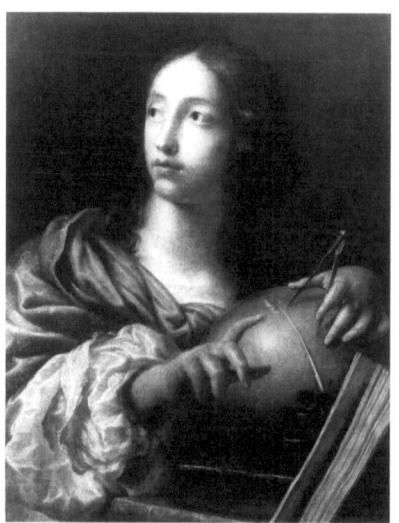

Cesare Dandini "Allegory of Astronomy" oil on canvas, 1632-1634 (?), former collection of Stiozzi Ridolfi, current location is unknown.

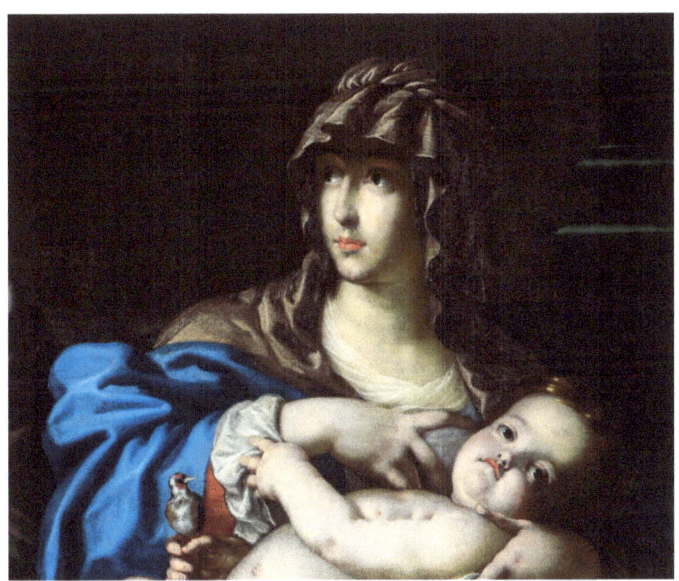

Cesare Dandini "Holy Family with the Infant Saint John (detail)" oil on canvas, 1632-1634 (?), Church of the Holy Family, New Rochelle, NY, United States.

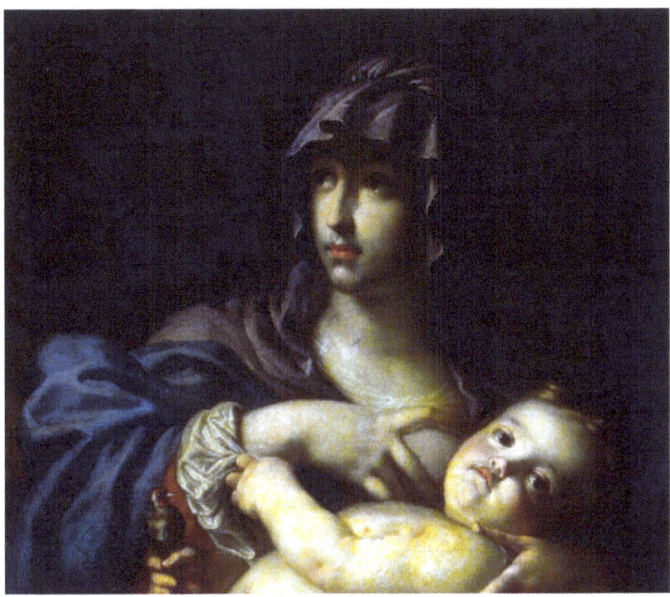

Cesare Dandini "Holy Family (detail)" oil on canvas, 1632-1634 (?), State Hermitage Museum, Saint Petersburg, Russia.

Sandro Botticelli "Birth of Venus (detail)," tempera on canvas, ca. 1485. Uffizi Galleries, Florence, Italy.

Sandro Botticelli "La Primavera (detail)," tempera on poplar wood, ca. 1480. Uffizi Galleries, Florence, Italy.

Sandro Botticelli "Idealized Portrait of a Woman (Portrait of Simonetta Vespucci as Nymph)," tempera on poplar wood, ca. 1480-1485. Städel Museum, Frankfurt am Main, Germany.

Was the female figure's face, which the artist arguably returned to more than any other, more than merely one of several types Dandini chose from? There is no evidence that the features of this female figure represented or even resembled someone Dandini knew or cared for, and to suggest this would be pure speculation. Baldinucci wrote that Dandini "rarely, if ever," took part in relationships, ultimately choosing the more dutiful life of a painter.[60] Of course, being in a committed relationship, such as matrimony, did not preclude an individual from pursuing artistic endeavors during the *seicento*. Dandini's younger brother Vincenzo was married at a young age and subsequently enjoyed a successful career as a painter.[61] As a biographer, Baldinucci certainly romanticized his subjects and may have attempted to polish Dandini's image for posterity. Failing to mention the self-portraits as saints surely helped to keep this notion buried for centuries, even though he tantalized with physical descriptions of the painter. Baldinucci might have also intentionally omitted a distressing episode that occurred later between Dandini and another Florentine artist (explained in the final chapter). Unlike Giorgio Vasari, who seemed to relish sharing scandalous hearsay, Dandini's biographer may have deemed it unimportant, if not inappropriate, to mention the less meaningful relationships the painter may have taken part in throughout the years. Perhaps idealizing where he could, Baldinucci's implication of an almost monastic existence for Dandini aligned with the concept of *deus atrifex*, presenting his life as an artist as a kind of holy vocation. Famously, though, a pining artist could also be an inspired one: It is believed that the beautiful Simonetta Vespucci remained the muse of Sandro Botticelli years after her early death and that the fifteenth-century Florentine painter obsessively applied her ideal features to several of his female protagonists, including his depictions of Venus. Whether the female face that Dandini so frequently used was entirely the product of *invenzione* or it possessed a specific meaning beyond its utility as a studio resource, those features undeniably held significant value to him.

60 On Dandini relationships see Baldinucci, Filippo, p. 129.

61 Information regarding Vincenzo Dandini's marriage found in Bellesi, Sandro, Vincenzo Dandini e la pittura a Firenze alla metà del Seicento, Felici, Pisa, 2003, p. 14, n. 11 (Giovanni Tragioni Tozzetti, XVIII sec. a, c. 3, in S. Bellesi, 1988a, p. 99).

Based on subject matter, style (although this is less applicable to the "Charity" paintings due to the possibility of Vincenzo Dandini's finishing hand), process, and the presence of one of the painter's favorite models for a number of years, the bearded, balding older man, it is reasonable to consider that this group of connected paintings by Dandini was created during or not long after his prolific plague period output, possibly as late as the middle 1630s.

Regardless of whether or not the Casino Medici project had been started at this point, any thoughts of recognizing another historic Medici achievement would have been proven premature. Apparently it was not aired widely, but Dandini must have heard the news that Ferdinando II had been infected with the plague.[62] According to an anonymous manuscript written during this time, there was a recipe that promoted healing, and it contained bread cooked in a "wineless meat broth."[63] Desperately, the young Grand Duke was administered the remedy with bread from the grave of Sister Domenica for added spiritual potency.[64] Although Ferdinando II appears to have recovered quickly,[65] the contagion had even reached the Medici; clearly, the struggle was not over yet.

By 1633, authorities feared and prepared for the worst; strict protocols were once again enacted, causing most Florentine businesses to stop operating for four months.[66] All activities and work throughout the city that weren't considered necessary were impacted by protocols, including art commissions. The three-artist effort of Matteo Rosselli, Jacopo Vignali and Giovanni Bilivert at the Church of San Michele e Gaetano was left unfinished. Bilivert wouldn't complete his commission for at least another three years.[67]

62 Calvi, Giulia, Histories of a Plague Year: The Social and Imaginary in Baroque Florence p. 18, n. 38 (Magliabecchiano, cl. XV, cod. xv, Antidotario di medicamenti di piu autori," 1632.

63 Ibid

64 Ibid

65 Ibid

66 Cochrane, Eric, Florence in the Forgotten Centuries, p. 198

67 Contini, Roberto, Bilivert: Saggio di ricostruzione, Sansoni, Firenze, Lucca, p. 117, 1985.

This time, even the *Mercato Vecchio* was shut down.[68] Citizens had to make their purchases throughout multiple *piazze* to prevent the congested assemblage in a single space that had promoted gathering since its original function as an ancient Roman forum.[69] The fourteenth-century Florentine poet Antonio Pucci wrote of the famed marketplace, painting a vivid picture.[70] He described it as a location where all classes converged; there, the most privileged Florentines would experience a variety of characters that included merchants, con artists, beggars, prostitutes, and pimps, all of whom became "embroiled in noisy scuffles."[71] But somehow, it was also a place of "beauty" that "filled (Pucci) with the desire to sing."[72] Surely, such a theater of life must have become even more boisterous and colorful by the *seicento*. Now, though, it was silent and empty. Marking the location of the *Mercato Vecchio* was the *Colonna dell'Abbondanza*, a free-standing column from the ancient period. The great Early Renaissance sculptor Donatello completed a sandstone *Allegoria della Dovizia* (Allegory of Abundance) for the top of the column during the *quattrocento* to promote plentitude and financial success. Donatello's abandoned *Dovizia* must have appeared to be a most ironic allegorical figure or worse, an impotent talisman—Florence was as far from abundant or prosperous as it had been in centuries.

The Grand Duke was now fully engaged in three separate conflicts that, when combined, could have seemed like a battle for the mind, body and soul of Florence. First in severity was another round against an invisible enemy many thought was sent from the heavens. The second was endeavoring to deal with the financial consequences caused by the original quandary. Among other things, this called for more funding for the poor, subsidies and food for the quarantined, and salaries for

68 Henderson, John, Florence Under Siege, p. 280.
69 Ibid
70 Antonio Pucci's poem, *Proprietà di Mercato Vecchio*, in *Rimatori del Trecento*, ed. Corsi, Giuseppe, (Turin, 1969), p. 874, translated and quoted in Atkinson, Niall, The Republic of Sound: Listening to Florence at the Threshold of the Renaissance, I Tatti Studies in the Italian Renaissance, Volume 16, Number 1/2 Fall 2013, University of Chicago Press, pp. 57- 84.
71 Ibid
72 Ibid

administration and workers needed to uphold protocols and run the *lazaretti*.⁷³ The third engagement was diplomatic in nature and had been taking place through the Tuscan ambassador with the pope in order to keep Galileo Galilei in the city and avoid prosecution.⁷⁴ Giordano Bruno was found guilty of heresy as a result of his eight-year Inquisition trial in Rome.⁷⁵ Bruno held steadfast beliefs in an "infinite universe" and the Copernican heliocentric theory, which he tried to spread throughout Europe, and following the censure of his books, he was publicly gagged and burned alive in Rome's Campo de'Fiori in the year 1600. Because of this historical precedent, Galileo and Ferdinando II were both aware that the cost for an unwavering perspective that clashed with Roman Catholic ideology could be frighteningly savage. Despite the Grand Duke's efforts, one of his three conflicts was ultimately lost: it was determined that Galileo would stand before the Inquisition Tribunal in Rome.⁷⁶ .

Galileo's printed *Dialogo* was considered the principal evidence in the case against him, and it was Cesare Dandini's former student Stefano della Bella who produced the engraved artwork for the publication. A very intriguing frontispiece presented Copernicus with the likeness of Galileo rather than the typical features used to depict the Polish Renaissance astronomer. Whether this depiction reflected a symbolic request from Galileo or the artist's imaginative notion, the final approval for the entire design would have likely been made by Galileo after viewing the rendered *schizzi*. Della Bella's time at the Dandini workshop undoubtedly played a role in shaping his renowned drawing prowess and talent for *invenzione*; consequently,

73 Henderson, John, Florence Under Siege, p. 283.

74 Mayer, Thomas, The Roman Inquisition on the Stage of Italy C. 1590- 1640, University of Pennsylvania Press, Philadelphia, 2014 (1951 1st Edition), p. 213 and from n. 164 Bolognetti- F. Barberini, 28 July 1632. Barberini Archivio Vaticano (BAV), Barb. Lat. 7306, fo. 6r-v.

75 Mayer, Thomas, The Roman Inquisition on the Stage of Italy C. 1590- 1640, University of Pennsylvania Press, Philadelphia, 2014 (1951 1st Edition), p. 5.

76 Archivum Congregationis Doctrinae Fidei Sanctum Officium Decreta Sancti Officii, 1632, fo. 149r. 30, Quoted in Mayer, Thomas, The Roman Inquisition on the Stage of Italy C. 1590- 1640, University of Pennsylvania Press, Philadelphia, 2014 (1951 1st Edition), p. 214.

Stefano della Bella, Frontispiece of Galileo's Dialogue, Engraving, 1631-1632. Metropolitan Museum of Art, New York, United States.

he swiftly gained recognition as one of the leading printmakers in Florence. At the outset, the commission for Galileo's *Dialogo* likely appeared to be an exceptional opportunity for him, but the young

artist must have been concerned upon learning of the book's censure. However, a prior commission involving the pope just may have proved to be a saving grace: nearly two years earlier, della Bella was chosen to create engravings for the book that documented and showcased the celebrations held in Florence for Pope Urban VIII's canonization of Saint Andrea Corsini, and the book had finally been published in 1632.[77] The outstanding work della Bella provided for a cause of such significance to the pontiff, which was now available to the public, may have spared the young artist any complications of his own regarding the *Dialogo* frontispiece.

During this period, perhaps Dandini was afforded some moments to contemplate the broader implications of Galileo's situation and Florence in general. Like the polymath, he enjoyed the formidable support of the Medici, but Galileo's conflict with Rome was testing the strength of Florence's most powerful family, which had already showed some signs of waning in recent years.[78] Before the plague arrived, the city

77 Buommattei, Benedetto, *Descrizione delle feste fatte in Firenze per la canonizzazione di S. Andrea Corsini*, In Fiorenza : Nella stamperia di Zanobi Pignoni, 1632, pp. 4- 104, Getty Research Institute, (Internet Archive).

78 During this time, the greater Tuscan economy was largely driven by wool exportation and the textile industry. Since the late sixteenth century, this industry experienced a pronounced contraction, mostly due to competition from other Italian regions and other parts of Europe such as Spain, England and the Netherlands. A weaker regional economy was disadvantageous both domestically and abroad and in theory may have led to compromises such or lesser financial independence. For more details, see: Cipolla, Carlo M. "The Decline of Italy: The Case of a Fully Matured Economy." *The Economic History Review*, vol. 5, no. 2, 1952, pp. 178–87. *JSTOR*, https://doi.org/10.2307/2591055.

Grain production also suffered due to unusually "cold and wet winters" during the years 1619- 1621 referred to by Eric Cochrane as "the most disastrous crop failure ever recorded in the history and memory of past times." Also stated by Eric Cochrane: this resulted in such a pronounced increase in grain prices that "no one could plan more than a month ahead." See Cocrane, Eric, Florence in the Forgotten Centuries 1527- 1800 pp. 195- 196. Some signs of lessened Medici strength are mentioned in Cocrane, Eric, Florence in the Forgotten Centuries 1527- 1800, p. 199: "(Grand Duke Ferdinando II) had lost enough "face" in 1631, after all, by quietly letting the pope grab Urbino and not pressing claims to it." This is a reference to Pope Urban's annexation of Urbino. Ferdinando II's betrothed was Vittoria della Rovere, daughter of Federico Ubaldo, the Duke of Urbino. Their union was arranged in advance

appeared to be brimming with artists and *cognoscenti*, but it was only an exceptional few, the most intellectually and creatively courageous spirits, who dared to venture past the accepted norms that kept *seicento* Florence connected to its legendary past. More profound than the potential silencing of a single genius like Galileo, the poor economic state of the region, and even the epidemic, which the church presented as a divine response to the failings of the Florentines, was the slow, steady decline of a once unparalleled culture. From the intellectual and artistic perspective, Florence remained a more than viable location, but the city had not been the "New Athens" for centuries, and the architecture and artwork were tangible reminders of its former glory. Dandini's years of training, rooted in centuries of tradition, suggest that he was aware of the history. Arguably, the first nearly fatal blow to the *rinascita* (rebirth) occurred in the late *quattrocento* when Savonarola's comprehensive changes to life in Florence included a cleansing of vice, demonizing of paganism and even the destruction of certain artistic masterworks. Impeding the pursuit of knowledge and truth by a psychological weaponizing of religious faith, the friar who ruled Florence taunted humanist scholars, "Plato, Aristotle, and the other philosophers are fast in hell."[79] In more recent years, the Roman Inquisition and the interpretation of Counter-Reformation reforms undoubtedly contributed to this decline, of which there were indications beyond Florence, such as the need to conceal an illuminating portion of a painting or the decision not to look through a telescope. And there was the plague. If the history and the current state of affairs weighed heavily on Dandini, there was certainly no adverse effect on the quantity or quality of his work. Contrarily, a great painter was emerging from this crucible. The Roman philosopher Lucius Annaeus Seneca had once written, "Difficulties strengthen the mind as labor

by Christina of Lorraine for the sake of Medici power consolidation. However, by annexing Urbino, the pope not only added papal territory, thus increasing his own influence (and independence) with a cost of less autonomy for other territories, Urbino could no longer be seen as a true prospective extension of Medici authority and this was understood for years before the marriage even took place.

79 Horsburgh, Edward Lee Stuart, *Girolamo Savonarola*, Methuen, London, p. 287, 1911 (Internet Archive).

does the body," and with the possible exception of some labored breathing, Cesare Dandini appeared to embody this venerable ancient Italian notion. And as he had demonstrated with his "Assumption" painting, his spirit was as courageous as it was persistent.

In June of 1633, Galileo was found guilty and declared "vehemently suspected of heresy" with a sentence of life in prison.[80] Apparently the polymath had wavered though: facing torture, he recanted his belief in the heliocentric theory. Although the Medici, Sanità, and church officials were occupied with crisis management and the trial had already concluded, the Grand Duke and the Tuscan ambassador, Francesco Niccolini, appealed to the pope in the hopes of sparing Galileo the harshest incarcerative conditions.[81]

Four weeks of processions were organized as a full-scale spiritual offensive with the aim of impeding, if not eradicating, the plague.[82] The cycle began in the month of April with the carrying of the head of Saint Zenobius and concluded with the Madonna of Impruneta's return to the city, which took place during May over the course of three days.[83] Although the sacred transports varied from relics to a divine work of art, the sights, sounds and smells were nearly the same with each procession; church bells rang out and "fragrant herbs" were burned in attempts to combat the deadly *miasma*.[84] As was the case two years earlier, all residents were able to experience these holy spectacles from either an open window or doorway; some even

80 Allan-Olney, Mary, The Private Life of Galileo, by Galileo Galilei, Macmillan and Company, London, 1870, *R, Clay, Sons,* and *Taylor,* Printers *Bread Street* Hill, p. 258.

81 Ibid, Allan-Olney, Mary, The Private Life of Galileo, pp. 239, 240, 261, 262.

82 Henderson, John, Florence Under Siege, pp. 280, 281, n. 14 (Rondinelli, F., *Relazione*, p. 202).

83 Ibid

84 Cipolla, Carlo M., Faith, Reason and the Plague in Seventeenth-Century Tuscany, Translated by Muriel Kittel, W.W. Norton & Company, New York, London, 1979. The author used the term "fragrant herbs."

watched on street corners.[85] Cesare Dandini surely could have taken some of these opportunities to breathe the air outside of his studio; he was probably, at the very least, tepidly faithful and curious about the processions. Although the burning ingredients, such as juniper, rosemary, or bay leaves, and some of the perfumes used by residents from their doorways could have caused a bronchial response even from a distance, minor reactions such as a cough or recurrent throat clearing probably would not have deterred him from watching. The most hopeful of onlookers may have even been motivated to stay after the event ended to witness an inspiring outcome that was either an assurance from the heavens or merely an interpretation based on their own beliefs. Once the cheerless pageantry ended, after the sonorous pitch from the bells had long faded and the last of the ritual walkers were out of sight, the empty streets were scrubbed to remove potential traces of contagion. Following the street cleanings, and while the sweet aroma of the burnt herbs and perfumes still lingered, for a brief moment and from some vantage points, the beleaguered city may have appeared immaculate.

From the most devout perspective, the procession of the Madonna of Impruneta appeared to deliver a decisive blow to *la peste;* within ten days, the *lazeretti* reported that fewer were dying, and twelve days after that, 184 convalescents had been cured and returned home.[86] The most encouraging trend of declining plague fatalities persisted, and there was cause for celebration when it was confirmed that no citizens had fallen ill or perished from the contagion.[87] On July 8th and 9th, the city's bells tolled and fires were lit in the evening; jubilation was communicated through cannon blasts and the pops and bangs of

85 Henderson, John, p. 281, n. 15 (Rodinelli, *Relazione*, pp. 275-8; Giuliano di Cesare Cecchini in Casotti, Memorie storiche, p. 189).

86 Henderson, John, Florence Under Siege p. 281, n. 16 (Casotti, *Memorie Storiche*, p. 200).

87 Ciofi, Marisa Brogi, La peste del 1630 a Firenze con particolare riferimento ai provvedimenti igenico sanitari e sociali, source: Archivio Storico Italiano, 1984, Vol. 142, No. 1 (519), (1984), pp. 47- 75, Casa Editrice Leo S. Olschki s.r.l., p. 69, n. 50 (Casotti, G.B. Memorie Istoriche della Miracolosa Immagine di Maria Vergine dell'Impruneta, Firenze 1714, pp. 199- 203), https://www.jstor.org/stable/26211963

firecrackers.[88] By the middle of August, the city was "healed from the contagion," according to Francesco Rondinelli.[89] The Medici family would eventually lead a large Thanksgiving procession to Impruneta, which concluded with the bestowal of gifts upon the miraculous painted Madonna.[90]

88 Ibid, Ciofi, Marissa Brogi, p. 69, n. 50 (Casotti, G.B

89 Rondinelli, Francesco, Relazione del Contagio Stato in Firenze L'Anno 1630 e 1633, Nuova Edizione in Firenze Nella Stamperia di S.A.R., Per Jacopo Guiducci e Santi Franchi. Con Licenza de Superiori 1714, from Carnessechi.eu http://www.carnesecchi.eu/peste1630.pdf, p. 217.

90 Henderson, John writes about gifts to the Madonna of Impruneta: pp. 178, 179, n. 143 (Rondinelli, *Relazione*, pp. 285-6).

CHAPTER 9

Apotheosis of Carita

Alas, it was in the early autumn season that a much belated *primavera* began to take place in Florence. In the absence of the terrible *miasma*, the crisper air of the fall must have felt more revitalizing with each breath. Florentine industry was positioned for recovery, but neighboring regions were experiencing their own struggles with the plague, so a full restoration of trade would take more time. Galileo Galilei had returned, but not to the city proper; he had to remain under house arrest outside the walls of Florence in a villa on a hillside at Arcetri for the rest of his life.[1] Galileo's *Dialogo* was prohibited and all of his writings, published or not, were placed on the *Index Expurgatorius*, the list of books considered forbidden by the Roman Catholic Church unless certain passages deemed dangerous to faith or morals were deleted or changed.[2] With the permission of an Inquisitor, however, the great thinker could receive guests.[3] The pope's eventual acquiescence to transfer the imprisonment of Ferdinando II's astronomer-philosopher from Rome and Siena to the proximate region of Florence could have been perceived, at least locally, as a temporary restoration of some of the old Medici dominion. It was probably at this time that Cesare Dandini and Cardinal Carlo

1 Cochrane, Eric, Florence in the Forgotten Centuries, pp. 225- 226.
2 Allan-Olney, Mary, The Private Life of Galileo, by Galileo Galilei, Macmillan and Company, London, 1870, *R, Clay, Sons,* and *Taylor,* Printers *Bread Street* Hill, p. 261.
3 Ibid, Cochrane, Eric, p. 226.

de' Medici either reengaged their discussion or confirmed the terms for the "Allegory of Christian Charity" commission.[4]

Conceptually, the civic and religious associations with the Christian virtue of charity (*carita*) were clear, but the location for the completed work suggested that Dandini would need to paint a more complex communication, undoubtedly from a Medici perspective. Of course, no visitor needed reaffirmation that their hosts came from a most illustrious Florentine lineage, but one only had to look up at the richly painted frescoes covering the ceilings within the stately interior for a sensational family history lesson. The visual narratives were unquestionably aggrandizing, even for allegorical paintings, but scenes such as Cosimo I being crowned with a laurel wreath accompanied by Valor and Fame and Ferdinando I's endorsement by the god Neptune for his fortification of the ports of Livorno could have probably moved even the most incredulous of viewers.

Those preexisting associations with the ancient world on the ceilings of Casino Medici could have easily sparked the painter's imagination. Or possibly it was a discussion with Cardinal Carlo de' Medici that guided Dandini's vision. There is no known record of such an interaction, and there would likely have been no need for a formal written *contratto* between Dandini and the Medici, but surely a conversation took place. And of course, the results are likely the best indication of what may have been addressed. Given the tone of the preceding years, the number of lives lost, the conservatism exacted from Rome, and the family's concurrent dedication to Christianity, it is possible that the two men discussed a less overt exaltation that presented the attributes of Christian virtue yet still proclaimed a Medici-led victory over the epidemic, and perhaps more. Such a project was indeed a moment for both patrons and painter alike, but the opportunity for Dandini was particularly extraordinary; he was chosen to paint the conclusion of a momentous Florentine story, one to which he had already contributed masterfully during the darkest period three years prior. This was also a chance for him to reinforce his standing as one of the city's preeminent painters.

4 Whether or not the "Allegory of Christian Charity" painting was initiated in 1632, the painter's methodical pace, the size of the work and given that it was completed in 1634, Dandini and the Cardinal would have needed to at least discuss such a project in advance.

As with other projects of this scope, it was important for Dandini to first arrange everything on paper and at least some of the preparatory work was executed in red chalk, evidently a preferred drawing medium. The versatility of red chalk was appealing, as it possessed sufficient density for line drawing but also enough softness for blending tonal values. It also contrasted less than black chalk with most shades of paper allowing for the creation of subtle tonal changes when applied lightly. In Dandini's deft hands, a rich, vivid crimson could swiftly emerge in a single descriptive stroke from the faintest, barely observable edge. In his *Vite*, Giorgio Vasari described the *furore* (furor) of a quick sketch and the *grazia* (grace) of the most beautiful of finished works.[5] However, Dandini's first drawn mark on paper was nearly as graceful as his last; there was little or no fury in his drawing. Nor was it likely detectable at this time in the demeanor of the artist, who mostly maintained an outwardly serene appearance but could burn red-hot internally. There was no evidence to suggest that Dandini was feeling anything other than eager to realize a project that may have been considered for a prolonged period.

In compositions with disparately sized figures, artists typically began developing the largest figure before all others for the sake of overall spatiality. The studies for this figure could have included depictions of the same pose from multiple perspectives, a vestige of the Renaissance anatomical drawing tradition that Dandini found value in. After choosing the position of a prospective figure, shapes could quickly evolve into voluminous forms by applying varying concentrations of drawing material and blending. Although the primary figure's head may have been generally accounted for early on, Dandini sometimes focused on the bodies or body parts of his drawn figures separately.[6]

5 Levy, Evonne and Mangone, Carolina, Material Bernini, Routledge London and New York, 2016. p. 154. I wanted to cite Evonne Levy and Carolina Mangone for putting these contrasting terms, *furore* and *grazia* together, but as the authors acknowledged, these are terms Giorgio Vasari uses often throughout his "Lives."

6 Although not found in every case, several surviving drawings by Dandini exhibit the artist's tendency to focus on the body or body parts for studies separate from the head or face of the subject. In some cases, when the head or face was referenced along with body or body part studies, Dandini sometimes included a more generalized arrangement of facial features. See the following examples:

Cesare Dandini "Study for Allegory of Christian Charity (Lying Putto)," red chalk on paper, 1633-34, collection of Sir Mark Fehrs Haukohl, Houston, Texas.

And in this particular case, he already had a source in mind for the face.[7] Supporting figures and other elements were likely drawn on separate sheets of paper, serving as pieces of a compositional puzzle that would only come together in the next phase on canvas. For all of his planning on paper for this commission, only a single red chalk study for a putto remains.[8] Even in such a small partial body sketch, Dandini's command of the medium is demonstrated as is the importance of his fundamental stage, where anatomy, pose, light source and the perspective he intended to use were established.

Study for the Allegory of Christian Charity, Haukohl family collection, Study of arms, hands and male face (Study for Saint Antonino Pierozzi and the Miracle of the basket of fruit)," Florence private collection and "Standing Draped Male Figure, His Left Arm Resting on a Pillar," Metropolitan Museum of Art.

7 The reference that Dandini used for the face of his "Charity" primary figure is revealed later in this chapter.

8 Bellesi, Sandro, p. 73.

Benvenuto Cellini "Perseus Holding the Head of Medusa,"
bronze, middle 1500s, Piazza della Signoria, Florence, Italy.
Photo credit: Andrea Izzotti.

The influence of Cesare Ripa's iconography was apparent in Dandini's unfinished Charity paintings, and was certainly a starting point for the Casino Medici commission on the painter's second largest canvas to date. The pose for his *Carita* figure, however, shows

the persistent allure of the sixteenth-century. And was the essence of Benvenuto Cellini's iconic bronze Perseus an ingredient Dandini brought back to his studio? The sculpture "Perseus Holding the Head of Medusa" is thought to have been created to honor Grand Duke Cosimo I's victory over the prospective restoration of the Republic and to warn those in Florence who dared to challenge Medici rule. The victorious ancient hero created for Cosimo I holds the evil gorgon's head high, but Dandini's protagonist triumphantly holds up the burning sacred heart, proclaiming victory of Christ's enduring love. The virtues of Faith and Hope are represented in two of the three putti, but it is the smiling putto on the right side of the canvas holding a scroll that displays the phrase *"Maiestate Tantu"* ("Great Majesty"), the motto of previous Grand Duke Ferdinando I that leaves no doubt that the work was created as much to glorify Medici rule as it was to present Christian virtue. Such an inclusion represents a legible family signature applied to this triumph. Ferdinando I, a former Cardinal turned Grand Duke, brought a shrewd amalgamation of political, economic, and spiritual authority during his reign, although it can be argued that he was merely enhancing what had long been a foundational element of Medici authority.[9] Ferdinando II, along with the Grand Duchess, maintained this approach throughout the epidemic by either participating in religious rituals or leading processions. While the title "Allegory of Christian Charity" clearly serves only one master, the additional message in the work is thinly veiled.

Beginning in the *quattrocento*, and as recently as Cellini's Perseus sculpture, the equestrian monuments of Cosimo I and Ferdinando I by Giambologna, and the Casino frescoes, the Medici had exhibited a humanist ethos, drawn from the classical era, that was generally grounded by their Roman Catholic beliefs. In this context and with regards to time and place, the burning heart can also be seen as a means of lighting the way for the Florentines through their darkest period in generations. In the course of honoring the Medici and accentuating the

9 Versteegen Gijs, Magnificence in the Seventeenth Century: Performing Splendor in Catholic and Protestant Contexts, BRILL Leiden, Boston, 2021, p. 204.

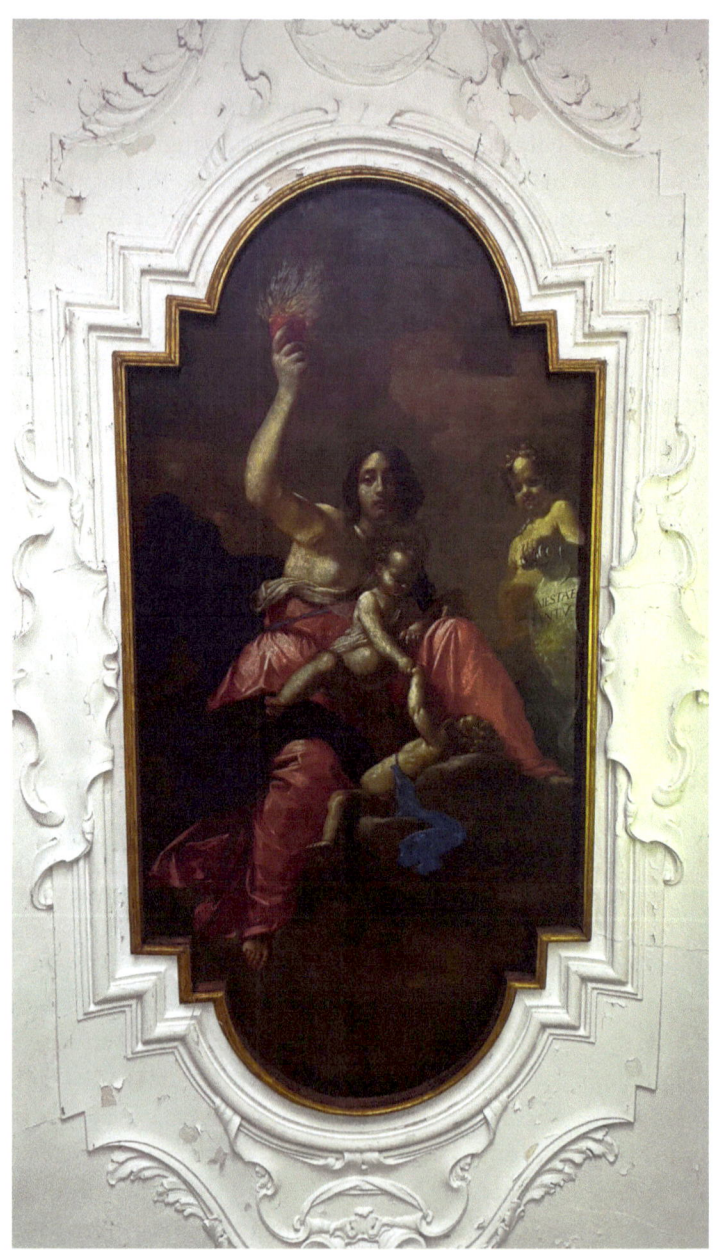

Cesare Dandini, "Allegory of Christian Charity", oil on canvas, 1634, Palazzo Buontalenti (Casino Mediceo da San Marco), Florence, Italy.

Cesare Dandini, "Allegory of Christian Charity (Detail; Maiestate Tantu)," 1634, Palazzo Buontalenti (Casino Mediceo da San Marco), Florence, Italy.

ultimate achievement of continuance, had not Dandini transformed his *Carita* figure, existing among the clouds and appearing more empowered than typical representations, into a goddess? *Feronia,* or *Proserpina,* a classical-era goddess of the enslaved, was typically represented holding her lit torch, and now, literally, Florence was freed from the plague as well as the confinement, restrictions, and fear that accompanied it.

Blending the attributes of *Feronia* and *Libera* was common in ancient Rome, and their combined qualities perfectly represented the Medici's commitment to charity and their vision for a world beyond the epidemic. *Libera* was a pre-Roman Italic goddess who protected plebian rights; although a liberation for all had taken place, it was the plebeian demographic of Florence who benefitted the most from the Grand Duke's programs. Since *Libera* encouraged male fertility, she was also an appropriate symbol for the hopeful regeneration of the populace.

Although this figure may evoke the nearly genderless sibyls of Michelangelo, her stoic and wearied face was even more familiar to the painter. Since Dandini's own features are remarkably similar to those of his charity figure, it appears that the painter once again recognized the merit of his first teacher's premise.

In 1634, the completed "Allegory of Christian Charity" was installed in a ceiling at Casino Medici.[10] The specific placement for Cesare Dandini's painting was just beyond a door that opened to an outside area believed to be a portion of Lorenzo de' Medici's garden.

During this first full year free of the epidemic, Florence exhibited a once-lost vitality, complete with comings and goings, emerging new talent, and the persistence of certain elements that remained unaltered, for better or for worse. The Medici family was reinforcing their role as the great patrons of Florentine arts and culture: the music and voice of Francesca Caccini was heard once again in the city.[11] A recently widowed mother of two children, the famous singer, composer and musician known as *La Cecchina* ("The Songbird") had returned to her home city and reemployment by the first family of Tuscany after living in Lucca.[12] "*Maria, O' Dolce Maria* (Mary, Oh Sweet Mary), sung in her signature trilling style, would have been a nearly perfect expression of the chastened gratitude felt by faithful Florentines:

10 Archivio di Stato Firenze, Possessioni Medicee n. 4170, c. 171 s.; cited in Contini, Roberto, *Il Seicento fiorentino: Arte a Firenze da Fernando I a Cosimo III*, 1986, p. 300; si veda anche A.S.F, Mediceo n. 5279, ins. 107, c.n.n. con datazione al 24 luglio 1634, quoted in Bellesi, Sandro, p. 73.

11 For information that establishes Caccini's return to Florence in 1634 see Cusick, Suzanne G. "'Thinking from Women's Lives': Francesca Caccini after 1627." *The Musical Quarterly*, vol. 77, no. 3, 1993, p. 496, n. 44 (Correspondence with Michelangelo Buonarotti the younger, I-Fl Buonarotti, 52, n.o 1543-47).

12 Ibid, pp. 484, n. 1, (Ademollo, Alessandro, La bell'Adriana ed altre virtuose del suo tempo alla corte di Mantova, 1888) and 491–492 (with credit given to: Lucca, Archivio della Parrocchia di San Frediano, Liber Mortuorum, 1625-55, f. 20r., *JSTOR*, http://www.jstor.org/stable/742392

Mary, sweet Mary,
A name so gentle
That whoever pronounces it learns to speak from the heart,
Sacred name and holy
That inflames my heart with heavenly love.
Mary, never would I know how to sing
Nor my tongue
Draw out from my breast ever
A more felicitous word than to say Mary.
Name that lessens and consoles
Every grief.
Tranquil voice that quiets every breathless agitation,
That makes every heart serene
And every spirit light.[13]

Although he had moved out of the city to serve as the parish priest in Mugello, Francesco Furini was recalled into service by Ferdinando II with a commission to paint "Lot and His Daughters," an Old Testament tale of survival at all costs.[14]

Justus Sustermans was also among the beneficiaries of resumed Medici patronage, but one of his portrait painting commissions was a posthumous one and a tragic loss for the family: the younger brother of the Grand Duke, nineteen-year-old Francesco de' Medici, died of the plague during the Siege of Regensburg, which was part of the Thirty Years War.[15]

Vincenzo Dandini had been showing exceptional ability for years and was poised to broaden his education beyond his older brother's studio. In nearly one year's time, Vincenzo would be leaving for Rome to study with Pietro da Cortona, the renowned Tuscan painter whose approach greatly differed from Cesare's process.[16] The fame of an even

13 Caccini, Francesca, Maria, O' Dolce, *Il primo libro delle musiche*, no. 4, 1618.
14 *Lot and his Daughters - The Collection*. (n.d.). Museo Del Prado. https://www.museodelprado.es/en/the-collection/art-work/lot-and-his-daughters/703e2792-decb-4f67-9085-0b318dd9a0eb
15 The engraving by Stefano della Bella that was made from a portrait painted by Sustermans in the Pitti Palace. "Print | British Museum." *The British Museum*, www.britishmuseum.org/collection/object/P_1874-0711-2030.
16 Bellesi, Sandro, Vincenzo Dandini e la pittura a Firenze alla metà del Seicento, p. 16, n. 25 (G. Tragioni, Tozzetti, XVIII sec. a, c. 4, in S. Bellesi, 1988a, p. 99-100).

younger painter continued to grow; it was becoming clear that the beauty and precision of eighteen-year-old Carlo Dolci's work were unmatched. However, it was also known by this time that his pace was extremely slow and he likely required substantially more time than any painter in the city, including Cesare Dandini, to complete commissions. Filippo Baldinucci, who later studied under Dolci, explained that the painter could spend weeks painting "a single foot."[17] The pious Dolci's painstaking application of paint wasn't a perfect fit for larger-scale projects or time-sensitive constraints, but in post-plague Florence, there was once again a call for work of all sizes and for painters of all kinds. The reappearance of Giovanni da San Giovanni in the city must have brought an almost palpable energy; the accomplished painter and poet was best known for his fresco painting ability, as well as his eccentric personality and unique wit. Many years earlier, in addition to his painted "Charity" charade, San Giovanni had once destroyed his own painted mural at Porta Romana after its unveiling, in front of the same audience who had just applauded it, just to demonstrate that he did not value their praise.[18] San Giovanni's prior antics did not prevent him from acquiring new commissions—surely, a testament to his talents—and a new opportunity to paint at Palazzo Pitti awaited him.

Sometime after his return to Florence and while housebound due to periods of gout, Giovanni da San Giovanni read Traiano Boccalini's *De' Ragguagli di Parnaso* ("Reports from Mount Parnassus") which contained criticisms of leaders throughout Europe, including the Medici.[19] Inspired to write his own version of "Reports," San Giovanni focused on his Florentine contemporaries, which made some enemies in the process.[20] One of the contemporaries he wrote about was Cesare

17 Baldinucci, Filippo, Notizie, p. 402 get parte and Vol., 1812 (Internet Archive).

18 Cochrane, Eric, Florence in the Forgotten Centuries, p. 205.

19 Steen, Morton, essay, Butchering the Bull of St. Luke: Unpublished Writings by and about the Painter-Poet Giovanni da San Giovanni, ANALECTA ROMANA INSTITUTI DANICI XL-XLI, Accademia di Danimarca ISSN 2035-2506 p. 65, n. 3 (Baldinucci 1846-1847, vol. 4, 247–251, 278.) 2016. Traiano Boccalini published his Ragguagli di Parnaso in Venice 1612-1613, while the final part of the work appeared posthumously in 1614 under the title *Pietra del paragone politico*.

20 Ibid, n. 4 (Baldinucci was too respectful to mention that Cesare Dandini

Dandini, describing his painted figures as looking like they were "made of glass."[21] Obviously, San Giovanni did not adhere to the same code as Dandini regarding the prohibition of openly criticizing the work of a fellow painter. The dishonor apparently sent Dandini into a rage; seizing a weapon, he set off.[22] There could have been a loud verbal exchange between the two, but it was more likely that Dandini's expression and the flickering glint of the blade of his sword prompted a nearly instant recall for San Giovanni—things that he had first heard about years ago.[23] These were fateful seconds; San Giovanni needed to hastily draw upon his talents for articulation to come away from the encounter without harm or worse. It appears that the imperiled artist-author's best appeal was humor, purportedly asking Dandini if he would like to first eat some dinner.[24] The strategy evidently worked; as the sword was lowered, both men must have breathed easier.

Dandini's development as a painter over the preceding years was undeniable, establishing himself as one of the finest *dipintore* of Florence. The subsequent high demand for his works attests to this, showing that the Dandini workshop had grown to be a prominent choice among prospective clients and patrons. And remarkably, this ascent had taken place during, if not as a result of, some of the most challenging years in the city's history. Moreover, this period must have resulted in significant personal self-discovery. Nonetheless, Cesare Dandini still maintained an unwavering adherence to his own principles; he remained a "Son of Thunder."

On the following clear day, the copper sphere surmounted by a cross that topped Filippo Brunelleschi's dome captured the rays of the sun high above the city.

<center>FINIS.</center>

was the implied artist, but the unpublished vita of Giovanni da San Giovanni (appendix) gives the enraged painter's name. Baldinucci & Marmi BN, Ms. II. II.110, fol. 16v; Baldinucci 1846-1847, vol. 4, 250–251; Fantuzzi 2003, 142.

21 Ibid
22 Ibid
23 Ibid
24 Ibid

Selected Bibliography

Acanfora, Elisa, Montauto, Novella Barbolani di, Bastogi, Nadia, Chiavacci, Maura, Fabbri, Maria Cecilia, Gregori, Mina, Spinelli, Riccardo, *Fasto di Corte: La decorazione murale nelle residenze dei Medici e dei Lorena. II. L'età di Ferdinando II de' Medici*, (1628-1670), Edifir, Firenze, 2006.

Allan-Olney, Mary, The Private Life of Galileo, by Galileo Galilei, Macmillan and Company, London, R, Clay, Sons, and *Taylor*, Printers Bread Street Hill, 1870.

Atkinson, Niall, *The Republic of Sound: Listening to Florence at the Threshold of the Renaissance*, I Tatti Studies in the Italian Renaissance, Volume 16, Number 1/2 (Fall 2013), University of Chicago Press, 2013.

Bailey, Meryl. "Charity as Act and Allegory in Venetian Art." *Studies in Iconography*, vol. 40, 2019, pp. 234. *JSTOR*, https://www.jstor.org/stable/27099506.

Baldassari, Francesca, Goldberg, Edward L., Goldenberg Stoppato, Lisa, Nethersole, Scott and Straussman-Pflanzer, Eve, The Medici's Painter: Carlo Dolci and Seventeenth-Century Florence, Davis Museum and Cultural Center at Wellesley College, 2017.

Baldinucci, Filippo, Notizie de' professori del disegno da Cimabue in qua opera di Filippo Baldinucci fiorentino accademico della Crusca con note ed aggiunte, dalla Società tipografica de' classici italiani contrada del Cappuccio, Milano, 1812, (Internet Archive).

Banti, Anna, *Giovanni da San Giovanni: Pittore della Contraddizione*, Sansoni, Florence, 1977.

Barker, Sheila, "Christine of Lorraine and Medicine at the Medici Court" offprint from Medici Women: The Making of a Dynasty in Grand Ducal Tuscany, Edited by Giovanna Benadusi and Judith C. Brown. Essays and Studies, 36. Toronto: Centre for Reformation and Renaissance Studies, 2015, p. 157

Bauer, Linda, "Van Dyck, Replicas and Tracing," Flemish and Dutch Art, Burlington Magazine Publications Ltd., The Burlington Magazine, February 2007.

Bellesi, Sandro, Cesare Dandini, Artema: Compagnia di belle arti, Presentazione di Antonio Paolucci, Torino, 1996.

Bellesi, Sandro, Cesare Dandini: Addenda al Catalogo dei Dipinti Edizione Polistampa, 2007.

Bellesi, Sandro, Vincenzo Dandini e la Pittura a Firenze alla Metà del Seicento, Felici Editore, Pisa, 2003.

Biagioli, Mario, Galileo Courtier: The Practice of Science in the Culture of Absolutism, The University of Chicago Press, Chicago & London, 1993

Bisceglia, Anna, Armida, Uffizi Gallery, Armida by Cecco Bravo | Artworks | Uffizi Galleries. (n.d.). https://www.uffizi.it/en/artworks/armida-cecco-bravo and Chappell, Miles. "Cecco Bravo. Florence." *The Burlington Magazine*, vol. 141, no. 1159, 1999, pp. 646–47. *JSTOR*, http://www.jstor.org/stable/888547

Bisceglia, Anna, *Ila And the Nymphs by Francesco Furini 1632c, Artworks, Uffizi Galleries*. www.uffizi.it/en/artworks/hylas-and-the-nymphs, no date given.

Boni, Filippo de, Biografia degli artisti ovvero dizionario della vita e delle opere dei pittori, degli scultori, degli intagliatori, dei tipografi e dei musici di ogni nazione che fiorirono da'tempi più remoti sino á nostri giorni, Seconda Edizione, Venice; Googlebooks: Presso Andrea Santini e Figlio, 1852, p. 908

Bonnell, Robert A. "An Early Humanistic View of the Active and Contemplative Life." *Italica*, vol. 43, no. 3, University of Illinois Press, Sept. 1966, p. 225. *Crossref*, https://doi.org/10.2307/477732.

Borea, Evelina, Trofani, Annamaria Petrioli, Langedijk, Karla, Italia Soprintendenza ai beni artistici e storici per le province di Firenze e Pistoia, La Quadreria di Don Lorenzo de' Medici: Villa Medicea di Poggio a Caiano, Centro Di, Firenze, 1977.

Borromeo, Carlo, *Instructionum Fabricae et Supellectilis Ecclesiasticae: Libri II*, ed. M. Marinelli, Vatican City, p. 70, 2000.

Brown, Beverly Louise. "The Patronage and Building History of the Tribuna of SS. Annunziata in Florence: A Reappraisal in Light of New Documentation." *Mitteilungen Des Kunsthistorischen Institutes in Florenz*, vol. 25, no. 1, 1981, *JSTOR*, http://www.jstor.org/stable/27652520.

Buommattei, Benedetto, *Descrizione delle feste fatte in Firenze per la canonizzazione di S. Andrea Corsini*, In Fiorenza : Nella stamperia di Zanobi Pignoni, 1632, Getty Research Institute, (Internet Archive).

Caccini, Francesca, Maria, O' Dolce, *Il primo libro delle musiche*, no. 4, 1618

Callahan, Meghan, Preaching in a Poor Space: Savonarolan Influence at Sister Domenica's Convent of La Crocetta in Renaissance Florence, in Patronage, Gender and the Arts. Essays in Honor of Carolyn Valone, (author) edited by Katherine A. McIver and Cynthia Stollhans, New York: Italica Press, 2015.

Calvi, Giulia, Histories of a Plague Year: The Social and Imaginary in Baroque Florence, Translated by Dario Biocca and Bryant T. Ragan, JR, University of California Press, Berkley, Los Angeles, Oxford, 1989

Campbell, Malcolm. "Francesco Furini Drawings at the Uffizi." *The Burlington Magazine*, vol. 114, no. 833, 1972, pp. 571–570. *JSTOR*, http://www.jstor.org/stable/877084.

Chappell, Miles L, *Cristofano Allori's Paintings Depicting St Francis*, The Burlington Magazine, vol. 113, no. 821, 1971, pp. 444–55. *JSTOR*, http://www.jstor.org/stable/876712

Ciofi, Marisa Brogi, La peste del 1630 a Firenze con particolare riferimento ai provvedimenti igenico sanitari e sociali, source: Archivio Storico Italiano, 1984, Vol. 142, No. 1 (519), (1984), pp. 47- 75, Casa Editrice Leo S. Olschki s.r.l., https://www.jstor.org/stable/26211963

Cipolla, Carlo M., Faith, Reason and the Plague in Seventeenth-Century Tuscany, Translated by Muriel Kittel, W.W. Norton & Company, New York, London, 1979.

Cochrane, Eric, Florence in the Forgotten Centuries 1527- 1800, University of Chicago Press, Chicago, London, 1973

Cohn, Samuel. "After the Black Death: Labour Legislation and Attitudes Towards Labour in Late-Medieval Western Europe." *The Economic History Review*, vol. 60, no. 3, 2007, p 458 *JSTOR*, http://www.jstor.org/stable/4502106

Colarossi, Jessica. "Three Reasons Why COVID-19 Can Cause Silent Hypoxia." *Boston University*, 5 Apr. 2023, www.bu.edu/articles/2020/3-reasons-why-covid-19-can-cause-silent-hypoxia.

Contini, Roberto, Bilivert: Saggio di ricostruzione, Sansoni, Firenze, Lucca, 1985

Corsi, Giuseppe, Ed, Antonio Pucci's poem, *Proprietà di Mercato Vecchio*, in *Rimatori del Trecento*, (Turin, 1969), p. 874, translated and quoted in Atkinson, Niall, The Republic of Sound: Listening to Florence at the Threshold of the Renaissance, I Tatti Studies in the Italian Renaissance, Volume 16, Number 1/2 Fall 2013, University of Chicago Press, pp. 57- 84.

Covoni, Pierfilippo, *Il casino di San Marco costruito dal Buontalenti ai tempi Medicei*, Tipografica Cooperativa, Firenze, 1892.

Cusick, Suzanne G. "'Thinking from Women's Lives': Francesca Caccini after 1627." *The Musical Quarterly*, vol. 77, no. 3, 1993.

Da Silva, Josie Agatha Parrilha, and Marcos Cesar Danhoni Neves. "DOMENICO CRESTI (PASSIGNANO) AND THE FIRST ARTISTIC REPRESENTATION OF THE GALILEAN TELESCOPIC MOON." *International Journal of Research -GRANTHAALAYAH*, vol. 6, no. 6, Granthaalayah Publications and Printers, June 2018, pp. 260–80. *Crossref*, https://doi.org/10.29121/granthaalayah.v6.i6.2018.1372.

Devlieger, Lionel. "Deconstructing the Doctrine of *Disegno*". Thomine-Berrada, Alice, and Barry Bergdol. *Repenser les limites : l'architecture à travers l'espace, le temps et les disciplines: 31 août - 4 septembre 2005*. Paris: Publications de l'Institut national d'histoire de l'art, 2005, http://books.openedition.org/inha/1820.

Elam, Caroline. "Lorenzo de' Medici's Sculpture Garden." *Mitteilungen Des Kunsthistorischen Institutes in Florenz*, vol. 36, no. 1/2, 1992, pp. 41–84. *JSTOR*, http://www.jstor.org/stable/27653323.

Etro, Federico, Marchesi, Silvia, and Pagani, Laura, The Labor Market in the Art Sector of Baroque Rome. Econ Inq, 53: 365-387. https://doi.org/10.1111/ecin.12115), 2015

Ezekiel 28:13, https://www.kingjamesbibleonline.org/Ezekiel-28-13/

Fantoni, Marcello, Il Culto dell'Annunziata e La Sacralità del Potere Mediceo, Archivio Storico Italiano, Vol. 147, No. 4 (542), Casa Editrice Leo S. Olschki s.r.l, Ottobre-Dicembre 1989.

Farago, Claire, Renaissance Quarterly. Vol. 67, No. 2, pp. 558-559 Published by: Cambridge University Press on behalf of the Renaissance Society of America, Summer 2014.

Farago, Jason, New York Times article, "That $450 Million Leonardo? It's No Mona Lisa," November 15, 2017.

Farrar, Linda. "Roman Gardens." *Gardens and Gardeners of the Ancient World: History, Myth and Archaeology*, Oxbow Books, 2016, pp. 138–84. *JSTOR*, https://doi.org/10.2307/j.ctv13gvgxf

Fumagalli, Elena, Painting for Profit: The Economic Lives of Seventeenth-Century Italian Painters, Florence, New Haven, Yale University Press, 2010.

Galilei, Galileo, et al. *Dialogo di Galileo Galilei Linceo, matematico sopraordinario dello studio di Pisa. E filosofo e matematico primario del serenissimo gr. duca di Toscana, doue ne i congressi di quattro giornate si discorre sopra i due massimi sistemi del mondo tolemaico e copernicano, proponendo indeterminatamente le ragioni filosofiche e naturali tanto per l'una quanto per l'altra parte*. Fiorenza, Per Gio: Batista Landini, 1632. Pdf. Retrieved from the Library of Congress, www.loc.gov/item/12018406/

Grasman, Edward. "On Closer Inspection - The Interrogation of Paolo Veronese." *Artibus et Historiae*, vol. 30, no. 59, 2009.

Hannam, James, The Genesis of Science: How the Christian Middle Ages Launched the Scientific Revolution, Regnery Publishing, INC., Washington, DC, 2011

Haskell, Francis, "Patrons and Painters, Art and Society in Baroque Italy" Yale University Press, New Haven and London, 1980.

Henderson, John. "PLAGUE AND PUBLIC HEALTH IN ITALY AND EUROPE." *Florence Under Siege: Surviving Plague in an Early Modern City*, Yale University Press, 2019, *JSTOR*, https://doi.org/10.2307/j.ctvk8w059.6

Holmes, Megan, the Miraculous Image in Renaissance Florence, Yale University Press, New Haven and London, 2013.

Horsburgh, Edward Lee Stuart, *Girolamo Savonarola*, Methuen, London, (Internet Archive),1911.

Kennedy, Leonard A., *Cesare Cremonini and the Immortality of the Human Soul, Vivarium*, Vol. 18, No. 2, 1980.

King, Ross, *Leonardo and the Last Supper*, Ross King Bloomsbury publishing, 2012.

Kirshner, Julius, Epidemics in Renaissance Florence, American Journal of Public Health, 1985.

Land, Norman E., "Giotto as an Ugly Genius: A Study in Self-Portrayal," Explorations in Renaissance Culture, Vol. 23, South Central Renaissance Conference, Memphis, 1997.

Levy, Evonne and Mangone, Carolina, Material Bernini, Routledge London and New York, 2016.

Luke, 9:49 and 9:53-56, King James Bible, www.kingjamesbibleonline.org, 2007.

MacCurdy, Edward, ed., The Notebooks of Leonardo da Vinci, Konecky & Konecky, Connecticut, 2003.

Mark 3:17, King James Bible, www.kingjamesbibleonline.org, 2007.

Martinelli, Elsa, *Nei panni dell'eroe: costumi e protagonisti di due drammi per musica dati a Firenze nel 1760*, Fashioning Opera and Musical Theatre: Stage Costumes from the Late Renaissance to the 1900, Valeria De Lucca (cura) e Centro Studi per la Ricerca Documentale sul Teatro e il Melo drama Europeo, Fondazione Giorgio Cini Onlus, Venezia, 2014

Mayer, Thomas, The Roman Inquisition on the Stage of Italy C. 1590- 1640, University of Pennsylvania Press, Philadelphia, 2014.

McMahon, Philip A., *A Treatise on Painting by Leonardo da Vinci*, J. B. Nichols and Son, London, p. 86, 1835.

Montaiglon, Anatole de, Mariette , Pierre Jean, Chennevières, Philippe de, Abecedario de P.J. Mariette: et autres notes inédites de cet amateur sur les Arts et les Artistes, Volume II, JB Dumoulin, Quai des Agustins #13, Paris; 1853-1854.

O'Donnell, J. Reginald, and Berthold L. Ullman. "The Humanism of Coluccio Salutati." *Phoenix*, vol. 19, no. 1, JSTOR, 1965.

Ostrow, Steven F., *Cigoli's Immacolata and Galileo's Moon: Astronomy and the Virgin in Early Seicento Rome*. The Art Bulletin, 78(2), 218–235, 1996, https://doi.org/10.2307/3046173.

Pagliarulo, Giovanni, La Devozione della Famiglia Bonsi e le Commissioni per San Gaetano di Firenze, Sansoni, Firenze, 1982.

Paleotti, Gabriele, *Discorso intorno alle immagini sacre e profane (1582)*, ed. S. Della Torre, Milan, 2002

Quinn, Kenneth, Poet and Audience in the Augustan Age, In Haase, Wolfgang (ed.). Aufstieg und Niedergang der römischen Welt. Vol. 30/1, 1982.

Ripa, Cesare, Iconologia (Moral Emblems), Benj. Motte, London, 1709.

Robertson, Clare, *Annibale Carracci and Invenzione: Medium and Function in the Early Drawings, Master Drawings*, vol. 35, no. 1, 1997, pp. 3–42. *JSTOR*, http://www.jstor.org/stable/1554287.

Rondinelli, Francesco, Relazione del Contagio Stato in Firenze L'Anno 1630 e 1633, Nuova Edizione in Firenze Nella Stamperia di S.A.R., Per Jacopo Guiducci e Santi Franchi. Con Licenza de Superiori 1714, from Carnessechi.eu http://www.carnesecchi.eu/peste1630.pdf

Ruggio, Thomas, Cesare Dandini's Holy Family with the Infant St. John: A Rediscovered Florentine Baroque Masterpiece, Iona College, 2021.

Shearman, John, *Andrea Del Sarto's Two Paintings of the Assumption*, The Burlington Magazine, vol. 101, no. 673, 1959, pp. 124–122. *JSTOR*, http://www.jstor.org/stable/872645

Sohm, Philip Lindsay, The Artist Grows Old: The Aging of Art and Artists in Italy, 1500-1800, Yale University Press, New Haven, 2007.

Spike, John T., Italian Baroque Paintings from New York Private Collections, The Art Museum, Princeton University in association with Princeton University Press, New Jersey, 1980

Steen, Morton, essay, Butchering the Bull of St. Luke: Unpublished Writings by and about the

Painter-Poet Giovanni da San Giovanni, ANALECTA ROMANA INSTITUTI DANICI XL-XLI, Accademia di Danimarca ISSN 2035-2506, 2016

Strocchia, Sharon T., The nun apothecaries of Renaissance Florence: marketing medicines in the convent

Renaissance Studies, Journal Article Vol. 25, No. 5 (NOVEMBER 2011), p. 629 https://www.jstor.org/stable/24420278

Tacconi, Marica S., Cathedral and Civic Ritual in Late Medieval and Renaissance Florence: The Service Books of Santa Maria del Fiore, Cambridge University Press, 2006

Thiem, Christel, *Fabrizio Boschi and Matteo Rosselli: Drawings Relating to the Theme of the 'Martyrdom of St. Sebastian, Master Drawings*, vol. 7, no. 2, 1969, pp. 148–211. *JSTOR*, http://www.jstor.org/stable/1553016

Townsend, G.L., "The Plague Doctor: AN Engraving by Gerhart Altzenbach (17th Century). New Haven, Yale Medical Library, Clements C. Fry Collection." *Journal of the History of Medicine and Allied Sciences*, vol. 20, no. 3, 1965, pp. 276–276. *JSTOR*, http://www.jstor.org/stable/24621993.

Urmson, J. O. "Aristotle on Excellence of Character." *New Blackfriars*, vol. 71, no. 834, 1990, pp. 33–37. *JSTOR*, http://www.jstor.org/stable/43248477.

Versteegen Gijs, Magnificence in the Seventeenth Century: Performing Splendor in Catholic and Protestant Contexts, BRILL Leiden, Boston, 2021.

Waldman, Louis Alexander, A Document for Andrea del Sarto's "Panciatichi Assumption," The Burlington Magazine, Vol. 139, No. 1132, pp. 469-470, The Burlington Magazine Publications Ltd. Stable, July 1997, URL: http://www.jstor.org/stable/887506

Załuski, Wojciech. "On the Relations between Vita Contemplativa and Vita Activa." AVANT. The Journal of the Philosophical-Interdisciplinary Vanguard 10.1, pp.15–28. Academia.edu, 2019.

Acknowledgments

I wish to extend my gratitude to everyone who has made valuable contributions to this research endeavor and the subsequent publication.

First and foremost, I must thank both Iona University and the Church of the Holy Family in New Rochelle, New York. The resources and funding provided by Iona made it possible for me to effectively engage in this endeavor. Individuals who provided support in multiple ways and whom I wish to thank by name include Joseph Stabile, Ph.D., dean of the School of Arts and Science; Tricia Mulligan, Ph.D., provost and senior vice president for Academic Affairs; Nadine Barnett Cosby, Ph.D., associate vice provost for Academic Affairs; Rick Palladino, director of libraries; Edward Helmrich, interlibrary loan specialist; Richard Murray, director of facilities management; and Louis Kangas, trades manager. Thank you, Thomas Mussio, Ph.D., professor of Italian and chair of the Arts and Languages department, for generously providing crucial translations of seventeenth-century Italian vernacular. Thank you, Christina Carlson, Ph.D., professor of English, for sharing feedback on my earliest drafts and bolstering my confidence. And last but not least of my Iona University colleagues, thank you, Jeanne Sheehan Zaino, Ph.D., professor of Political Science, for encouraging me to write this book. I would like to express my deep appreciation to Monsignor Dennis Keane, Pastor of the Church of the Holy Family, for his understanding, regular provision of vital information, access to Dandini's formerly lost painting, and also his friendship. I am also grateful to Fran Gray, parish secretary, and Marianne Gannon, administrative assistant, for their assistance.

I am very thankful for the medical guidance I received from Dr. Cindy Hope Baskin, Assistant Professor of Medicine, Weill Cornell Medical in New York City, and Dr. Helen Reddel, Research Leader, Woolcock Institute of Medical Research, Macquarie University in Sydney, Australia, regarding asthma.

In the subsequent four paragraphs, I would like to extend my appreciation to some of the distinguished scholars and professionals who contributed to this project and are listed according to their respective geographical locations.

New York, USA: I express my sincerest gratitude to David Pullins, Ph.D., Associate Curator of European Paintings at the Metropolitan Museum of Art, for his ongoing interest and support for my research; his invaluable perspective and insights have greatly enriched my work. I thank Blair Bailey, painting conservator at ArtCare Conservation, for her exceptional analytical efforts, collaboration, and unwavering passion for this project.

Madrid, Spain: I would like to thank Andrés Úbeda, Ph.D., Curator of European Paintings at the Museo Nacional del Prado in Madrid, Spain, for graciously sharing his unparalleled insight and advice. Thanks to Señor Joaquín Luaces for kindly allowing me and my daughter Livia to visit his residence to view his outstanding art collection.

Lucca, Italy: Once again, I was fortunate enough to collaborate with and learn from Dott. Massimo Bonino, a renowned conservator and restorer of old master paintings and a friend. I thank him for joining me in Florence, his expert analysis and key assistance. I thank Dott.ssa Paola Betti, expert on Italian Renaissance and Baroque paintings, for her ongoing provision of essential insights.

Florence, Italy: I would like to begin by thanking Dott. Federico Berti, esteemed scholar of Italian Baroque Florentine painting who has been an indispensable source throughout my research. My thanks to Father Emanuele Cattarossi, the convent archivist of the Basilica della Santissima Annunziata for granting firsthand scholarship of Cesare Dandini's work housed in the sacred Basilica. Laura Bechi, user support coordinator, Real Estate and Facilities Service of the European University Institute at Palazzo Buontalenti (Casino Mediceo di San Marco), and Andrea Sacchettini, building officer, are thanked for providing access to Casino Medici and supplementary information, respectively. I would like to express my utmost appreciation to Dott. Sandro Bellesi, one of the great scholars of seventeenth-century Florentine art, for his interest in my work and for generously imparting his expertise.

Special thanks to Bordighera Press, particularly Anthony Tamburri, Ph.D., dean of the John D. Calandra Italian American Institute of Queens College, CUNY and Distinguished Professor of European Languages and Literatures for believing in the literary merit of *Finding Dandini*. I also wish to extend my thanks to Nicholas Grosso, Managing Editor, for his great work on this project as well as his guidance and patience.

Finally, I am grateful to the following institutions who supported this research by either providing information, documents, or images: the Metropolitan Museum of Art, El Museo Nacional del Prado, Le Gallerie degli Uffizi, La Biblioteca degli Uffizi, L'Accademia delle Arti del Disegno, L'Archivio Comunale Storico di Firenze, L'Archivio Di Stato Di Firenze, Il Museo Nazionale di Pisa, Palazzo Arcivescovile di Siena, La Galleria Borghese, La Pinacoteca di Brera, Piacenti Fine Art, the State Hermitage Museum, the British Museum, the National Gallery (London), the Royal Collection Trust, and the Städel Museum.

About the Author

THOMAS RUGGIO is a professor of fine art and art history at Iona University. He earned an MFA at Queens College, CUNY, and studied at the New York Studio School of Drawing, Painting, and Sculpture. As an artist, his work has been exhibited throughout the United States and in galleries and museums in Mexico, Italy, Germany, and South Korea. In 2011, he founded the Studio Borgo art program in Lucca, Italy, where he served as director until 2019.

As a scholar, Thomas Ruggio has focused on sixteenth–seventeenth century European painting and has curated exhibitions such as *Peter Paul Rubens and the Flemish 17th Century* and *Cesare Dandini's Holy Family with the Infant St. John: A Rediscovered Florentine Baroque Masterpiece.*

VIA FOLIOS
A refereed book series dedicated to the culture of Italians and Italian Americans.

GARDAPHÈ, GIORDANO, TAMBURRI. *From the Margin.* Vol 171.
ANNA MONARDO. *After Italy.* Vol. 169. Memoir.
JOEY NICOLETTI. *Extinction Wednesday.* Vol. 168. Memoir.
MARIA FAMÀ. *Trigger.* Vol. 167. Poetry.
WILLI Q MINN. *What? Nothing.* Vol. 166. Poetry.
RICHARD VETERE. *She's Not There.* Vol. 165. Literature.
FRANK GIOIA. *Mercury Man.* Vol. 164. Literature.
LUISA M. GIULIANETTI. *Agrodolce.* Vol. 163. Literature.
ANGELO ZEOLLA. *The Bronx Unbound ovvero i versi bronxesi.* Vol. 162. Poetry.
NICHOLAS A. DiCHARIO. *Giovanni's Tree.* Vol. 161. Literature.
ADELE ANNESI. *What She Takes Away.* Vol. 160. Novel.
ANNIE RACHELE LANZILLOTTO. *Whaddyacall the Wind?.* Vol. 159. Memoir.
JULIA LISELLA. *Our Lively Kingdom.* Vol. 158. Poetry.
MARK CIABATTARI. *When the Mask Slips.* Vol. 157. Novel.
JENNIFER MARTELLI. *The Queen of Queens.* Vol. 156. Poetry.
TONY TADDEI. *The Sons of the Santorelli.* Vol. 155. Literature.
FRANCO RICCI. *Preston Street • Corso Italias.* Vol. 154. History.
MIKE FIORITO. *The Hated Ones.* Vol. 153. Literature.
PATRICIA DUNN. *Last Stop on the 6.* Vol. 152. Novel.
WILLIAM BOELHOWER. *Immigrant Autobiography.* Vol. 151. Literary Criticism.
MARC DIPAOLO. *Fake Italian.* Vol. 150. Literature.
GAIL REITANO. *Italian Love Cake.* Vol. 149. Novel.
VINCENT PANELLA. *Sicilian Dreams.* Vol. 148. Novel.
MARK CIABATTARI. *The Literal Truth: Rizzoli Dreams of Eating the Apple of Earthly Delights.* Vol. 147. Novel.
MARK CIABATTARI. *Dreams of An Imaginary New Yorker Named Rizzoli.* Vol. 146. Novel.
LAURETTE FOLK. *The End of Aphrodite.* Vol. 145. Novel.
ANNA CITRINO. *A Space Between.* Vol. 144. Poetry
MARIA FAMÀ. *The Good for the Good.* Vol. 143. Poetry.
ROSEMARY CAPPELLO. *Wonderful Disaster.* Vol. 142. Poetry.
B. AMORE. *Journeys on the Wheel.* Vol. 141. Poetry.
ALDO PALAZZESCHI. *The Manifestos of Aldo Palazzeschi.* Vol 140. Literature.
ROSS TALARICO. *The Reckoning.* Vol 139. Poetry.
MICHELLE REALE. *Season of Subtraction.* Vol 138. Poetry.
MARISA FRASCA. *Wild Fennel.* Vol 137. Poetry.
RITA ESPOSITO WATSON. *Italian Kisses.* Vol. 136. Memoir.
SARA FRUNER. *Bitter Bites from Sugar Hills.* Vol. 135. Poetry.
KATHY CURTO. *Not for Nothing.* Vol. 134. Memoir.
JENNIFER MARTELLI. *My Tarantella.* Vol. 133. Poetry.
MARIA TERRONE. *At Home in the New World.* Vol. 132. Essays.
GIL FAGIANI. *Missing Madonnas.* Vol. 131. Poetry.

LEWIS TURCO. *The Sonnetarium*. Vol. 130. Poetry.
JOE AMATO. *Samuel Taylor's Hollywood Adventure*. Vol. 129. Novel.
BEA TUSIANI. *Con Amore*. Vol. 128. Memoir.
MARIA GIURA. *What My Father Taught Me*. Vol. 127. Poetry.
STANISLAO PUGLIESE. *A Century of Sinatra*. Vol. 126. Popular Culture.
TONY ARDIZZONE. *The Arab's Ox*. Vol. 125. Novel.
PHYLLIS CAPELLO. *Packs Small Plays Big*. Vol. 124. Literature.
FRED GARDAPHÉ. *Read 'em and Reap*. Vol. 123. Criticism.
JOSEPH A. AMATO. *Diagnostics*. Vol 122. Literature.
DENNIS BARONE. *Second Thoughts*. Vol 121. Poetry.
OLIVIA K. CERRONE. *The Hunger Saint*. Vol 120. Novella.
GARIBLADI M. LAPOLLA. *Miss Rollins in Love*. Vol 119. Novel.
JOSEPH TUSIANI. *A Clarion Call*. Vol 118. Poetry.
JOSEPH A. AMATO. *My Three Sicilies*. Vol 117. Poetry & Prose.
MARGHERITA COSTA. *Voice of a Virtuosa and Coutesan*. Vol 116. Poetry.
NICOLE SANTALUCIA. *Because I Did Not Die*. Vol 115. Poetry.
MARK CIABATTARI. *Preludes to History*. Vol 114. Poetry.
HELEN BAROLINI. *Visits*. Vol 113. Novel.
ERNESTO LIVORNI. *The Fathers' America*. Vol. 112. Poetry.
MARIO B. MIGNONE. *The Story of My People*. Vol 111. Non-fiction.
GEORGE GUIDA. *The Sleeping Gulf*. Vol 110. Poetry.
JOEY NICOLETTI. *Reverse Graffiti*. Vol 109. Poetry.
GIOSE RIMANELLI. *Il mestiere del furbo*. Vol 108. Criticism.
LEWIS TURCO. *The Hero Enkidu*. Vol 107. Poetry.
AL TACCONELLI. *Perhaps Fly*. Vol 106. Poetry.
RACHEL GUIDO DEVRIES. *A Woman Unknown in Her Bones*. Vol 105. Poetry.
BERNARD BRUNO. *A Tear and a Tear in My Heart*. Vol 104. Non-fiction.
FELIX STEFANILE. *Songs of the Sparrow*. Vol 103. Poetry.
FRANK POLIZZI. *A New Life with Bianca*. Vol 102. Poetry.
GIL FAGIANI. *Stone Walls*. Vol 101. Poetry.
LOUISE DESALVO. *Casting Off*. Vol 100. Fiction.
MARY JO BONA. *I Stop Waiting for You*. Vol 99. Poetry.
RACHEL GUIDO DEVRIES. *Stati zitt, Josie*. Vol 98. Children's Literature. $8
GRACE CAVALIERI. *The Mandate of Heaven*. Vol 97. Poetry.
MARISA FRASCA. *Via incanto*. Vol 96. Poetry.
DOUGLAS GLADSTONE. *Carving a Niche for Himself*. Vol 95. History.
MARIA TERRONE. *Eye to Eye*. Vol 94. Poetry.
CONSTANCE SANCETTA. *Here in Cerchio*. Vol 93. Local History.
MARIA MAZZIOTTI GILLAN. *Ancestors' Song*. Vol 92. Poetry.
MICHAEL PARENTI. *Waiting for Yesterday: Pages from a Street Kid's Life*. Vol 90. Memoir.
ANNIE LANZILLOTTO. *Schistsong*. Vol 89. Poetry.
EMANUEL DI PASQUALE. *Love Lines*. Vol 88. Poetry.
CAROSONE & LOGIUDICE. *Our Naked Lives*. Vol 87. Essays.
JAMES PERICONI. *Strangers in a Strange Land: A Survey of Italian-Language American Books*. Vol 86. Book History.

DANIELA GIOSEFFI. *Escaping La Vita Della Cucina*. Vol 85. Essays.
MARIA FAMÀ. *Mystics in the Family*. Vol 84. Poetry.
ROSSANA DEL ZIO. *From Bread and Tomatoes to Zuppa di Pesce "Ciambotto"*. Vol. 83. Memoir.
LORENZO DELBOCA. *Polentoni*. Vol 82. Italian Studies.
SAMUEL GHELLI. *A Reference Grammar*. Vol 81. Italian Language.
ROSS TALARICO. *Sled Run*. Vol 80. Fiction.
FRED MISURELLA. *Only Sons*. Vol 79. Fiction.
FRANK LENTRICCHIA. *The Portable Lentricchia*. Vol 78. Fiction.
RICHARD VETERE. *The Other Colors in a Snow Storm*. Vol 77. Poetry.
GARIBALDI LAPOLLA. *Fire in the Flesh*. Vol 76 Fiction & Criticism.
GEORGE GUIDA. *The Pope Stories*. Vol 75 Prose.
ROBERT VISCUSI. *Ellis Island*. Vol 74. Poetry.
ELENA GIANINI BELOTTI. *The Bitter Taste of Strangers Bread*. Vol 73. Fiction.
PINO APRILE. *Terroni*. Vol 72. Italian Studies.
EMANUEL DI PASQUALE. *Harvest*. Vol 71. Poetry.
ROBERT ZWEIG. *Return to Naples*. Vol 70. Memoir.
AIROS & CAPPELLI. *Guido*. Vol 69. Italian/American Studies.
FRED GARDAPHÉ. *Moustache Pete is Dead! Long Live Moustache Pete!*. Vol 67. Literature/Oral History.
PAOLO RUFFILLI. *Dark Room/Camera oscura*. Vol 66. Poetry.
HELEN BAROLINI. *Crossing the Alps*. Vol 65. Fiction.
COSMO FERRARA. *Profiles of Italian Americans*. Vol 64. Italian Americana.
GIL FAGIANI. *Chianti in Connecticut*. Vol 63. Poetry.
BASSETTI & D'ACQUINO. *Italic Lessons*. Vol 62. Italian/American Studies.
CAVALIERI & PASCARELLI, Eds. *The Poet's Cookbook*. Vol 61. Poetry/Recipes.
EMANUEL DI PASQUALE. *Siciliana*. Vol 60. Poetry.
NATALIA COSTA, Ed. *Bufalini*. Vol 59. Poetry.
RICHARD VETERE. *Baroque*. Vol 58. Fiction.
LEWIS TURCO. *La Famiglia/The Family*. Vol 57. Memoir.
NICK JAMES MILETI. *The Unscrupulous*. Vol 56. Humanities.
BASSETTI. ACCOLLA. D'AQUINO. *Italici: An Encounter with Piero Bassetti*. Vol 55. Italian Studies.
GIOSE RIMANELLI. *The Three-legged One*. Vol 54. Fiction.
CHARLES KLOPP. *Bele Antiche Stòrie*. Vol 53. Criticism.
JOSEPH RICAPITO. *Second Wave*. Vol 52. Poetry.
GARY MORMINO. *Italians in Florida*. Vol 51. History.
GIANFRANCO ANGELUCCI. *Federico F*. Vol 50. Fiction.
ANTHONY VALERIO. *The Little Sailor*. Vol 49. Memoir.
ROSS TALARICO. *The Reptilian Interludes*. Vol 48. Poetry.
RACHEL GUIDO DE VRIES. *Teeny Tiny Tino's Fishing Story*. Vol 47. Children's Literature.
EMANUEL DI PASQUALE. *Writing Anew*. Vol 46. Poetry.
MARIA FAMÀ. *Looking For Cover*. Vol 45. Poetry.
ANTHONY VALERIO. *Toni Cade Bambara's One Sicilian Night*. Vol 44. Poetry.
EMANUEL CARNEVALI. *Furnished Rooms*. Vol 43. Poetry.

BRENT ADKINS. et al., Ed. *Shifting Borders. Negotiating Places.*
 Vol 42. Conference.
GEORGE GUIDA. *Low Italian.* Vol 41. Poetry.
GARDAPHÈ, GIORDANO, TAMBURRI. *Introducing Italian Americana.*
 Vol 40. Italian/American Studies.
DANIELA GIOSEFFI. *Blood Autumn/Autunno di sangue.* Vol 39. Poetry.
FRED MISURELLA. *Lies to Live By.* Vol 38. Stories.
STEVEN BELLUSCIO. *Constructing a Bibliography.* Vol 37. Italian Americana.
ANTHONY JULIAN TAMBURRI, Ed. *Italian Cultural Studies 2002.*
 Vol 36. Essays.
BEA TUSIANI. *con amore.* Vol 35. Memoir.
FLAVIA BRIZIO-SKOV, Ed. *Reconstructing Societies in the Aftermath of War.*
 Vol 34. History.
TAMBURRI. et al., Eds. *Italian Cultural Studies 2001.* Vol 33. Essays.
ELIZABETH G. MESSINA, Ed. *In Our Own Voices.*
 Vol 32. Italian/American Studies.
STANISLAO G. PUGLIESE. *Desperate Inscriptions.* Vol 31. History.
HOSTERT & TAMBURRI, Eds. *Screening Ethnicity.*
 Vol 30. Italian/American Culture.
G. PARATI & B. LAWTON, Eds. *Italian Cultural Studies.* Vol 29. Essays.
HELEN BAROLINI. *More Italian Hours.* Vol 28. Fiction.
FRANCO NASI, Ed. *Intorno alla Via Emilia.* Vol 27. Culture.
ARTHUR L. CLEMENTS. *The Book of Madness & Love.* Vol 26. Poetry.
JOHN CASEY, et al. *Imagining Humanity.* Vol 25. Interdisciplinary Studies.
ROBERT LIMA. *Sardinia/Sardegna.* Vol 24. Poetry.
DANIELA GIOSEFFI. *Going On.* Vol 23. Poetry.
ROSS TALARICO. *The Journey Home.* Vol 22. Poetry.
EMANUEL DI PASQUALE. *The Silver Lake Love Poems.* Vol 21. Poetry.
JOSEPH TUSIANI. *Ethnicity.* Vol 20. Poetry.
JENNIFER LAGIER. *Second Class Citizen.* Vol 19. Poetry.
FELIX STEFANILE. *The Country of Absence.* Vol 18. Poetry.
PHILIP CANNISTRARO. *Blackshirts.* Vol 17. History.
LUIGI RUSTICHELLI, Ed. *Seminario sul racconto.* Vol 16. Narrative.
LEWIS TURCO. *Shaking the Family Tree.* Vol 15. Memoirs.
LUIGI RUSTICHELLI, Ed. *Seminario sulla drammaturgia.*
 Vol 14. Theater/Essays.
FRED GARDAPHÈ. *Moustache Pete is Dead! Long Live Moustache Pete!.*
 Vol 13. Oral Literature.
JONE GAILLARD CORSI. *Il libretto d'autore. 1860 - 1930.* Vol 12. Criticism.
HELEN BAROLINI. *Chiaroscuro: Essays of Identity.* Vol 11. Essays.
PICARAZZI & FEINSTEIN, Eds. *An African Harlequin in Milan.*
 Vol 10. Theater/Essays.
JOSEPH RICAPITO. *Florentine Streets & Other Poems.* Vol 9. Poetry.
FRED MISURELLA. *Short Time.* Vol 8. Novella.
NED CONDINI. *Quartettsatz.* Vol 7. Poetry.

ANTHONY JULIAN TAMBURRI, Ed. *Fuori: Essays by Italian/American Lesbians and Gays.* Vol 6. Essays.
ANTONIO GRAMSCI. P. Verdicchio. Trans. & Intro. *The Southern Question.* Vol 5. Social Criticism.
DANIELA GIOSEFFI. *Word Wounds & Water Flowers.* Vol 4. Poetry. $8
WILEY FEINSTEIN. *Humility's Deceit: Calvino Reading Ariosto Reading Calvino.* Vol 3. Criticism.
PAOLO A. GIORDANO, Ed. *Joseph Tusiani: Poet. Translator. Humanist.* Vol 2. Criticism.
ROBERT VISCUSI. *Oration Upon the Most Recent Death of Christopher Columbus.* Vol 1. Poetry.

www.ingramcontent.com/pod-product-compliance
Lightning Source LLC
Chambersburg PA
CBHW041133200526
45172CB00019B/1175